Mary Cassatt

AND PHILADELPHIA

THIS EXHIBITION

AND CATALOGUE HAVE BEEN

MADE POSSIBLE BY

MELLON BANK

THE BOHEN FOUNDATION

AND THE PEW MEMORIAL TRUST

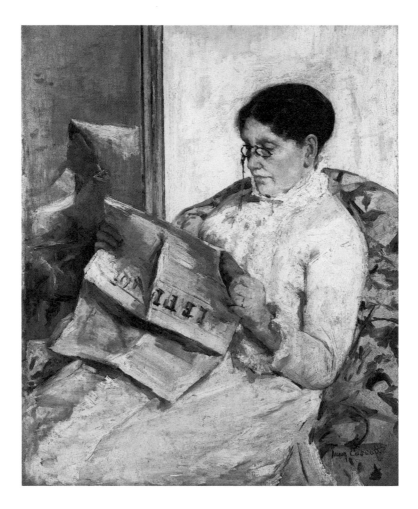

Reading Le Figaro, c. 1878
Oil on canvas, 39¾ × 32″ (101 × 81.3 cm)
Private Asset Management Group, Inc., New York

Mary Cassatt

AND PHILADELPHIA

SUZANNE G. LINDSAY

FEBRUARY 17–APRIL 14, 1985

PHILADELPHIA MUSEUM OF ART

Cover: Mary Cassatt, *In the Loge*, c. 1879 (no. 5)

Editor: Judith Ebbert Boust
Design: Laurence Channing,
with Mark La Rivière
Composition: John C. Meyer and Son, Inc.
Printing: Baum Printing, Inc.

Library of Congress Cataloging in
Publication Data

Lindsay, Suzanne G., 1947–
 Mary Cassatt and Philadelphia.

 Catalogue of the exhibition held Feb. 17–
Apr. 14, 1985 at Philadelphia Museum of Art.
 Bibliography: p. 96
 1. Cassatt, Mary, 1844–1926—Exhibitions.
2. Art—Pennsylvania—Philadelphia—
Exhibitions. I. Philadelphia Museum of Art.
II. Title.
N6537.C35A4 1985 760′.092′4 84-29623
ISBN 0-8122-7952-2 (University of Penn-
sylvania Press)
ISBN 0-87633-061-8 (pbk.)

Contents

Lenders to the Exhibition

Peter Borie, New York

Bryn Mawr College Library

Mrs. Gardner Cassatt, Bryn Mawr

Robert K. Cassatt, Brooksville, Maine

The Metropolitan Museum of Art, New York

Philadelphia Museum of Art

Private Asset Management Group, Inc., New York

Mr. and Mrs. Edgar Scott, Villanova

Estate of Jean Thompson Thayer, Devon

Anonymous Lenders (13)

Preface

*M*ary Cassatt, in her recently published letters and in the fresh variety of paintings, pastels, and prints in this exhibition, remains exhilaratingly immediate to the sensibilities of a late-twentieth-century audience. Her determination to maintain a brisk internationalism, at once affectionately disposed to her native country and "the good city of P.," as she called Philadelphia in her student days, and yet ever conscious that Paris was the center of the art world, strikes a modern note. Her submission of her own work to exhibitions in France and the United States; her steady, even urgent, persuasion of American institutions, collectors, and friends to buy works of art she considered important; and her refusal to serve on juries, since the system militated against the chances of some artists to exhibit, all turned on her passionate belief in the importance of exposing people to art and bringing the new art of France to artists and the general public here. With the advantage of hindsight, Cassatt emerges as a vigorous influence upon the increasing sophistication of the American eye. This exhibition celebrates not only the vivid immediacy of her work, but also her role in making the advanced art of her time visible in Philadelphia. The juxtaposition of *Mary Cassatt and Philadelphia* with two exhibitions devoted to the art of her friend and mentor Edgar Degas would have pleased her, following as it does the joint exhibition of their work in New York in 1915 by exactly seventy years. In her letter to a friend persuading him to lend a Degas painting on that occasion, she wrote: "The sight of that picture may be a turning point in the life of some young American painter. The first sight of Degas pictures was the turning point in my artistic life."*

We are most grateful to Suzanne G. Lindsay, who approached this project with enthusiasm and her customary thoroughness, discovering previously unpublished material in archives and family records, and broadening our understanding of Cassatt's relationship to her contemporaries in Philadelphia. This is the Museum's third comprehensive exhibition devoted to Cassatt; the first was the memorial tribute in 1927, and the second was held in 1960. Since that time, extensive research by scholars, most notably Adelyn D. Breeskin, has rendered many aspects of Cassatt's life and work increasingly accessible, and the Museum joins Dr. Lindsay in her warm thanks to all those who have helped with information or references.

We can never sufficiently express our gratitude to the lenders to the exhibition, many of whom have shared archival material as well as their splendid works of art with the public. Members of the Cassatt family have been extraordinarily helpful. We owe heartfelt thanks to those who provided the funding for this exhibition and its catalogue. The Pew Memorial Trust has supported a number of the Museum's projects, and its contribution to this one is greatly appreciated. We are happy to acknowledge the thoughtful, enthusiastic support of the Bohen Foundation. Finally, it is a source of great pleasure and pride that Mellon Bank provided a grant that helped make this exhibition possible. The presence in Philadelphia of a distinguished Pittsburgh institution makes a pleasing link to the career of Mary Cassatt. Born in what is now part of Pittsburgh, she adopted Philadelphia as her home and remained, all her life, a citizen of the world.

*Mathews 1984, p. 321

Anne d'Harnoncourt
The George D. Widener Director

Acknowledgments

The realization of this project is the result of the efforts of many individuals, to whom I extend heartfelt thanks. Anne d'Harnoncourt and Joseph J. Rishel proposed the idea of a Mary Cassatt exhibition; the concept of examining the Philadelphia career of this artist who lived abroad grew out of our numerous conversations on the subject. Their support and insight were crucial and are deeply appreciated.

I am particularly grateful to Adelyn D. Breeskin, the doyenne of Cassatt studies, and her assistant, Marie K. McCarthy. With characteristic enthusiasm, they provided unpublished information destined for Mrs. Breeskin's forthcoming revised catalogue raisonné of paintings, pastels, watercolors, and drawings. Nancy Mowll Mathews, whose Ph.D. dissertation and recent book of selected letters are major sources for this catalogue, assisted in all aspects of the project, often providing new material intended for her own book on Cassatt, soon to be published by Harry N. Abrams, Inc.

A large portion of the research would not have been possible without the generosity of the Pennsylvania Academy of the Fine Arts, which, primarily through the assistance of Linda Bantel and Catherine Stover, permitted special access to archives. Similarly, Marilyn Floreck of the Archives of American Art was helpful in making archives on microfilm available on short notice. The Cassatt family has been of central importance to this project. Special thanks in this regard must go to Mr. and Mrs. J. Robert Maguire for their unstinting cooperation and resourcefulness. Mrs. Stewart Simmons, the late Clement B. Newbold, Mrs. W. West Frazier, Mr. and Mrs. Alexander J. Cassatt, and Mrs. George Vehr were of valuable assistance in providing family reminiscences and traditions.

The long search through local periodicals for references to Mary Cassatt during her lifetime was shared with Caroline V. W. Goldberg. Others who generously provided information or unusual assistance include: Martha Asher, Jean Sutherland Boggs, Gérard Brignon, Cheryl Brutven, Christopher Burge, Carol Campbell, Laura Catalano, Trevor Fairbrother, Kenneth Finkel, Nancy Gillette, Robert Harman, Leslie A. Hasker, Sheila Hoban, Paul M. Ingersoll, Mrs. Jules James, Mary Leahy, Alison Luchs, Laura C. Luckey, Martha Manson, Beatrice C. Nash, Sandra L. Petrie, Helen Raye, Louise S. Richards, Bill Scott, Donna Seldin, Barbara S. Shapiro, Marjorie Shelley, John S. Stillman, Peter A. Strickland, and George E. Thomas.

Members of the staff of the Museum who significantly contributed to this project include: Carl Strehlke, Don La Rocca, Regina Zienowicz, Michael Hughes, Bill Hilley, Barbara Sevy, Louise Rossmassler, Darrel Sewell, Beatrice Garvan, Ellen S. Jacobowitz, Alice Lefton, Suzanne Wells, Conna Clark, Gail Tomlinson, Eric Mitchell, Joan Broderick, George H. Marcus, Laurence Channing, Jane Watkins, Judith Boust, Mark La Rivière, Sherry Babbitt, Janet Chase, Victoria Ellison, Jo Hynes, Elizabeth Drazen, Denise Thomas, Faith Zieske, Marigene Butler, Irene Taurins, Julia Addison, Grace Eleazer, T. S. Farley, Hal Jones, Michael MacFeat, Tara Robinson, Sandra Horrocks, Laura Gross, Kathryn Plummer, and Sue Roberts.

Finally, special thanks go to my husband, Bruce, whose support and patience were essential.

Suzanne G. Lindsay

Introduction: Mary Cassatt and Philadelphia

*I*t has become a tradition to argue Philadelphia's abysmal ignorance about Cassatt as an artist by means of a tiny local news item of around 1899: "Miss Mary Cassatt, sister of President Cassatt of the Pennsylvania Railroad, returned from Europe yesterday. She has been studying painting in France and owns the smallest Pekingese dog in the world."[1] This viewpoint has been gleefully relished for its myopia: her dog was, in fact, a rare Belgian griffon, and the fifty-five-year-old Cassatt, no mere fledgling, had a formidable international reputation as a painter.

This conventional ploy can be parried with a contemporary observation by another Philadelphia newspaper: "[Cassatt's] contributions to the leading exhibitions of the world are everywhere received with the high consideration due to the work of an artist of the first rank, and while we of Philadelphia may take just pride in claiming her as a member of our community, she is one of the brilliant galaxy of cosmopolitan painters whose fame is worldwide and who are citizens of the world of art."[2]

Evidence such as this reveals that certain quarters of Philadelphia were aware of Cassatt's international achievement. Furthermore, the passage typifies the local art criticism in scrutinizing her as a professional, not as the sister of a powerful corporate executive or as the owner of an exotic pet. There are glaring disjunctures, however, which suggest the complexity of the relationship. Her work was acclaimed by local critics and consistently sought by local art organizations for exhibition, but little of it was bought by Philadelphians. Cassatt despaired of Philadelphia as an art market, but at the peak of her career she and her dealer increased the frequency of exposure there; in fact, she appears to have exhibited in Philadelphia more often than in any other city. Her own family acquired most of her work by default, but her Philadelphia private and institutional patrons eventually honored her as did few others.

The fact that Cassatt lived abroad emphasizes the deliberateness of the link between the artist and Philadelphia. After spending much of her youth there, Cassatt moved to Europe in late 1871 and returned only three known times, in 1875, around 1899, and in 1908. She died and was buried in France in 1926, though her will claimed her legal domicile as Philadelphia,[3] where her two brothers and their families had remained.

Beyond its personal ties, Philadelphia attracted Cassatt as an art center. Discussions in her correspondence—both negative and constructive—bespoke the professional interest even from afar that her extended activity there implied. There was good reason for that professional interest. Philadelphia was a vital professional resource to be cultivated by any artist who sought a nationwide reputation in the United States, and Cassatt was among the many expatriates who pursued that ambition.[4]

The Philadelphia Art World during Cassatt's Career

*O*riginally the primary cultural center of the United States,[5] Philadelphia was second only to New York during the post–Civil War years in which Cassatt began her career. Philadelphia's continued dominance was due primarily to the Pennsylvania Academy of the Fine Arts (fig. 2). Established in 1805, the Academy differed from its counterparts in other American cities in fulfilling numerous functions: as a museum, in building a permanent art collection available to the public; as an art school, in offering educational facilities; and as a sponsor of temporary annual exhibitions in which artists

FIG. 1. Mary Cassatt at Grasse, c. 1914. Frederick A. Sweet Papers, Archives of American Art, Smithsonian Institution, Washington, D.C.

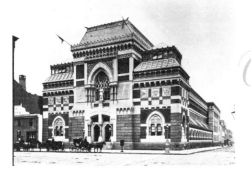

FIG. 2. The Pennsylvania Academy of the Fine Arts, Broad and Cherry streets, Philadelphia, photographed by Frederick Gutekunst c. 1877. PAFA Archives

FIG. 3. Professor Edward A. Smith with four students at the Pennsylvania Academy of the Fine Arts, Philadelphia, in 1862. The students (from left to right) are Mary Cassatt, Inez Lewis, a Miss Welch, and Eliza Haldeman. PAFA Archives

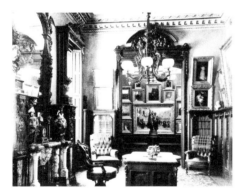

FIG. 4. Library in William B. Bement's house at 1814 Spring Garden Street, Philadelphia. Bement was one of the most prominent collectors and patrons of the arts in Philadelphia in the late nineteenth century. Photograph by Frederick Gutekunst. From Charles M. Skinner, *Catalogue of Works of Art . . . of William B. Bement of Philadelphia, Pa.* (Philadelphia, 1884)

could regularly present their work to the public.[6] It thus constituted a pivotal resource center for artists, critics, and patrons that was unmatched elsewhere. Cassatt had been a student at the Academy (fig. 3), and she later gave paintings to its permanent collection and exhibited there for decades.

By the late nineteenth century, the Academy annual was sufficient to make Philadelphia vital for practicing artists such as Cassatt. This exhibition was widely considered the American art event of the year, the equivalent of the celebrated Paris Salon.[7] After 1860, the scope of the annuals expanded beyond local art, causing Philadelphia artists to complain of neglect,[8] but eliciting national applause for being more representative, yet more selective, than those of New York. Even New York critics conceded the Academy's supremacy: "Less purely metropolitan than the exhibitions of the National Academy of Design in this city, it is more national, its awards have always been highly esteemed, as it draws pictures from all over the country—pictures even from New York painters of eminence who seldom exhibit at the Academy here."[9]

The cosmopolitanism of Academy exhibitions extended to the international forum; they not only presented works by foreign artists, but also actively sought those by American expatriates. Notices for the annuals, with instructions on gathering-points, were published in European journals, so even less-known artists had an opportunity to compete.[10]

The exhibitions were discussed nationwide in newspapers and art journals; thus the potential for national public and critical attention was enormous. The commercial possibilities were also far-reaching. Many entries in the Academy annuals, as was true elsewhere, were for sale, often submitted by local, national, and international dealers.[11] The success of the exhibition was even judged in part by the number of sales.[12]

The Academy's commercial function may have contributed to the apparent weakness of the local commercial art galleries,[13] which already suffered from the superior strength of the market in nearby New York.[14] By the late nineteenth century, what few dealers there were in Philadelphia depended either on the Academy as a major outlet,[15] or on other geographic or material resources. Philadelphia's leading dealer of that period, Charles F. Haseltine, opened branches in New York, Chicago, Paris, and Brussels for increased activity.[16] James Earle, a dealer who became active during the late 1850s, primarily sold mirrors and frames;[17] J. E. Caldwell and Bailey & Co. were jewelry and silver companies that also exhibited and sold paintings.[18]

The Academy's hold on the Philadelphia market was not exclusive, however, during the late 1880s; it was shared with a less-known organization that has not survived, the Art Club of Philadelphia. Founded in 1887 and devoted to the arts and letters, the Art Club held annuals on a smaller scale that were active and highly publicized outlets for artists until well into the twentieth century.[19] Cassatt herself regularly exhibited works there late in her career.

C. W. Brownell, a New York critic active during the 1870s, identified yet another reason for Philadelphia's artistic prominence at the time. He believed its collectors were among the finest in America: "Its private galleries are not only famous, but so deservedly famous that they contain by far the best works of several modern masters that are in this country."[20] Visits to private collections (see fig. 4) had been part of the Academy's educational program during Cassatt's years there as a student,[21] but the potential for patronage, which these collections signified, later drew Cassatt's professional attention.

FIG. 5. The Last Hour Gallery in Henry C. Gibson's house at 1612 Walnut Street, Philadelphia. Joseph Bailly's marble sculptures *The Expulsion* and *The First Hour* flank Auguste Friedric Schenk's painting *The Last Hour*, all bequeathed to the Pennsylvania Academy of the Fine Arts in 1892. PAFA Archives

Although little known today and largely dispersed, these collections were extensive, recently formed, and typical of most American holdings in representing nineteenth-century European painters who have since lost the appreciation they once had throughout Europe and the United States.[22] They included Salon painters such as William Bouguereau and Jean-Léon Gérôme, Spanish genre painters such as Mariano Fortuny (fig. 1d), and Northern painters such as Anton Mauve, Andreas Achenbach, Baron Hendrik Leys, and Adolf Schreyer. The most repeatedly and highly acclaimed collections in Philadelphia of the 1870s and 1880s boasted French Romantic, Barbizon, and Realist paintings. One of the most distinguished collections was that of Mr. and Mrs. Adolph E. Borie; renowned throughout the United States and France for its quality and historical interest, it focused particularly on Romanticism with four paintings attributed to Delacroix.[23] The critics considered Philadelphia's most encyclopedic collection of the 1880s to be that of Henry C. Gibson, who acquired one hundred modern paintings from all countries and schools, although most were from France (fig. 5).[24]

The international status of Philadelphia collections was achieved by the following generation, who demonstrated a far more independent taste and greater artistic ambition. George W. Elkins and his son William each built a collection that added to the typical nineteenth-century European paintings a fine group of eighteenth-century English and nineteenth-century American works, such as Winslow Homer's *Life Line* (Philadelphia Museum of Art).[25] William Elkins assembled a broad and impressive collection of old-master paintings as well, many of which are now in the Philadelphia Museum of Art.[26]

John G. Johnson's celebrated collection, now also housed at the Philadelphia Museum of Art, numbered 1,279 before his death in 1917. He apparently began buying in the late 1870s in the usual American vein,[27] but by the 1890s his interest expanded to include the old masters by an unfashionable route, the Flemish primitives. Unlike Gibson, Johnson had neither program nor restraint, though he sold and gave away paintings as well as acquired them; by 1911 his house had, by his own report, no "Standing Room" because of the stacks of unhung paintings.[28]

The most fabulous collection in Philadelphia at the turn of the century belonged to Peter A. B. Widener and his son Joseph. The elder Widener initially bought in the same category as other Philadelphians, but, like Johnson, took a different direction in the 1890s. Together with his more aesthetically rigorous son, Widener radically departed from the relatively modest taste of his contemporaries to pursue the "Grand Style," and developed a major holding of eighteenth-century paintings and old-master works.[29] Given to the National Gallery of Art in Washington, D.C., in 1942, this remarkable collection was deemed one of the most significant private collections in the world and one of Philadelphia's greatest assets.[30]

For all their differences, these collectors were typical of the nineteenth century in being self-made wealthy professionals or members of a recently established, rich, professional family—not from an old Philadelphia family living on residual income.[31] The contemporary critic Earl Shinn noted this characteristic of Philadelphia patronage at the time: "A Phidias who makes a god may go abegging in the nineteenth century unless there is a weaver to buy it. . . . It is, then, only what one expects when [Philadelphia], the emporium of enormous industries, turns out to be the shelter for whatever is fine, strange, and beyond the common market."[32]

FIG. 6. Gustave Courbet (French, 1819–1877).
The Mayor of Ornans (Urbain Cuénot), 1847.
Oil on canvas, 37½ x 29½″ (95.3 x 74.3 cm).
The Pennsylvania Academy of the Fine Arts,
Philadelphia. Gift of Mary Cassatt. 1912.10.2

Adolph Borie and Henry Gibson were successful second-generation wine or spirits merchants, financiers, and entrepreneurs;[33] John G. Johnson, born into a working-class family, built a formidable career as America's top corporate litigator of his day;[34] and P.A.B. Widener was a butcher who made a fortune in the transportation industry and its related enterprises.[35] Many had conventional artistic tastes, but others like Johnson and Widener displayed the same capacity for independence and risk in their collecting that characterized their professional lives. These attributes along with keen aesthetic insight may have helped them appreciate what was then the most controversial modern painting of France, that of Degas, Manet, and the Impressionists. These enterprising men, in some instances aided by Mary Cassatt, represented the earliest Philadelphia patrons of these artists.

Cassatt as Advisor to Philadelphia Collectors

While living in France, Cassatt helped build some of the most important private collections of European modern and old-master paintings in this country, most notably that of her close friends in New York, Louisine and Henry O. Havemeyer.[36] These efforts extended throughout America to private and public collections alike and are justly famous today.[37] Her hand in shaping Philadelphia collections while abroad has been less clearly perceived. Her intervention in Philadelphia, unlike elsewhere, seems to have been restricted to modern French painting in much smaller quantities.[38] She personally gave two Courbet portraits to the Academy in 1912, in memory of her family,[39] to be exhibited "on line" in the galleries for artists to study (fig. 6).[40] She also is known to have exerted varying degrees of influence over the purchases made by four Philadelphians who were visiting France; yet no direct impact on others buying at that time has been traced. Her effect on Philadelphia patronage was nonetheless crucial in the history of American collections, particularly of French Impressionism.

Late in life, in her letters from France to Philadelphia artist Carroll Tyson, Cassatt commented that Philadelphia needed new resources to encourage local buyers of modern art. She viewed the professional community as the most attractive source of new art patronage. Despite the outstanding example set by collectors such as Johnson, she regarded the majority as largely motivated by financial investment and as lacking a mediator to explain the value of art: "In these days of commercial supremacy artists need a 'middleman,' who can explain the merits of a picture . . . to a possible buyer. One who can point to the fact that there is no better investment."[41]

Although she was arguing the need for an effective dealer, she also seemed to explain her own advocacy of modern French art "from the field." She acted on her frequently articulated belief in the value of art to the life of a nation. As she remarked in an interview of 1911 with the Philadelphia *Public Ledger*: "All the pictures privately bought by rich Americans will eventually find their way into public collections and enrich the nation and the national taste. This is the case with all great collections in Europe."[42]

Her efforts in this vein began very early—within the decade of her arrival in Paris—and can be documented as couched within a financial idiom even then. However, the commercial approach must be understood in light of the public aesthetic benefit that she believed would result from private patronage.

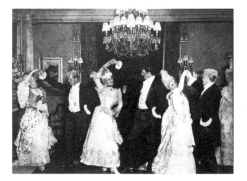

FIG. 7. Costume ball at Alexander Cassatt's townhouse, 202 Rittenhouse Square, Philadelphia, c. 1900. A pastel by Renoir (rear left), originally bought by the Cassatt family, remains in a family collection. Estate of Mrs. John B. Thayer

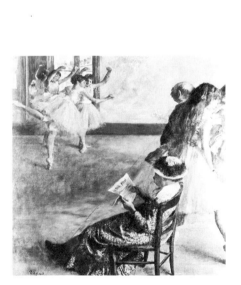

FIG. 8. Edgar Degas (French, 1834–1917), *The Ballet Class*, c. 1880. Oil on canvas, 32⅛ x 30⅛" (81.6 x 76.5 cm). Philadelphia Museum of Art. Purchased for the W. P. Wilstach Collection. W '37-2-1

Cassatt's campaign to place works by her French colleagues in Philadelphia began with her brother Alexander. Their father, who lived with the artist in Paris, understood the import of her undertaking. In spring 1881, he notified Alexander of the imminent arrival of paintings she had bought for him in Paris: "When you get these pictures you will probably be the only person in Philadᵃ who owns specimens of either [Monet or Pissarro]—Mame's [Mary's] friends the Elders [the family of Louisine Elder, later Mrs. H. O. Havemeyer] have a Degas & a Pissarro & Mame thinks that there are no others in America—If exhibited at any of your Fine Arts shows they are sure to attract attention."[43] Their father's predictions have since been largely confirmed. By making these purchases, Alexander was among those who initiated American interest in Impressionism. He took further action toward that end five years later by participating with two other private lenders, Erwin Davis and the Havemeyers, in the most important event in the history of American patronage of French Impressionism: the Impressionist exhibition in New York organized by Durand-Ruel in 1886.[44] Alexander Cassatt's seven entries were among those that implicitly motivated other Americans to buy.[45]

Alexander Cassatt typified the nineteenth-century American patron. By 1880, as first vice-president of the formidable Pennsylvania Railroad, he was one of the nation's most powerful corporate figures.[46] An aggressive and imaginative entrepreneur, he was favored as the successor to the railroad's ailing president, Thomas A. Scott (1823–1881).[47] Alexander had accumulated considerable wealth; thus he could partially subsidize his parents and sisters in France while living on an elaborate scale himself.[48] In 1872 and 1873, Philadelphia's leading architectural firm, Furness and Evans, built the Cassatts' country house, Cheswold, in Haverford.[49] During the winter, the family lived in the most prestigious neighborhood in town, Rittenhouse Square, where, in 1888, they purchased a house that Furness remodeled.[50] Although Alexander was reserved and exceedingly private, he and his wife were socially visible (fig. 7);[51] by his death in 1906, they were viewed as Philadelphia's leading family.[52] He belonged to the most exclusive social clubs in the area, including the Philadelphia and Rittenhouse clubs and the Assembly.[53]

Alexander Cassatt's leisure was devoted primarily to his great avocation, horses and horsemanship, including flat racing and coaching.[54] He was also a keen yachtsman. Contrary to the standard view that he was indifferent to the arts,[55] he figured prominently among local patrons of the arts. After 1874 he was a member of the Fairmount Park Art Association, a group devoted to the placement of public sculpture in the city,[56] and after 1892 he served as a commissioner of Fairmount Park.[57] He was one of the founders of the Art Club of Philadelphia in 1887.[58] He was a music enthusiast who arranged a special train for subscribers to see Wagner's *Parsifal* in New York in 1905.

Little is known about his collection prior to 1881, which, at that time, may have included only small family portraits.[59] His Impressionist holdings began with a work by Pissarro, one by Monet, and another by Degas that his sister selected and sent from Paris between the fall of 1880 and that of 1881. The chronology of these purchases coincides generally with the radical refurbishing of Cheswold early in 1880; a new wing had been built and new furniture was purchased during a summer trip to Europe.[60]

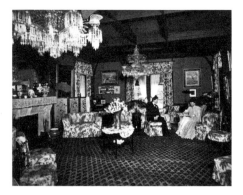

FIG. 9. Parlor in Alexander Cassatt's Haverford house, Cheswold, c. 1900. Seated at left is Elsie Cassatt, at right, Katharine Cassatt. To the right of the fireplace is James Abbott McNeill Whistler's *Arrangement in Black (No. 8): Mrs. A. J. Cassatt*; to the left of the double doors is Claude Monet's *Train in the Snow at Argenteuil*, to the right, Camille Pissarro's *Field of the Elder Lucien, Eragny*; and on the right wall, perhaps two other works by Pissarro. Estate of Mrs. John B. Thayer

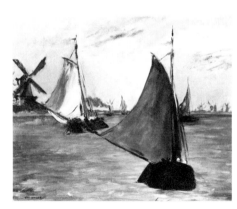

FIG. 10. Edouard Manet (French, 1832–1883), *Marine View in Holland*, 1872. Oil on canvas, 19½ x 24" (49.5 x 61 cm). Philadelphia Museum of Art. Purchased for the W. P. Wilstach Collection. W '21-1-4

Alexander's collecting ambition seems to have been modest. In December 1880, their mother wrote Alexander of the artist's search for reasonably priced works that would not seem "eccentric" to him.[61] Because Alexander seemed unfamiliar with the artists his sister recommended, she sent photographs merely to give an idea of a painter's style.[62] She also sought works representing his personal interests; when she had no luck finding paintings of horses by Degas,[63] she selected a work representing dancers, one of his "famous" subjects.[64] After the Degas painting was purchased, their mother still worried that "Alexander would be shocked by its eccentricity."[65]

The general description of the painting makes identification tenuous, but the canvas ultimately sent was likewise of dancers. It was shown as *Repetition of the Ballet* in the 1886 New York Impressionist exhibition (cat. 299) and is most likely the painting purchased from his granddaughter in 1937 by the Philadelphia Museum of Art (fig. 8).[66]

The Pissarro and Monet works purchased by Cassatt that winter, both of which are unidentified, were applauded as an astute investment by her father: "She has bought for you a Marine by Monet for 800 f. It is a beauty, and you will have an offer of 8000 for it."[67] All these pictures were to have arrived in Philadelphia by September 1881.[68]

After Cassatt's initial efforts in their behalf, Alexander and his wife, Lois, began buying on their own. Lois carefully reported her afternoon purchases in her journal during an extended visit to Paris in 1882 and 1883: "After lunch I went to see Mrs. Warren . . . then to Durand-Ruel's where we bought a head by Renoir then to Marguerite's to buy bonnets."[69] Ironically, during that same visit, they rejected Cassatt's suggestion that Renoir do Lois's portrait;[70] instead, they chose Whistler and were unhappy with the result (figs. 9 and 18a).[71]

Alexander apparently bought more works by Monet during that trip; his mother later inquired about their impact in Philadelphia: "Your father is anxious to know if any of your friends appreciate the Monets you took home."[72] Cassatt felt she had not pushed hard enough for more since their market value was increasing. She informed her brother, "Monet is coming up"; because ten thousand francs had been refused for one, she warned, "Hold on to your Monet's, I am only sorry I did not urge you to buy more."[73]

Cassatt also bought him paintings from Manet's heirs and at the Manet estate sale in winter 1883. She wrote that she hoped he would like what was bought for him: "There are two life size heads one a half figure . . . & neither of them cost 500 frcs."[74] These might be the works he owned that are currently identified as *Portrait of Marguerite de Conflans* (Oskar Reinhart, Winterthur) and *Italian Woman*.[75] She may have also purchased for him at that time Manet's *Marine View in Holland* (fig. 10), which he lent in 1886 for the Impressionist exhibition in New York (cat. 298, *Boats on the Meuse, Holland*). Five of his new paintings were in that landmark exhibition: the dance scene by Degas, the Manet seascape, and three Monet seascapes.[76]

By 1888 he had added to his collection two Pissarro paintings purchased from Durand-Ruel in Paris, a snowy landscape and a Pontoise landscape with figures.[77] In 1893 Alexander lent Pissarro's *Spring* to exhibitions at the Union League of Philadelphia (cat. 60) and the Chicago Columbian Exposition (cat. 2963). *Spring* might have been the unidentified painting purchased in 1881 or the gouache of 1888.

A precise account of what he owned during his life is still difficult to determine. Today, works attributed to his collection are relatively numerous: at

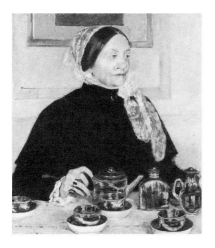

FIG. 11. Mary Cassatt, *Lady at the Tea Table*, 1885. Oil on canvas, 29 x 24″ (73.7 x 61 cm). The Metropolitan Museum of Art, New York. Gift of Mary Cassatt. 23.101. This portrait of Mrs. Robert Moore Riddle, begun during her trip to Europe in 1883, was Cassatt's gesture of thanks for Mrs. Riddle's gift of the Japanese tea service depicted in the painting

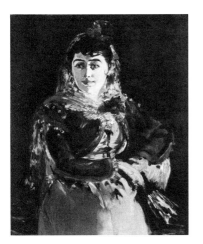

FIG. 12. Edouard Manet, *Emilie Ambre in the Role of Carmen*, 1880. Oil on canvas, 36 x 29″ (91.4 x 73.7 cm). Philadelphia Museum of Art. Gift of Edgar Scott. 64-114-1

least eight by Monet;[78] four by Renoir;[79] three by Manet; two by Degas, including the pastel *The Jockey* at the Philadelphia Museum of Art; one by Morisot, *Boats*, which is still in a family collection; at least four by Pissarro, including *The Meadow and the Great Walnut Tree in Winter, Eragny*; one by Raffaelli;[80] and two by Whistler, including the portrait of Lois Cassatt.[81] Mary Cassatt can be credited with much of the initiative and logistics that helped build this important collection. However, in shaping it as an integral part of their domestic ménage,[82] her brother and sister-in-law also made many choices on their own—at times as equably as buying a hat.

Alexander Cassatt's Impressionist collection was perhaps the first in Philadelphia, but others that began in the same decade were likewise affected by Mary Cassatt's intervention. Her cousin Anna (Annie) Riddle Scott, widowed in 1881 with the death of her husband, Thomas, president of the Pennsylvania Railroad, went to Europe with her mother (fig. 11) and two children in 1883 for about three years.[83] She and her husband had had a typical Philadelphia collection of Barbizon and Salon paintings, which were frequently exhibited in the city.[84] After she went to Paris, however, her aesthetic assumptions were radically subverted by the work of Cassatt's colleagues. The artist's mother observed that Anna "seemed inclined to buy [a painting] by Renoir, but she says all her ideas of art are upset & she won't buy much until she knows exactly what she likes—at present she is somewhat in the dark."[85] By early December, she had bought three works by Manet before the artist's estate sale: *Emilie Ambre in the Role of Carmen* (fig. 12)[86] and two pastels, *Young Girl en déshabillé* (Mr. and Mrs. Edgar Scott, Villanova) and *Mme Loubens on Her Bed* (private collection).[87] According to family tradition, Anna Scott was persuaded to buy the Manet works, which she disliked, under pressure from Cassatt. The purchase of *Emilie Ambre* allegedly was consummated only when a Corot was added to mollify the hostile client.[88] Nonetheless, with or without Cassatt's intervention, she went on to buy other works. At some point before 1892, perhaps while she was in Europe, she purchased two Degas works representing dancers—a fan (Mr. and Mrs. Edgar Scott, Villanova) and a monotype with pastel[89]—and Monet's *Autumn*.[90]

Cassatt also can be linked with an early and long-forgotten collection in Philadelphia, which has since been dispersed: that of Alexander Cassatt's long-time friend Frank Graham Thomson (1841–1899). The two men had been colleagues at the Pennsylvania Railroad since the 1860s.[91] During Alexander Cassatt's seventeen-year retirement from active management beginning in 1882, Thomson was second vice-president and became president in 1897. Thomson's death in June 1899 precipitated Alexander Cassatt's return to railroad management as president.[92]

In spring 1884, Cassatt had written her brother that "I will get the Monets for Mr Thompson if I can at the price."[93] Thomson, while in Europe in 1886, wrote to the artist and requested her help with an introduction to Monet.[94] Because Monet was away for the summer, Cassatt arranged for Thomson to see some of his work at Durand-Ruel; she also selected a Degas racing subject from a more modestly priced dealer, Portier. To her great indignation, Thomson disregarded her choices in favor of others: "Also just got a letter from Mr Thompson to tell me that Portier bought him two Monets or three, cheap, but he preferred buying one from Durand at 3000 frcs. I feel rather snubbed! I advised him to buy cheap, but I suppose he is the kind to prefer buying dear. I have very little doubt Portiers were the best pictures."[95]

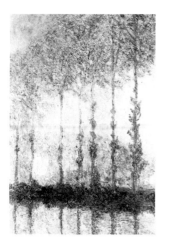

FIG. 13. Claude Monet (French, 1840–1926), *Poplars on the Bank of the Epte River*, 1891. Oil on canvas, 39½ x 25¾″ (100.3 x 65.4 cm). Philadelphia Museum of Art. Bequest of Anne Thomson as a memorial to her father, Frank Thomson, and her mother, Mary Elizabeth Clark Thomson. 54-66-8

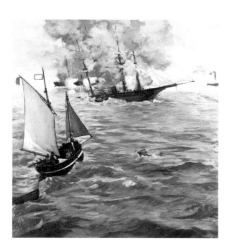

FIG. 14. Edouard Manet, *Battle of the Alabama and the Kearsarge*, 1864. Oil on canvas, 54⅝ x 51⅛″ (138.7 x 129.9 cm). John G. Johnson Collection at the Philadelphia Museum of Art. Cat. no. 1027

Whatever her actual contribution, the Thomson collection grew in focus and scale to one comparable to Alexander Cassatt's. This expansion was furthered by Thomson's son and daughter, who acquired a Degas pastel, *Two Dancers in Linen Skirts* (location unknown);[96] Manet's *Marine* (Philadelphia Museum of Art); at least nine works by Monet, four of which were bequeathed to the Philadelphia Museum of Art (see fig. 13);[97] Sisley's *Canal at Saint Mammès* (Philadelphia Museum of Art); and two works by Renoir, *Girl with a Falcon* (Sterling and Francine Clark Art Institute, Williamstown, Mass.) and *Head of a Girl* (Fitzwilliam Museum, Cambridge, England).

The Philadelphia business and social network may have linked Thomson to Cassatt in France. However, exposure to Alexander Cassatt's collection perhaps spurred him to act quickly, two years before the 1886 exhibition, suggesting the influence of that early collection within Philadelphia.

The 1886 New York Impressionist exhibition may have influenced John G. Johnson, Peter A. B. Widener, and William L. Elkins to buy in this category, since their Impressionist acquisitions all date after that event. Between 1888 and 1892, the date of his first published catalogue, Johnson purchased the Impressionist pictures now in the John G. Johnson Collection at the Philadelphia Museum of Art, as well as a few that were later sold. Most were bought from major New York dealers such as Durand-Ruel and Boussod-Valadon.[98] Among Johnson's purchases in 1888 were Monet's *Manne Porte, Etretat* and Manet's celebrated *Battle of the Alabama and the Kearsarge* (fig. 14), which had been in the 1886 New York exhibition (cat. 178). During the following three years he bought the three works by Degas currently in the Johnson Collection and Pissarro's *Early River—Early Morning*, all currently in the Johnson Collection.

Mary Cassatt probably was not directly involved with Johnson's purchases of Impressionist works, since most of them were made in the United States. However, Johnson probably knew Alexander Cassatt's collection, particularly since the two men had direct business relations—Johnson was Cassatt's long-time corporate lawyer,[99] and later his personal counsel.[100]

Peter A. B. Widener's incentive to collect Impressionist paintings may have stemmed from his association with Alexander Cassatt and John G. Johnson. A racing companion and business associate of Cassatt,[101] and a picture-hunting colleague of Johnson, Widener purchased Monet's *Regattas at Sainte-Adresse* around 1891.[102] About 1894 he bought Manet's celebrated *Dead Toreador* and Degas's *Races* in New York from Cottier & Co.[103] His Impressionist holdings, following the sale of four works by Monet,[104] consisted of two works by Degas and two by Manet—a small but impressive collection now in the National Gallery of Art, Washington, D.C.

William L. Elkins's purchase of three works by Monet in the early 1890s might also have been sparked by his Philadelphia colleagues' acquisitions—he and Alexander Cassatt were racing companions.[105] Already an experienced collector like the others, Elkins apparently bought these Impressionist works from his usual dealers; he purchased *A Bend in the Epte River, near Giverny* from Boussod-Valadon on February 10, 1892, and *The Custom House at Varangeville* (both in the Philadelphia Museum of Art) from Durand-Ruel on April 16, 1892.[106]

The independence of these early collectors stands out especially in light of the local critical reaction to Impressionism. When initially exhibited in the early 1890s,[107] these paintings met violent resistance. The critics' wrath was

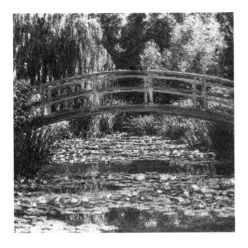

FIG. 15. Claude Monet, *The Japanese Foot Bridge and the Water Lily Pool, Giverny (Le Bassin et Nymphéas)*, 1899. Oil on canvas, 35⅛ x 36¾″ (89.2 x 93.3 cm). Philadelphia Museum of Art. Mr. and Mrs. Carroll S. Tyson, Jr., Collection. 63-116-11

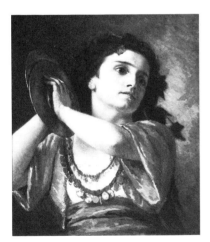

FIG. 16. Mary Cassatt, *Bacchante*, 1872. Oil on canvas, 24 x 20″ (61 x 50.8 cm). The Pennsylvania Academy of the Fine Arts, Philadelphia. Gift of John F. Lewis. 1932.13.1

particularly provoked by the 1892 Academy annual in which four works by Monet were included: *Autumn* (cat. 171), then owned by Anna Scott; *Haying* (cat. 173, *Haystacks at Giverny*) and *Banks of the Seine* (cat. 174; perhaps the Philadelphia Museum's *Port of Le Havre*), then owned by Frank Thomson; and an unidentified *Shining Stream* (cat. 172) that belonged to the distinguished physician, provost of the University of Pennsylvania, and civic leader, William Pepper (1843–1898).[108]

In terms of critical impact, the 1892 annual seems to have represented Philadelphia's counterpart to the 1886 New York exhibition, but with a predominantly negative reaction. The four paintings by Monet drew such pervasive fire that criticism of the entire annual focused largely on Monet's implications for modern art.[109]

The objections of Philadelphia reviewers were standard fare in the criticism of Impressionism, but they were couched in a purely local idiom. They regarded the paintings as the perversion of nature and art. The critic from the *Inquirer* singled out *Shining Stream* as the target for his litany of Monet's sins. He condemned the painting as an explosion of colored mud springs, covering the landscape with "flecks of bright yellow, red, and purple. Through the midst of this chromo-circus runs a stream which recalls the Schuylkill [the river traversing the west end of Philadelphia] when the coal banks around its source have left their color effect upon its swollen waters. And that's the 'shining stream.' "[110] This critic's quip about nature gone berserk not only suggests his hostility to Monet's subjective treatment of nature, but also emphasizes what he otherwise claimed was the total lack in these paintings of discernible organization. He concluded that the basic requirement of Impressionism was "an atmosphere of fog . . . all is vague, misty, indefinite."

In the decades that followed, the critical barrier against Impressionism began to weaken.[111] By 1913, the year of the Armory Show, advocates and buyers were plentiful. Cassatt, aware of the change, told Carroll Tyson in 1904, "I have lived so long in the intimacy of artists now so celebrated, but when I first knew them so neglected."[112] As a consequence, perhaps, her intervention during these years was greatly reduced.

Tyson was himself an outstanding collector of modern art for whom Cassatt arranged a visit to see the works of Manet and Degas at Durand-Ruel, Paris, in 1904.[113] Tyson, by then, had purchased two Impressionist works; one, Monet's *Nymphéas* (fig. 15), had been painted the year he bought it, 1899.[114] After World War I he began buying in earnest; among his paintings associated with Impressionism are Manet's celebrated *Le Bon Bock* and Renoir's monumental *Bathers* of 1887, both at the Philadelphia Museum of Art.

There is no documented contact between Cassatt and one of the most formidable collectors of modern art in Philadelphia, Albert Barnes, who seems to have begun buying after 1905, often assisted by the painter William Glackens.[115] Barnes bought and sold Impressionist works throughout his career and ended up with what continues to be one of the largest and most important Renoir collections in America, buttressed with paintings by Cézanne, Manet, Monet, Degas, and others (Barnes Foundation, Merion, Pa.).

Cassatt's role seems to have been crucial at the outset, making pioneers of the Philadelphia collectors who bought works by the wide range of artists identified with Impressionism. However, her direct intervention appears to have been limited; the developing networks within Philadelphia and other parts of the United States seem to have eventually predominated. Those who were

FIG. 17. Mary Cassatt, *Musical Party*, 1874. Oil on canvas, 38 x 26" (96.5 x 66 cm). Musée du Petit Palais, Paris. 3737

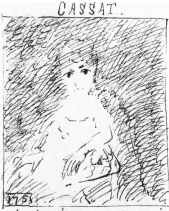

FIG. 18. Caricature of Mary Cassatt's *Portrait of a Lady*, done by a student for a pamphlet, *L'Académie pour rire*, at the time of the "Forty-ninth Annual Exhibition" at the Pennsylvania Academy of the Fine Arts, Philadelphia, April 22–June 2, 1878. The legend reads "J'adore les yeux noirs, moi" (Myself, I adore black eyes). PAFA Archives

already experienced collectors, who already knew the art market and responded to Impressionism, needed no advocate.

For all her efforts in Philadelphia on behalf of her French colleagues, Cassatt seems to have had little sustained contact with their Philadelphia counterparts. Her relations with Thomas Eakins, an exact contemporary and fellow student at the Academy, and with another Academy classmate, printmaker and art educator Emily Sartain, appear not to have survived long after her move to Paris.[116] She later knew and despised the popular portraitist Cecilia Beaux as intellectually pretentious and for "catering too much to 'Society.'"[117] Late in life, however, she enjoyed warm friendships with younger artists such as Carroll Tyson and Adolphe Borie, both of whom sought her out in Paris at the beginning of this century and received generous professional counsel from her for years.[118] Although not a major influence on Philadelphia artists, this formidable expatriate was regarded as an important figure to visit in France even during her twilight years, and she welcomed them until she died. George Biddle, who had admired her work even as a child, was one of the last to talk with her only days before her death in June 1926—mark of her abiding interest in the artistic community of Philadelphia.[119]

Cassatt's Philadelphia Patrons

Following Mary Cassatt's death, Philadelphia became the major locus in America of her work, with over fifty known oils and pastels, countless drawings and watercolors, and hundreds of prints. However, only one painting was in a public collection, and only a modest group had been gifts or purchases during her lifetime. The importance of the Philadelphia holdings—and they remained the largest for decades—is largely due to what she gave or bequeathed to her family. Philadelphia failed to produce patrons who bought in great quantity, such as those of New York and Connecticut: the Havemeyers, James Stillman, Payson Thompson, the Hammonds, the Popes, and the Whittemores. Yet for all Cassatt's difficulty in this area, her Philadelphia patrons included some of the most distinguished collectors, and they purchased a wide range of works representing nearly the full span of her career.

In 1873, probably marking her professional debut in Philadelphia, the jewelry and silver store Bailey & Co. showed two of her Sevillian paintings in its west window: *On the Balcony* (no. 1) and *Spanish Dancer Wearing a Lace Mantilla* (National Museum of Art, Washington, D.C.).[120] Despite extensive discussion in local newspapers, Cassatt's mother expected few buyers, since it was summer and potential patrons were probably away.[121] Indeed, apparently failing to sell the painting then and later, Cassatt eventually gave *Spanish Dancer* to her housekeeper Mathilde Valet.[122] *On the Balcony* fared better, perhaps even at this exhibition, since it reemerged in a Philadelphia collection within the next ten years.

Cassatt's first recorded patrons in Philadelphia, however, date from the 1870s. Cassatt's *Bacchante* belonged to local collector John W. Lockwood, who lent it to a large exhibition of private collections at the Pennsylvania Academy of the Fine Arts in 1877 (cat. 343). That painting has tentatively been identified as the *Bacchante*, signed and dated "Parma 1872," now at the Academy (fig. 16), suggesting that Lockwood's painting was one of her earliest expatriate works to enter a Philadelphia collection.

Little is known about Lockwood except that he lived at 1906 Walnut Street,[123] and that he was a partner in a business of "inspectors."[124] To judge

FIG. 19. Mary Cassatt, *Young Lady Reading*, c. 1878. Oil on panel, 15⅞ x 24⅜" (40.3 x 61.9 cm). Private collection

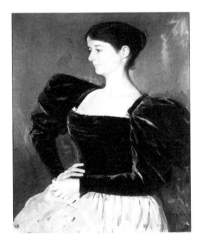

FIG. 20. Mary Cassatt, *Portrait of Mrs. Clement B. Newbold*, c. 1898–99. Oil on canvas, 33 x 27" (83.8 x 68.6 cm). Private collection

by the 1877 Academy exhibition catalogue, he was also a notable collector by Philadelphia standards. His fifteen entries in the 1877 exhibition reveal that his collection was in the typical Philadelphia eclectic vein. Among them were works by Alberto Pasini, Charles-Théodore Frère ("Frère Bey"), and Adolf Schreyer, the latter two popular for their Oriental genre. If the Academy's *Bacchante* was Lockwood's, its classical subject modernized as exotic genre, active pose, and earthy colors were compatible with his other holdings.

Yet other paintings by Cassatt in this Romantic-Realist vein found neither a home in Philadelphia nor the official recognition extended by Boston, where she received a silver medal for *Musical Party* (fig. 17), which had been shown in Philadelphia with no such acclaim.[125] Cassatt decided that Philadelphia was unappreciative and that, despite Boston's applause, New York was her only acceptable forum. In 1878 her mother reported that "she will never send anything except to New York where there is some chance and where she is known & acknowledged to have some talent—In Phil[a] it is the case of a 'prophet is never without honor &c.' "[126]

The Cassatts blamed both the Philadelphia public and her dealer, an obscure agent named Hermann Teubner. They complained about Teubner's seeming indifference to the large quantity of works in his charge. By December 1878 the Cassatts estimated that he had fifteen of her paintings, including *Musical Party* and *Torero and Young Girl* (fig. 1c).[127] Cassatt was so anxious to sell that she repeatedly urged Teubner not to hold out for high prices.[128] Living abroad, she was unable to negotiate directly with him; her instructions by correspondence or through an intermediary, a Mrs. Mitchell, were so ineffectual that the family asked Alexander and Gardner Cassatt in Philadelphia to intervene.[129]

Cassatt's perception of Teubner's inertia may have been exaggerated. He entered two of her paintings in the Academy annual of 1878, *Torero and Young Girl* (cat. 192) and an unidentified *Portrait of a Lady* (cat. 175; see fig. 18).[130] He may have exhibited *Portrait of a Lady* earlier at James Earle's gallery, where it was apparently reviewed by a local critic.[131]

Teubner's record might be further improved by a work linked to him that has recently come to light. A small signed figure painting on mahogany, now privately owned, is identified by the labels on the back as *Young Lady Reading* (fig. 19), a work submitted by Teubner to the Academy on August 17, 1878.[132] The inscribed date reveals that it was not intended for the annual, since that exhibition had closed in early June, so the reason for its presence at the Academy at that time is still unknown. The label identifies the owner as P. Koonz, the current holder's grandfather, a dentist from Jersey City. Although not a major work, this painting suggests that some of Cassatt's early paintings placed with local dealers found immediate buyers. *Young Lady Reading*, in a different vein from *On the Balcony*, represents the quiet, intimate subject matter and style of her work of the late 1870s that is associated with her Independent colleagues in Paris—Manet, Renoir, and Monet.

Teubner, Bailey & Co., and Earle's gallery are Cassatt's only recorded Philadelphia dealers, and their role was restricted to the 1870s. By 1881 she was represented exclusively by Durand-Ruel in Paris and New York, the source of all her work distributed thereafter throughout Europe and America.

Cassatt's Philadelphia patrons of the seventies and early eighties also bought her work directly in Paris. In 1877, Rodman Barker Ellison, a Philadelphia businessman who may have known the Cassatt family, commissioned a portrait

FIG. 21. "One-hundredth Anniversary" installation at the Pennsylvania Academy of the Fine Arts, Philadelphia, January 23–March 4, 1905, in which Mary Cassatt's *Portrait of Mrs. Clement B. Newbold* (fig. 20) was exhibited. PAFA Archives

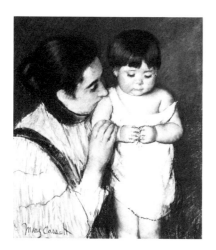

FIG. 22. Mary Cassatt, *Young Thomas and His Mother*, c. 1893. Pastel on cardboard, 24 x 20" (61 x 50.8 cm). The Pennsylvania Academy of the Fine Arts, Philadelphia. Deposited by Mrs. Clement B. Newbold. 1904.10

of his daughter Mary (no. 2), who was on an extended visit in Paris. This date equates Rodman Ellison with John Lockwood as Cassatt's earliest recorded Philadelphia patrons.

Six years later, Cassatt found a buyer among traveling Philadelphians for one of her strongest works of the late 1870s, *In the Box* (no. 4). It was purchased in Paris from Cassatt's new dealer, Durand-Ruel, in 1883 by her widowed cousin Anna Riddle (Mrs. Thomas) Scott. This theater subject, shown that year in London in an Impressionist exhibition, is one of the first of Cassatt's works identified with that group to enter a Philadelphia collection. During the 1890s, Anna Scott acquired one of the rare sets of Cassatt's color prints and several drypoints (Mr. and Mrs. Edgar Scott, Villanova). Cassatt holdings were, therefore, particularly noteworthy in quality and number among those in Philadelphia acquired as purchases rather than gifts.

Around 1880, John G. Johnson, a previously unknown Philadelphia patron of Cassatt, apparently acquired *On the Balcony*, which appears in a photograph of his parlor (fig. 1b). Cassatt's painting was thus in one of the most distinguished Philadelphia collections at the earliest stage of its evolution.

For the first twenty years of Cassatt's career, five patrons from Philadelphia can be identified, with only about ten works purchased among them. Although they included the celebrated *In the Box* owned by Anna Scott, the Philadelphia holdings were already best represented by family portraits that were as acclaimed then as they are now: *Reading Le Figaro* (fig. 28), which probably arrived in 1879, and the *Family Group* of 1880 (no. 7).

Although Cassatt had vowed never to exhibit her works in Philadelphia again, in the early twentieth century Durand-Ruel undertook a strong, sustained program to place works available for sale in Philadelphia exhibitions; the Academy and the Art Club together received at least one almost every year between 1900 and 1913. Not counting those privately owned, about thirty paintings and pastels were exhibited in Philadelphia because of that policy. Very few subsequently remained in the city.

Two, however, entered the collection of Frank Thomson and his family. *Girl with an Orange* (fig. 30) was exhibited at the Art Club's watercolor and pastel show in 1906 (cat. 158) and at the Academy's watercolor exhibition in 1910 (cat. 339). It entered the Thomson collection at an unknown date, as did *Young Mother and Her Children*, a pastel lent to the Academy in 1920 by his daughter Anne Thomson (cat. 8), which might be the *Children Playing with Their Mother* (Breeskin 1970, cat. 386, private collection) shown at the Art Club (cat. 157) with *Girl with an Orange* in 1906 and in 1909 (cat. 217).

If the Thomsons did acquire their pastels from these exhibitions, the collection gained its only works by Cassatt very late in its formation; on the other hand, these are handsome works of precisely that late period in Cassatt's career. *Girl with an Orange*, probably done in 1893, is a particularly striking example of Cassatt's post-Impressionist iconic, formal style that was much discussed by Philadelphia critics.

Other patrons also emerged during the 1890s. Among the earliest is Anna Scott's daughter Mary (Mrs. Clement B.) Newbold, who not only commissioned a portrait painted in the severe style of the 1890s (figs. 20 and 21), but also owned the pastel *Young Thomas and His Mother* (fig. 22). The source of the pastel is unknown, but, like most works, it might have come from Durand-Ruel.

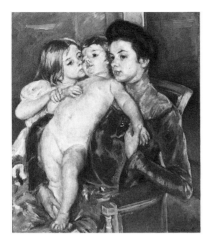

FIG. 23. Mary Cassatt, *The Caress*, 1902. Oil on canvas, 32⅞ x 27⁵⁄₁₆″ (83.5 x 69.4 cm). National Museum of American Art, Smithsonian Institution, Washington, D.C. Gift of William T. Evans. 1911.2.1

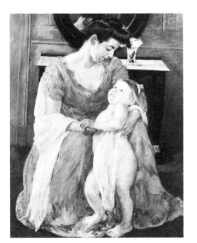

FIG. 24. Mary Cassatt, *Mother and Child*, c. 1908. Oil on canvas, 46 x 35½″ (116.8 x 90.2 cm). The Metropolitan Museum of Art, New York. Bequest of Miss Adelaide Milton De Groot (1876–1967). 67.187.122

Mr. and Mrs. Newbold lent it to the Academy's watercolor exhibition of 1905 (cat. 7). This pastel, which Breeskin (1970, cat. 227) dates about 1893, represents Cassatt's post-Impressionist pursuit of a more simple, classical style.

The Newbolds, who otherwise owned distinguished eighteenth-century American portraits and inherited part of Mrs. Scott's modern European collection, were among the first to be approached by Academy officials as potential buyers of her painting in the annual of 1904. In a letter to the managing director, Clement Newbold wrote, "Mrs. Newbold has made up her mind that she dont want Miss Cassatt's picture at all. . . . I am sorry Walter Lippincott did not take it."[133] Both the date and the reference to Lippincott suggest that the unidentified picture is *The Caress* (fig. 23), winner of Cassatt's only Philadelphia award, the Walter Lippincott Prize for figure painting, which gave its founder first option to buy the painting.[134]

Philadelphia thus became one of several cities in which this work was exhibited without attracting a buyer. *The Caress* was ultimately purchased by the renowned American collector William T. Evans, who bequeathed it in 1911 to the National Collection of Fine Arts in Washington, D.C. (now the National Museum of Fine Arts); it was one of the earliest paintings by Cassatt in a national collection.

Mrs. Algernon Curtis, another Philadelphian, is associated with Cassatt because of a portrait (Breeskin 1970, cat. 569, private collection) that was commissioned ostensibly during the artist's last trip to Philadelphia. Unfortunately, little is known of the project. The pastel portrait of Mrs. Curtis is one of the most explicitly Japanist in Cassatt's work.

John F. Braun, a Philadelphia patron who was active late in Cassatt's career, lent *Mother and Child* (fig. 24) to the Academy annual of 1911. The date of purchase and the previous owner are unknown; ultimately, however, it went to the celebrated collection of Adelaide M. De Groot, New York. This relatively late, monumental composition formed part of Braun's large collection of American paintings, which was regarded by his contemporaries as a complete overview of that category. Cassatt's painting joined Whistler's *Harmony in Gray and Peach Color* (Fogg Art Museum, Harvard University, Cambridge, Mass.) in representing the expatriate European influence.[135]

An unfinished variant, *Mother and Child* (fig. 25), whose provenance is likewise unknown, was in another American collection in Philadelphia, that of Alex Simpson, Jr. When given to the Pennsylvania Museum in 1928, Simpson's collection was applauded as a relatively complete survey of late-nineteenth-century painting in which Cassatt's work again served as evidence of French influence.[136]

Cassatt's work was introduced into Philadelphia public collections in 1906 with Johnson's gift of *On the Balcony* to the municipally owned Wilstach Collection, then as now under the care of the Philadelphia Museum of Art. *On the Balcony* appears to be the first Cassatt painting to have entered a museum in the United States; thus Philadelphia may have the distinction of being Cassatt's first American public supporter. The next known museum acquisition occurred in 1908, when the Detroit Institute of Arts was given a pastel, *Three Women Admiring a Child* (Breeskin 1970, cat. 272). Between 1909 and 1910, about four other pastels and paintings entered American museums. The Academy in Philadelphia, the artist's alma mater and the most frequent exhibitor of her art in that city, did not receive its only work by Cassatt, *Bacchante*, until 1932.[137]

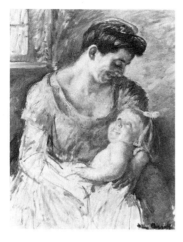

FIG. 25. Mary Cassatt, *Mother and Child*, 1908. Oil on canvas, 32 x 23⅞″ (81.3 x 60.6 cm). Philadelphia Museum of Art. The Alex Simpson, Jr., Collection. 28-63-3

FIG. 26. "One-hundred-sixth Annual Exhibition" at the Pennsylvania Academy of the Fine Arts, Philadelphia, February 5–March 26, 1911, in which Mary Cassatt's *Lydia Reading in a Garden* (The Art Institute of Chicago) is seen at far left. PAFA Archives

Critical Perceptions of Cassatt in Philadelphia

As an expatriate with no local dealer after the 1870s, Cassatt depended on exhibitions for professional exposure in Philadelphia. Toward that end, she and Durand-Ruel capitalized on the most important artistic outlets in the city, the annuals of the Academy (fig. 26) and of the Art Club.

Her doctrines as an Independent—rejection of juries and academies in the interest of artistic freedom—seem not to have interfered. Although she later complained about the Academy's restrictive jury system,[138] she apparently did not participate in the "rebel" exhibitions of the Philadelphia Society of Artists, unlike in New York, where her art was exhibited at the Society of Artists' annual in 1879, and in Paris, where after 1879 it was shown exclusively with the Independents, not in the Salon.

She exhibited with a remarkable breadth in Philadelphia. Her works were in at least forty local exhibitions between 1873 and 1927, in contrast with New York, where she entered about seven, many of which were large individual exhibitions. Hundreds of paintings, pastels, watercolors, and prints were shown during that fifty-four-year period; the chronology of the exhibitions, however, is erratic. Her works appeared annually at the Academy in the 1870s; perhaps working exclusively on her European exhibitions, she disappeared from the Philadelphia forum in the 1880s and 1890s—except when Alexander Cassatt's entries were in the Academy annual of 1885. But works by Cassatt were shown at the Academy virtually every year from 1898 to 1920 and at the Art Club after 1905—and at the watercolor and pastel exhibitions at both institutions beginning in 1909.[139] She was thus at the peak of her public exposure in Philadelphia at the beginning and end of her career.

Likewise, Philadelphia art groups were extremely interested in Cassatt, whose submissions are not known to have ever been rejected. Later—surely by the twentieth century—the Academy actively sought her works, soliciting the artist and her family or sending the director to New York to select entries from Durand-Ruel's inventory.[140]

However, Cassatt's work rarely won the coveted place of honor in an exhibition, line center in the main gallery. She is known to have been given that location only twice, in exhibitions of watercolors and pastels, a less-important category of work in the traditional hierarchy of mediums.[141] She was arguably limited by the modest scale of her work, since the site demanded a large object as a focus for the gallery. She won only one prize for her painting during those years, the Academy's Walter Lippincott Prize for figure painting in 1904; however, she later removed herself from consideration for such prizes by stipulating that some of her entries were ineligible.[142]

Just as she seldom held the place of honor in the gallery, she was rarely the leading artist in critical reviews in the local press, which was influenced by the Academy's policies. In the reviews located to date, Cassatt often receives only a passing reference or none at all. Nonetheless, the local reviews and articles are crucial sources for how Philadelphians perceived the artist and her work during her lifetime.

The earliest discussion located thus far is an extensive review in the *Daily Evening Telegraph* of her works exhibited in 1873 at Bailey & Co.;[143] the anonymous critic, Eakins's champion during these years, was greatly impressed by what he saw.[144] Already familiar with her work, he perceived that she had grown significantly from a student to an outstanding, albeit still immature,

FIG. 27. Mary Cassatt, *Portrait of the Artist's Father, Robert S. Cassatt*, 1871–75. Oil on canvas, 26½ x 22⅛" (67.3 x 56.2 cm). Private collection

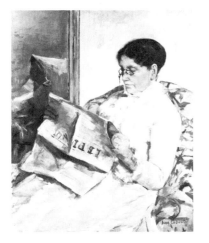

FIG. 28. Mary Cassatt, *Reading Le Figaro*, c. 1878. Oil on canvas, 39¾ x 32" (101 x 81.3 cm). Private Asset Management Group, Inc., New York

artist. He felt the paintings on view, *On the Balcony* (no. 1) and *Spanish Dancer Wearing a Lace Mantilla* (National Museum of American Art, Washington, D.C.), demonstrated Cassatt's particularly forceful style, which he celebrated in spite of its extremism: "It is a great thing . . . to see a lady artist paint in this firm and decided manner, and we can readily forgive a fault so easily corrected for the sake of the sure knowledge and real power which it indicates."[145]

Subsequent criticism focused far less on the particulars of her work than on its implications for American art and society. Almost always presented as a positive example, Cassatt played a highly conceptual role for many Philadelphia reviewers, including the critic from the *Daily Evening Telegraph* who continued to be impressed with her.[146] His discussion of her Academy debut in 1876 with two portraits (see fig. 27) and *Musical Party* set the tone for his subsequent coverage. Though all were "scarcely more than spirited sketches," they reflected, he claimed, a formidable artist who was merely immature within her chosen approach: "Miss Cassatt . . . is an artist of great ability, who has been well trained in a good school, and her crudest works challenge admiration for their intrinsic qualities, such as it is impossible to give to the performances of many of her male rivals. Many of the pictures she is now painting must be regarded as simply experiments in a method which she has not thoroughly mastered, but which when she does master it, will give her a rank with the best portrait painters of the day—certainly the best on this side of the Atlantic."[147]

During the next years, this critic claimed that Cassatt had gained that command of her métier. He praised her works in the Academy annuals— primarily *Torero and Young Girl* (fig. 1c) shown in 1878 and *Reading Le Figaro* (fig. 28) shown in 1879—and considered her a model of the successful formation of an artist.[148] Unlike her fellow Americans abroad, Cassatt represented the best of what he sought in a mature artist, that assimilation of study through hard work that eventually formed a distinct character without the stamp of Paris, Munich, or Antwerp. The critic implicitly celebrated this artist as an American and an individual—both important examples for Philadelphia as a center of formal art education and as a national leader in contemporary American art.

Cassatt's impact on the critics was so great that they decried her absence from the Philadelphia exhibitions of the 1880s. Earl Shinn particularly faulted the Academy in 1881 for having no "impressions by Miss Cassatt."[149] Shinn, in using this terminology, was among the first to link Cassatt with French Impressionism—two years after her first exhibition with the Independents in 1879.

However, once the critics perceived her work as Impressionist, they still found it too personal to identify as wholly within the idiom of that French movement. Two paintings, dating from 1880 and belonging to Alexander Cassatt, were shown at the Academy in 1885 after acclaimed appearances in European Impressionist exhibitions: *Family Group* (no. 7), in Paris in 1881, and *Elsie with a Dog* (Breeskin 1970, cat. 81, private collection), in Durand-Ruel's London show of 1883. A Philadelphia critic observed upon seeing them: "Miss Cassatt has for years been one of the most interesting of our painters who inhabit Paris. She has an unmistakable individuality, notwithstanding her entire subscription to the canons of the impressionists. An ardent admirer of Degas, not to say Manet, she nevertheless has a wholly virile point of view, rather than imitation of the manner of her masters, that characterizes her works."[150] The

critic's praise of her "virile" point of view was a back-handed compliment of the assertiveness of her art, a characteristic noted in 1873 by the *Daily Evening Telegraph* and later by several French commentators. Gauguin distinguished her work from that of her women colleagues by claiming that Cassatt's had more force than Morisot's.[151] The Philadelphia critic thereby stressed her uniqueness, despite her allegiance to a body of artistic principles that ostensibly bound her to her French colleagues.

By contrast, in 1885 the critic from the *Daily Evening Telegraph* denied any link between Cassatt's work and the new wave of Impressionists.[152] He felt that, unlike the paintings of the "sensation-seeking" French, Cassatt's works showed that she had succeeded in a traditional pursuit of painting *a la prima* (direct, spontaneous, sketchy execution) in which others had previously failed.

Although they agreed on the individuality of her Impressionism, the critics were at odds on her precise relationship to traditional and current art. Regardless of their point of view on that issue, they fundamentally appreciated her work. When it reappeared in Philadelphia exhibitions in 1898, however, it was apparently repudiated by many local critics.

The nature of the problem was revealed in an impassioned attack in 1898 by the critic from the *Daily Evening Telegraph* against what he regarded as a gross underevaluation of her work in Philadelphia. He claimed the public and the art community could not perceive the learned artistry in Cassatt's style: "If she is unconventional, it is not because she is ignorant of conventions, but because after having served an apprenticeship and learning her trade thoroughly, she has been given original power to go forth in absolute independence, working out her own ideals in her own way"; he claimed the resulting painting was "a truthful representation of facts . . . without regard to what conventional people expect to find in a regulation academic picture."[153] For this critic, the very success of Cassatt's realism seemed thus to blame; its rendering of modern life seemed too "artless" to a public that needed a more obvious reference to tradition in order to regard it as serious painting—a classic prejudice against realism in art. Cassatt had not rejected tradition, merely transformed it, unlike, he claimed, George de Forest Brush's *Mother and Child* (location unknown), hung in the Academy's place of honor that year. The critic felt that Brush's painting owed its success to its blatant imitation of Renaissance Holy Family groups.

Perhaps as a symptom of that lack of general appreciation, Cassatt's Academy entries that year, *Woman Seated* (unidentified) and *The Bath* (fig. 29), drew little critical attention. *The Bath* was prominently illustrated and summarily described as having a "quaint composition"—in effect its radical, close-up, "Japanese" viewpoint.[154]

Cassatt's exhibited works were subsequently rarely mentioned in reviews until after the turn of the century, by contrast with the overwhelming focus on portraiture by Sargent and Whistler, and a new interest in modern religious paintings such as Henry O. Tanner's *Annunciation* (Philadelphia Museum of Art) and John La Farge's *Adoration* (the Brooklyn Museum, New York).[155] The critics also widely applauded the Realist narrative paintings by Eakins and Homer, which were seen to be heavy with symbolism.[156] The human values of Cassatt's work apparently did not coincide with those of the Philadelphia critics who sought a modern art with meaning.

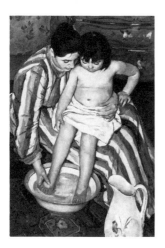

FIG. 29. Mary Cassatt, *The Bath*, 1891–92. Oil on canvas, 39½ x 26″ (100.3 x 66 cm). The Art Institute of Chicago. Robert A. Waller Fund. 1910.2

FIG. 30. Mary Cassatt, *Girl with an Orange (Margaret Milligan Sloane)*, c. 1893. Pastel on paper, 32 x 26″ (81.3 x 66 cm). Location unknown

Critical perceptions of Cassatt began to change in 1904 when she was awarded the Walter Lippincott Prize for *The Caress* (fig. 23). The distinction failed to trigger substantial criticism of the painting itself, but certain newspapers focused on the award's importance for Philadelphia. This recognition gave luster to her family, and she was identified as a "sister of Mr. A. J. Cassatt."[157] Her international reputation and local attachment apparently lent even greater prestige: "She holds a high place among the pleinair painters of France, though she maintains the stoutest allegiance to her native city."[158]

Her rejection of the Lippincott Prize as unwelcome discrimination attracted even greater attention. The critics began to discuss Cassatt in a moral light. The Philadelphia *Press* claimed that in refusing the Lippincott Prize she was trying merely to maintain her moral integrity as an artist and a person.[159] She was quoted as saying that because she saw no hope of converting others to her point of view, she had to be consistent and hence had rejected all prizes and medals offered her. To this commentator, her unconventional moral strength implicitly determined the character of her art: "Her work is very strong and original in line and color, and her handling of all her subjects is far from conventional."[160]

Subsequent discussions of her art similarly applauded its originality, but noted that as such it eluded the public's understanding. In 1906, the *Inquirer* critic who saw the Art Club watercolor and pastel show said that Cassatt "has always an original point of view, seldom entirely understood by the layman, and her contributions are no exception to the general rule."[161] Her *Children Playing with Their Mother* seemed almost "too audacious in its carelessness of color and drawing," but the other, *Girl with an Orange* (fig. 30), "is almost Holbeinesque in its dignity."[162]

Her individualism was the primary theme of one of the most extraordinary published commentaries of her life and values at the time. Its appearance in March 1907 in a Philadelphia daily newspaper, the *North American*, suggests that it may have been triggered by the publicity surrounding the disposition of Alexander Cassatt's estate that winter; although exaggerating her known financial worth to an extreme, the anonymous account claimed that "Miss Cassatt belongs, by right of birth and breeding, to the social realms of the Quaker City, and had she chosen might have been a ruling power in our exclusive circle, but she voluntarily gave up such diversions to devote her life to art. Heiress to millions, the richest artist living, this woman has worked away with untiring energy, all the while living in an unostentatious manner." The result was an art that was permeated with her character: "Besides the solid technique, correct value, and adroit interpretation of nature, her paintings disclose a profound sentiment. They are works of an artist who has spent years in search for character and truthfulness without regard for petty prettiness."[163]

This discussion contradicts several published interpretations of Cassatt's lifetime reputation in Philadelphia. In contrast with Nancy Hale (1975), it suggests that by at least 1907 she was no social pariah in Philadelphia; indeed, she was perceived as among its elite. To judge from these observations, by then she had little reason to escape Philadelphia in order to be taken seriously as an artist—which contradicts the opinion of another Philadelphia expatriate, George Biddle.[164] Furthermore, these remarks were not isolated, and they recurred, such as in the following year, during her last visit to her family.[165]

These observers felt Cassatt's problem in Philadelphia was that her work was too sophisticated. One critic intended a tribute when he noted that while "no

artist has won quite the place held in France by Miss Mary Cassatt," her work "has never attracted the wide and general public. It appeals almost exclusively to artists." The result, the critic claimed, was that it was "to be found [only] in fastidious collections."[166]

Philadelphia journalists also made an issue of her uncompromising morality. One of the most telling examples is an anecdote published in 1910 in the *Public Ledger*, which claimed that when approached by the Capitol "ring" for a kickback on a mural commission for the Pennsylvania Statehouse in Harrisburg, she not only threw their agent out, but stopped the project as well. This source concluded, "There are few artists who preserve so rigid an independence of the motives of vanity and gain as she does."[167]

The predominantly human concern of these commentators is radically different from that of critics after 1910, who largely focused on aesthetic considerations. Her link with tradition as an undisputed modernist was the primary issue, much as it was in the 1880s when her place within Impressionism was under discussion. By the 1920s, however, the dominant aesthetic focus was Post-Impressionism and Cubism, particularly after the Armory Show of 1913. Cassatt's exemplary role was particularly manifest in a critical review of her pastels in the Philadelphia Art Club exhibition of 1919, only one of which can now be identified, *The Conversation* (Breeskin 1970, cat. 260, location unknown). The issue was the extent to which established artistic principles should be jettisoned as part of rebellion against tradition. To one critic, Cassatt represented the acceptable approach: "In the midst of many strenuous attempts to be in the new movement, they [the pastels] have the air of Old Masters, the serenity, the dignity. Their presence is a timely reminder that the rebels of Cassatt's day did not discard color, form, respect for surface, feeling for medium."[168]

In certain quarters, Cassatt's paintings were even perceived as part of the newer tendencies. The most important demonstration of this view took place in the Academy's 1920 exhibition (fig. 31), organized in part by Cassatt's friend Carroll Tyson. Including about forty of her works—by far the largest group of works by a single artist—the exhibition ranged from works by Courbet to those of the Synchromists.

Those who identified Cassatt as a modernist rebel claimed she had been institutionally suppressed in Philadelphia—an allegation that blatantly contradicted nearly fifty years of local exhibitions. The *Inquirer*, which had frequently supported her work over the years, went so far as to say: "[Local art lovers] are shown numerous examples of Manet, Degas, Courbet, Monet, Whistler, Renoir, Mary Cassat and other recognized modern masters which have long been available for exhibition here had they been desired. And the significance of it is not only that so many canvases have been assembled in the galleries at [the Academy] but that they are essentially modern canvases, many of them of a style rigorously excluded by the academy regime."[169] The alleged victim of an uncomprehending public erroneously became that of a censorial establishment.

Cassatt's forty-odd works, the largest group yet on exhibition in Philadelphia, were drawn from private collections and placed in a separate gallery, where they received extensive positive commentary. Yarnall Abbott of the *Press* regarded it as a "completely satisfying room showing Mary Cassatt at her distinguished best."[170]

FIG. 31. Gallery of works by Mary Cassatt in the "Exhibition of Paintings and Drawings by Representative Modern Artists" at the Pennsylvania Academy of the Fine Arts, Philadelphia, April 7–May 9, 1920. PAFA Archives

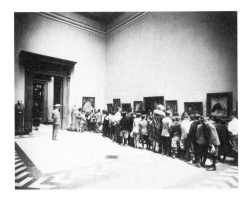

FIG. 32. "Mary Cassatt Memorial Exhibition" at the Pennsylvania Museum of Art (housed at Memorial Hall), Philadelphia, April 30–May 30, 1927.

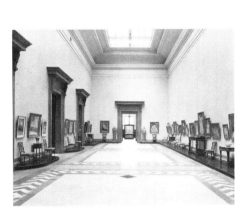

FIG. 33. "Mary Cassatt Memorial Exhibition" at the Pennsylvania Museum of Art (housed at Memorial Hall), Philadelphia, April 30–May 30, 1927.

Her obituaries six years later bore the stamp of the local critical tradition and acknowledged her high professional standing. The *Inquirer* claimed that in America and Europe she was considered "one of the best women painters of all time, member of a prominent Philadelphia family" who had "preferred her art, however, to the social life open to her."[171]

Philadelphia's perception of Cassatt was perhaps best revealed by the large memorial exhibition in 1927 at the Pennsylvania Museum at Memorial Hall. It was one of four held in the United States in that and the following year. Over forty paintings and pastels, fifteen drawings and watercolors, and one hundred prints were lent from Philadelphia and New York collections for a retrospective of her work (figs. 32 and 33). The exhibition drew nationwide as well as local attention. Philadelphia critics viewed the retrospective as a milestone for the city. Francis J. Ziegler of the *Record* claimed it was an "event of such an extreme importance artistically that one cannot help but wish that the galleries in which it is held were more easily accessible; in other words, that it could not have been arranged in the center of the city."[172]

Ziegler was subtly scolding the Academy, long associated with Cassatt, for failing to organize the exhibition. The show struck others as a revelation. C. H. Bonte of the *Inquirer* claimed: "Not until now . . . has there been afforded the opportunity to realize how varied was her accomplishment, and under what sundry influences she worked, though at all times maintaining her own individual style."[173]

The current view of Philadelphia's neglect of the artist took a turn—though perhaps unwittingly—in a review of the exhibition by the New York critic and acquaintance of Cassatt, Forbes Watson.[174] He wrote of her chagrin about the sacrifice necessitated by her career; to find resources for professional development, she had been forced to live abroad. Although Watson felt the resulting work had been ample justification, the cost had been great. He was particularly struck by the impression that relocation to Europe, despite increased professional stature, apparently had caused her home city to forget her. To support his argument, he quoted the infamous passage cited at the beginning of this essay, thus becoming the first of many to do so. Unlike later writers on Cassatt, Watson intended merely to celebrate Philadelphia's increasing recognition of the artist since the appearance of the news item, culminating in the 1927 retrospective, which he called "Philadelphia's definitely official memorial tribute."[175]

Watson, however, was wrong in one respect: Philadelphia and Cassatt, although physically remote, had been in regular contact, and the city had indeed recognized her before the 1927 exhibition. In Philadelphia, Cassatt's professional presence, both as advisor and artist, had been pervasive in exhibitions, the art market, and the city's collections. That extensive involvement elucidates both Cassatt's career and the aesthetic climate of the city, for, in singling out the threads of her professional activity and Philadelphia's response, the warp and weft of the city's cultural life become clearer.

Notes

1. Forbes Watson, "Philadelphia Pays Tribute to Mary Cassatt," *The Arts*, vol. 2, no. 6 (June 1927), p. 295 (without source or date). It was later said to have come from the Philadelphia *Public Ledger*, c. 1898–99; see Nathaniel Burt, *The Perennial Philadelphians* (Boston, 1963), p. 333; see also Sweet 1966, p. 150. Although the primary source of the passage is unknown, it must date after June 9, 1899, when Alexander Cassatt was elected president of the railroad. The chronology of the artist's visit to Philadelphia is unknown and may have extended to spring 1900, as her known correspondence from France resumed at that time. More recent citations of the passage are as unspecific as those in Burt and Sweet; see Hale 1975, p. 177. Others are derived from them; see E. Digby Baltzell, *Puritan Boston and Quaker Philadelphia* (New York, 1979), p. 314 (quoted from Burt). Both Burt and Baltzell used this passage to characterize Philadelphia's overall cultural state at that time. One of Burt's vital sources is the scathing condemnation of Philadelphia's many faults by an "old" Philadelphian who also moved to Europe and who considered Cassatt a kindred spirit; see George Biddle, *An American Artist's Story* (New York, 1939), for information on his admiration of her work and his reminiscence of a visit with her in France shortly before her death.

2. *Daily Evening Telegraph*, January 15, 1898, p. 7.

3. Last Will and Testament, July 18, 1911, AAA, PMA.

4. Cassatt's American exhibition career has never been studied systematically, but for insights into the frequency of her participation in American exhibitions, see Breeskin 1970 and Sweet 1966.

5. Joshua C. Taylor, *The Fine Arts in America* (Chicago, 1979), p. 44.

6. Frank H. Goodyear, Jr., "A History of the Pennsylvania Academy of the Fine Arts, 1805–1976," in Philadelphia, The Pennsylvania Academy of the Fine Arts, *In This Academy* (1976), pp. 15–20.

7. *Evening Bulletin*, January 14, 1899, p. 5; *Public Ledger*, January 15, 1900, p. 6; *Commercial Advertiser*, January 25, 1904; and *Washington Post*, January 31, 1904. (The latter two are in the Scrapbook, PAFA Archives.)

8. As a reaction against this perceived neglect, the Philadelphia Society of American Artists was founded along the lines of the New York group of the same name in the late 1870s to support local artists. It lasted only a few years, unlike its counterpart in New York. See "The Fine Arts: The Annual Exhibitions," an undated and unattributed clipping, c. 1881, Scrapbook, PAFA Archives.

9. *Evening Mail*, January 24, 1910, Scrapbook, PAFA Archives.

10. *Le Journal des arts*, May 22, 1883, Scrapbook, PAFA Archives. In the early 1880s, there were widely discussed exhibitions of works by American students working abroad.

11. Many annual catalogues distinguished works for sale with an asterisk or a price. Dealers whose names appeared among the owners of entries, in 1878 alone, included Knoedler (cat. 107 and 206) in New York and Earle & Son (cat. 39 and 103), McClees & Son (cat. 242), and Hermann Teubner (cat. 99, 100, 102, 175, and 192), all in Philadelphia.

12. *Item*, February 28, 1892, Scrapbook, PAFA Archives.

13. Beyond its guise as a marketplace where dealers and artists could place their works, the Academy regularly bought art exhibited there. Although there are no statistics, the Academy was considered the largest institutional buyer of modern art from its own shows (*Inquirer*, August 12, 1900, Scrapbook, PAFA Archives). Significantly, Cassatt herself did not benefit from this acquisition program.

14. By 1875 New York's major auction and gallery activity attracted buyers from all over the nation, including Philadelphia. The column entitled "The Art Galleries" in *The Art Amateur* is an excellent primary source for the history of the contemporary New York market and American patronage. For a profile of a contemporary out-of-state collector closely associated with the New York market, see Lewis Hall's "Introduction" in Washington, D.C., Corcoran Gallery of Art, *William A. Clark Collection* (April 26–July 16, 1978), pp. 1–14. For a survey of the American activity of French dealers in New York, see Lois Marie Fink, "French Art in the United States, 1850–1870, Three Dealers and Collectors," *Gazette des Beaux-Arts*, ser. 6, vol. 42 (September 1978), pp. 87–100. For a recent discussion of the relationship between New York and Europe, see Denys Sutton, "'One Paris, in the Universe,'" in New York, Wildenstein, *Paris–New York, a Continuing Romance* (November 3–December 17, 1977), pp. 7–35.

15. See n. 11.

16. The painter Charles F. Haseltine (1840–1915) was born of a wealthy Quaker merchant family; see *DAB*, s.v. Haseltine, James Henry (his brother). Haseltine Galleries, which opened around 1869 (see *Gopsill's Philadelphia City Directory*), was well known even in New York by the 1870s; see "The Art Gallery: Sale of the Season," *The Art Amateur*, vol. 1, no. 2 (July 1879), p. 26. Haseltine retired around 1913 (see the letter published as the cover of the auction catalogue of his gallery inventory at the Philadelphia Art Galleries, January 15–16, 1913). He is best known today as Eakins's dealer in the 1870s;

see Gordon Hendricks, *The Life and Work of Thomas Eakins* (New York, 1974), p. 92. For his expansion, see the letterheads of the Haseltine gallery bills of the late 1880s, Archives, John G. Johnson Collection at the Philadelphia Museum of Art.

17. See the advertisement for Earle's Galleries of paintings, looking glasses, mirrors, and engravings in Philadelphia, The Pennsylvania Academy of the Fine Arts, *Thirty-fifth Annual Exhibition* (1858), back cover.

18. See the notice of J. E. Caldwell's exhibition of Paul Jobert's paintings in the *Inquirer*, February 5, 1898, p. 7. Bailey & Co. exhibited works in their window, but for special sales, preview exhibitions were held at the Academy. See *Catalogue of a Superb Collection of Paintings of Messrs. Bailey & Co. to be sold March 27–28, 1867 . . . open for examination at the Pennsylvania Academy of the Fine Arts*.

19. See *Charter, Constitution, By-Laws, and House Rules . . . of the Art Club* (Philadelphia, 1903), pp. a3–a5.

20. C. W. Brownell, "The Art Schools of Philadelphia," *Scribner's Monthly*, vol. 18 (September 1879), p. 737.

21. Letter dated January 26, 1860, from Eliza Haldeman to Samuel Haldeman, PAFA Archives, in Mathews 1984, pp. 22–23. For a recent discussion of the artistic education of women at the Academy, see Christine Jones Huber's "Introduction" in Philadelphia, The Pennsylvania Academy of the Fine Arts, *The Pennsylvania Academy and Its Women, 1850–1920* (May 3–June 16, 1973), pp. 7–30.

22. The most thorough survey of these Philadelphia collections is the important contemporary account by Edward Strahan [Earl Shinn], *Art Treasures in America*, 3 vols. (Philadelphia, 1879–80).

23. Paul Durand-Ruel claimed to have sold Borie many of his French Romantic and Barbizon paintings; see "Mémoires de Paul Durand-Ruel," in Lionello Venturi, *Les Archives de l'Impressionisme* (Paris, 1939), vol. 2, p. 169. See also Strahan [Shinn], *Art Treasures in America*, vol. 3, pp. 15–24, and an important contemporary report of these collections by the French critic E. Durand-Gréville, "La Peinture aux Etats-Unis. Les Galeries privées (Premier article)," *Gazette des Beaux-Arts*, ser. 2, vol. 36 (July 1887), pp. 69–71. Shinn identified the Delacroix paintings as *The Meeting of Ruth's Kinsman and Boaz, Groom and Mare, The Capture of Goetz von Berlichingen*, and *The Lion Hunt*; he also described them at length and illustrated the latter two. *The Lion Hunt*, the most surely identified with paintings currently attributed to Delacroix, may be the 1858 variant of that subject bought by the Museum of Fine Arts, Boston. *The Capture of Goetz von Berlichingen*, if by Delacroix, relates to his lithographic

series on the subject of the 1840s. Although many were sold during Mrs. Borie's lifetime and others remained with their nephews, the collection was finally sold in 1906 (see Philadelphia, M. Thomas & Sons Galleries, *Catalogue of Paintings . . . of Mr. Adolphe E. Borie* [April 5–6, 1906]). For recent discussions of Borie's collection, see Louise d'Argencourt, "Bouguereau and the Art Market in France," and Robert Isaacson, "Collecting Bouguereau in England and America," in Montreal Museum of Fine Arts, *William Bouguereau, 1825–1905* (February 9, 1984–January 13, 1985), pp. 100–101, 106–7.

24. See Strahan [Shinn], *Art Treasures in America*, vol. 1, pp. 65–80. The collection was bequeathed to the Pennsylvania Academy of the Fine Arts in 1892. See Frank H. Goodyear, Jr., and Carolyn Diskant, *Henry C. Gibson Collection*, in Philadelphia, The Pennsylvania Academy of the Fine Arts, *The Beneficent Connoisseurs* (1974), n.p.

25. See Philadelphia Museum of Art, *Catalogue of Paintings in the Elkins Gallery* (1925).

26. See *Catalogue of Paintings in the Private Collection of W. L. Elkins*, 2 vols. (Paris, 1900).

27. Although it is generally assumed that Johnson began buying in the early 1880s, he was revealed as the anonymous buyer of *Near Chartres*, by the nineteenth-century Spanish painter Martín Rico, in the sale of the Albert Spencer collection in New York, April 13, 1879; see "The Art Gallery: Sale of the Season," p. 27. The painting was listed in the 1892 catalogue of the Johnson Collection as cat. 202, but apparently was subsequently sold.

28. The best discussion of the history of Johnson's collecting is in Aline B. Saarinen, *The Proud Possessors* (New York, 1958), pp. 92–117.

29. For discussions of the Widener Collection, see W. G. Constable, *Art Collecting in the United States of America* (London [1964]).

30. For a list of what was given, see Washington, D.C., National Gallery of Art, *Works of Art from the Widener Collection* (1942). For the value placed on it in Philadelphia, see the *Public Ledger*, January 24, 1907, Scrapbook, PAFA Archives.

31. For more on this sociological aspect of nineteenth-century patronage, see Fink, "French Art in the United States," p. 92.

32. Strahan [Shinn], *Art Treasures in America*, vol. 2, p. 83.

33. For a biographical discussion of Gibson, see Goodyear and Diskant, *Henry C. Gibson Collection*. For information on Borie, see *DAB*, s.v. Borie, Adolph Edward. Borie, of distinguished French émigré stock, helped to establish the prevailing professional class of nineteenth-century Philadelphia. For a genealogical discussion, see Frank Willing Leach,

"Old Philadelphia Families, CXLIV-Borie," *The North American*, January 5, 1913, pp. 6–7. For a sociological discussion of Borie's role in Philadelphia, see E. Digby Baltzell, *Philadelphia Gentlemen* (Glencoe, 1958), p. 92; see also Burt, *The Perennial Philadelphians*, p. 338.

34. See Saarinen, *The Proud Possessors*; see also Barnie F. Winckelman, *John G. Johnson, Lawyer and Art Collector* (Philadelphia, 1946).

35. *DAB*, s.v. Widener, Peter Arrell Brown.

36. For a general discussion of their collecting and Mary Cassatt's role, see Saarinen, *The Proud Possessors*, pp. 144–73. See also Louisine Havemeyer, *Sixteen to Sixty: Memoirs of a Collector* (New York, 1961).

37. See Sweet 1966; see also John Rewald, *History of Impressionism* (New York, 1973). For Cassatt's counsel to one of the most important collectors of Chicago, Mrs. Potter Palmer, see Saarinen, *The Proud Possessors*.

38. See Sweet 1966.

39. In 1912 she was the sole survivor of her immediate family. Her parents had died in the 1890s; Lydia, in 1882; Alexander, in 1906; and Gardner, in 1911.

40. Letter dated March 22 (1912) from Mary Cassatt to John F. Lewis, PAFA Archives. Both erroneously claimed these would be the only works by Courbet in Philadelphia public collections, either at the Academy, which had *Oak at Flagey*, or with the Johnson Collection, which was to be given to the City and included about seven of Courbet's works (letter dated April 9 [1912] probably from John F. Lewis to Mary Cassatt, PAFA Archives).

41. Letter dated July 11 (1904) from Mary Cassatt to Carroll Tyson, AAA, PMA.

42. *Public Ledger*, May 7, 1911, Scrapbook, PAFA Archives.

43. Letter dated April 18, 1881, from Robert Cassatt to Alexander Cassatt, AAA, PMA, in Mathews 1984, pp. 160–61.

44. See the revised exhibition catalogue, New York, American Art Association—National Academy of Design, *Works in Oil and Pastel by the Impressionists of Paris* (1886), cat. 298–310. For the importance of this exhibition, see Hans Huth, "Impressionism Comes to America," *Gazette des Beaux-Arts*, ser. 6, vol. 29 (April 1946), pp. 225–52. See also Sweet 1966; Rewald, *History of Impressionism*, pp. 523–32; and "Mémoires de Paul Durand-Ruel," in Venturi, *Les Archives de l'Impressionisme*, pp. 216–17.

45. "Mémoires de Paul Durand-Ruel," in Venturi, *Les Archives de l'Impressionisme*, pp. 216–17.

46. Patricia T. Davis, *End of the Line: Alexander J. Cassatt and the Pennsylvania Railroad*

(New York, 1978), pp. 14–77. For an evaluation of Cassatt's career within the context of the city's overall social and professional life, see Baltzell, *Philadelphia Gentlemen*.

47. For a brief biography of Scott, see *DAB*, s.v. Scott, Thomas Alexander. For a laudatory contemporary assessment, see the accounts of his impending death and the obituaries in the *Evening Bulletin*, May 21, 1881, p. 3, and the *Inquirer*, May 21, 1881, p. 1, and May 23, 1881, pp. 4, 8. For a negative view, see Davis, *End of the Line*.

48. Davis, *End of the Line*, pp. 44, 76–77. At his death in 1906, his worth was rumored to be about $7 million; see the Alexander Cassatt Obituary Scrapbook, Estate of Mrs. John B. Thayer.

49. Davis, *End of the Line*, p. 43. For a contemporary description of the house, see "The Homes of America: Some Pennsylvania Houses," *The Art Journal*, vol. 3 (1876), pp. 260–67. For a study of the architectural firm (the house is not mentioned), see Philadelphia Museum of Art, *The Architecture of Frank Furness* (April 15–May 27, 1973). For development of the suburban area along the Pennsylvania Railroad Main Line as a prestigious residence of the powerful professional class of Philadelphia, see Baltzell, *Philadelphia Gentlemen*, pp. 201–5.

50. Davis, *End of the Line*, pp. 42, 111. The architectural historian George E. Thomas provided information about Furness's modifications of the house.

51. This personality trait was used consistently in Philadelphia obituaries to contrast his conduct in a business meeting with his nonprofessional demeanor. The *Public Ledger* (December 29, 1906, p. 11) and the *Evening Bulletin* (December 29, 1906, p. 2) noted that he was so "diffident" to the public eye that he left his share of socializing to his wife. See also Davis, *End of the Line*.

52. *Public Ledger*, December 29, 1906, p. 11.

53. Ibid. They were members of the Assembly, an exclusive society that gave the most prestigious dance of the social season, at least by 1870; see Hale 1975, p. 48.

54. See Davis, *End of the Line*, and the Cassatt Obituary Scrapbook.

55. Sweet 1966, p. 84; Hale 1975, p. 107.

56. *Inquirer*, December 29, 1906, p. 1. See also the Fairmount Park Art Association's annual reports, 1874–90.

57. For his relationship with the Fairmount Park Commission, see the *Inquirer*, January 1, 1907, Cassatt Obituary Scrapbook.

58. See Minutes, Art Club, 1888, quoted in Philadelphia Museum of Art, *Philadelphia: Three Centuries of American Art* (April 11–October 10, 1976), cat. 366.

59. In 1879 he commissioned a group equestrian portrait of his family in gouache (now in a family collection) from Charles Detaille in Paris, presumably based on a photograph. See Sweet 1966, pp. 46–47.

60. Sweet 1966, p. 55. See also Davis, *End of the Line*, p. 82.

61. Letter dated December 10 (1880) from Katherine Cassatt to Alexander Cassatt, AAA, PMA, in Mathews 1984, pp. 154–55. This author follows Mathews as opposed to the hypothetical date of 1883 given in Sweet 1966, p. 83.

62. Letter dated November 18 (1880) from Mary Cassatt to Alexander Cassatt, AAA, PMA, in Mathews 1984, pp. 152–54.

63. Ibid.

64. Letter cited in n. 61.

65. Letter dated June 30, 1880, from Katherine Cassatt to Alexander Cassatt, Estate of Mrs. John B. Thayer.

66. This is the only painting attributed to the collection of Alexander Cassatt by Lemoisne; see P.-A. Lemoisne, *Degas et son oeuvre* (Paris, 1946), vol. 3, cat. 479.

67. Letter cited in n. 43.

68. Letter dated September 19 (1881) from Katherine Cassatt to Alexander Cassatt, AAA, PMA, in Mathews 1984, pp. 162–63.

69. See Lois Buchanan Cassatt, March 17 (1883), "Account of Our Trip to Europe in 1882," Estate of Mrs. John B. Thayer.

70. Letter dated December 29 (1884) from Mary Cassatt to Lois Cassatt, AAA, PMA, in Mathews 1984, pp. 186–87.

71. See Lois Cassatt, "Account of Our Trip."

72. Letter of November 30 (1883) from Katherine Cassatt to Alexander Cassatt, AAA, PMA, in Mathews 1984, pp. 174–75.

73. Letter dated October 14 (1883) from Mary Cassatt to Alexander Cassatt, AAA, PMA, in Mathews 1984, pp. 172–73.

74. Letter dated March 14 (1884) from Mary Cassatt to Alexander Cassatt, AAA, PMA, in Mathews 1984, pp. 180–81.

75. Sold by the heirs at Christie's, New York, October 31, 1978, lot 15.

76. *Sunset on the Seine* (cat. 300); *Banks of the Meuse, Holland* (cat. 301); and *Boats on the Meuse, Holland* (cat. 302).

77. A gouache entitled *Paysage près Pontoise*, signed and dated 1888, was sold by the heirs at Parke-Bernet, New York, April 15, 1959, lot 56 (repr.).

78. The Monet works (Wildenstein 1974 catalogue numbers in parentheses) are *The Green Wave* (cat. 73, The Metropolitan Museum of Art, New York); *Green Park, London* (cat. 165, Philadelphia Museum of Art); *The Basin of the Thames, London* (cat. 168, private collection); *Bank of the Zaan* (cat. 174, private collection); *View of the Zuiderkerk (South Church) in Amsterdam* (cat. 309, Philadelphia Museum of Art); *Regattas at Argenteuil* (cat. 340, sold at Sotheby's, New York, May 15, 1984, lot 5); *Train in the Snow at Argenteuil* (cat. 360, private collection); and *Steps at Vétheuil* (cat. 682, private collection).

79. A Renoir pastel (see fig. 7) is still in a family collection; a pastel bust-length figure of a young woman in brown is also in a family collection; a pastel portrait of Renoir's son Coco was sold by Alexander Cassatt's grandson at Parke-Bernet, New York, April 15, 1959, lot 63; and *Portrait of a Young Girl* was bought from the family by the Philadelphia Museum of Art (Françoise Daulte, *Auguste Renoir* [Lausanne, 1971], vol. 1, cat. 479).

80. The Loan Register (PAFA Archives) lists among the Raffaellis in a special exhibition of his work in 1895 a *Landscape*, register no. 1913, owned by Alexander Cassatt. This may be the Raffaelli work to which Cassatt referred when she identified the most recent Monet dealer as "Petit the man you bought your Raffaelli from" (letter cited in n. 73).

81. Whistler sent the Cassatts *Chelsea Girl* as a gesture of appeasement for his tardiness in finishing the portrait. See Hale 1975, p. 122; see also Andrew McLaren Young, Margaret MacDonald, and Robin Spencer, *The Paintings of James McNeill Whistler* (New Haven, 1980), vol. 1, cat. 314.

82. In a letter dated November 22, 1894, Alexander Cassatt refused the Academy's loan request for two portraits by Cassatt because their departure "would leave a great gap on our walls" (PAFA Archives).

83. The Cassatt correspondence from 1883 to 1886 referred to them regularly as being either in London or on the Continent until spring 1886. See the letter dated May 5, 1886, from Robert Cassatt to Alexander Cassatt (AAA, PMA, in Mathews 1984, pp. 197–98), which announced their projected arrival in Philadelphia. However, they returned to Europe the following year for an undisclosed length of time.

84. See Strahan [Shinn], *Art Treasures in America*, vol. 2, p. 40.

85. Letter cited in n. 72.

86. Denis Rouart and Daniel Wildenstein, *Edouard Manet* (Lausanne, 1975), vol. 1, cat. 334.

87. Ibid., vol. 2, cat. 40 and 88. The bill for the two from Manet's brother-in-law is quoted in cat. 88.

88. Unlike the family, Sweet (1966, p. 105) claims it was Thomas Scott who opposed the purchase of the Manet without the Corot. However, by 1883 he had been dead for two years, and the painting, dated c. 1880, postdates his last known visit to Europe in 1878 (DAB, s.v. Scott, Thomas Alexander).

89. In Lemoisne, *Degas et son oeuvre*, they are, respectively, cat. 594 (Mr. and Mrs. Edgar Scott, Villanova) and cat. 568 (sold by the heirs at Christie's, London, July 1, 1975, lot 13)

90. A painting signed "C. Monet" that generally conforms to that subject is owned by a descendant of the Scott family, but its authenticity is dubious.

91. For biographical information, see DAB, s.v. Thomson, Frank, and the extensive obituaries in the *Inquirer, Evening Bulletin*, and *Public Ledger* (all June 6, 1899). For Alexander Cassatt's professional relationship with Thomson, see Davis, *End of the Line*. Documented contact between them dates from Alexander's tenure with the railroad in Altoona; see the letter dated October 25, 1868, from Alexander Cassatt to Lois Cassatt, Estate of Mrs. John B. Thayer.

92. Davis, *End of the Line*, pp. 129–32.

93. This individual is referred to as "Mr. F. Thompson" in a letter dated September 2 (1886) from Mary Cassatt to Alexander Cassatt, AAA, PMA, in Mathews 1984, pp. 200–202. Mathews (p. 184) arrived independently at the same identification of this hitherto-unknown figure.

94. Letter dated September 2 (1886) from Mary Cassatt to Alexander Cassatt, AAA, PMA, in Mathews 1984, pp. 200–202.

95. Ibid.

96. Lemoisne, *Degas et son oeuvre*, cat. 1386.

97. Others at the Philadelphia Museum of Art are *Etretat—Marine, Morning Haze*, and *Port of Le Havre* (Wildenstein 1974, cat. 82, 1338, and 297). The remaining known works are *Sunset* (location unknown), *Banks at Vernon* (location unknown), *Haystacks at Giverny* (private collection), *Port of Argenteuil in Repair* (private collection), and *Entrance into the Small Tributary at Vétheuil* (private collection); see Wildenstein 1974, cat. 818, 844, 993, 194, and 601.

98. See the correspondence with these dealers in the Archives, John G. Johnson Collection at the Philadelphia Museum of Art.

99. Winckelman, *John G. Johnson*.

100. *Press*, January 2, 1907, Cassatt Obituary Scrapbook.

101. *Public Ledger*, November 4, 1899, p. 10.

102. Wildenstein 1974, cat. 91, The Metropolitan Museum of Art, New York.

103. *Pictures in the Collection of P.A.B. Widener* (Philadelphia, 1915), vol. 3, n.p.

104. Wildenstein 1974, cat. 91, 45, 733, and 1308.

105. See n. 101.

106. Inventory of Paintings: Wm. L. Elkins Collection, in the files of the Department of European Painting before 1900, Philadelphia Museum of Art. For the third unidentified work, see n. 107.

107. Philadelphia, The Pennsylvania Academy of the Fine Arts, *Sixty-first Annual Exhibition* (January 29–March 6, 1891); Monet's *Coast at Honfleur, France* (cat. 212), property of William Pepper (painting as yet unidentified). For the 1892 loan exhibition of French art (apparently sponsored jointly by the Academy and the University of Pennsylvania Lecture Association [no known catalogue]), the Loan Register, PAFA Archives, lists Mrs. Scott's *Emilie Ambre* (*Spanish Woman*, register no. 1291) by Manet and *Dancers* (register no. 1260) by Degas, and Johnson's work (register no. 1261) by Sisley. The loan exhibition at the Union League in 1893 (with catalogue) included Alexander Cassatt's *Thames, London* (cat. 9) and *Regattas on the Seine* (cat. 180), both by Monet, and *Spring* (cat. 60) by Pissarro; William L. Elkins's *In Switzerland* (cat. 188) by Monet; unidentified lender Alfred C. Harrison's *Sea Near Dieppe* (cat. 16) by Monet; and unidentified lender J. C. Patterson's *Inundation* (cat. 3) by Sisley.

108. *DAB*, s.v. Pepper, William.

109. See the critical reviews, Scrapbook, PAFA Archives.

110. *Inquirer*, February 7, 1892, Scrapbook, PAFA Archives.

111. Ibid., March 2, 1912. See also *Public Ledger*, November 10 (1913), Scrapbook, PAFA Archives.

112. Letter dated April 28 (1904) from Mary Cassatt to Carroll Tyson, AAA, PMA, in Sweet 1966, p. 161.

113. Ibid.

114. John Rewald, "The Collection of Carroll S. Tyson, Jr., Philadelphia, U.S.A.," *The Connoisseur*, vol. 34 (August 1954), pp. 62–68, reprinted in *Philadelphia Museum of Art Bulletin*, vol. 50, no. 280 (Winter 1960), p. 60. This article is the source of subsequent information on Tyson's collection.

115. Henry Hart, *Dr. Barnes of Merion* (New York, 1963), pp. 47–52; see also William Schack, *Art and Argyrol* (New York, 1960).

116. For the relationship of these three, see Mathews 1984, pp. 16 and 17; see also the letter dated New Year's evening 1873, from Mary Cassatt to Emily Sartain, PAFA Archives, in Mathews 1984, pp. 113–17. For signs of disruption of the friendship between Sartain and Cassatt, see the letter (c. May 25, 1875) between the two, PAFA Archives, in Mathews 1984, pp. 126–29.

117. Sweet 1966, p. 196. For Cassatt's conversation with John G. Johnson—possibly in Philadelphia about 1899—about Beaux's intellect, see the letter dated Christmas evening (1902) from Mary Cassatt to Louisine Havemeyer, The Metropolitan Museum of Art, New York, in Mathews 1984, pp. 275–79. This letter is also important evidence of the relationship between Cassatt and Johnson during these years.

118. See Hale 1975. For further discussion of Cassatt's relationship with Borie, see no. 23, a gift from the artist herself; despite her friendship with Tyson, he is not known to have owned any of her works.

119. See Biddle, *An American Artist's Story*.

120. *Daily Evening Telegraph*, June 16, 1873, p. 5. See also the discussion of the exhibition in the letter dated July 4 (1873) from Katherine Cassatt to Emily Sartain, PAFA Archives, in Mathews 1984, pp. 122–23. The Academy was completely closed for the construction of its new building from 1870 to 1876 and was therefore unavailable as an exhibition site, a factor perhaps reflected in Cassatt's presence at Bailey's in 1873. She exhibited at the Academy in 1876, when it reopened.

121. See the letter cited in n. 120.

122. See Breeskin 1970, cat. 21.

123. Entry for the *Bacchante*, cat. 343, 1877, Loan Register, PAFA Archives.

124. *Gopsill's Philadelphia City Directory* (1875).

125. Sweet 1966, p. 37; Hale 1975, pp. 94–95.

126. Letter dated November 22 (1878) from Katherine Cassatt to Alexander Cassatt, AAA, PMA, in Mathews 1984, pp. 141–42.

127. Letter dated December 13, 1878, from Robert Cassatt to Alexander Cassatt, AAA, PMA, in Mathews 1984, pp. 142–44.

128. Letter cited in n. 126.

129. Ibid.

130. See the Exhibition Record.

131. *Daily Evening Telegraph*, April 25, 1878, p. 4.

132. The information on the labels largely conforms with the details in the Loan Register (PAFA Archives) on Teubner's three submissions on that date; the Register adds a sale price of $100 and omits Koonz's name, suggesting that the panel was purchased while at the Academy. According to the Register, all three works were returned to Teubner on January 7, 1879. The other two works submitted by Teubner have not been identified as yet: register no. 384, *Spanish Lady* (half-length), with fan, 20½ x 26½", inscribed "M.S.C., Seville 1873," $125; and register no. 385, *French Lady* (head and bust), 17½ x 20½", inscribed "M. S. Cassatt, Paris, 1877," $100.

133. Letter dated March 2, 1904, from Clement Newbold to Harrison Morris, Registrar's Office, The Pennsylvania Academy of the Fine Arts. (The singular "don't" was grammatically acceptable in the nineteenth century.)

134. For the conditions of the prize, see "Preface," in Philadelphia, The Pennsylvania Academy of the Fine Arts, *Seventy-third Annual Exhibition* (January 25–March 5, 1904).

135. Henri Gabriel Marceau, "American Painting in the Braun Collection," *The Pennsylvania Museum Bulletin*, vol. 25, no. 135 (May 1930), pp. 21–23.

136. Arthur Edwin Bye, "The Collection of Alex Simpson, Jr.," *The Pennsylvania Museum Bulletin*, vol. 24, no. 122 (October–November 1928), p. 23.

137. *Young Thomas and His Mother* is only on deposit at the Academy. Cassatt was displeased by the Academy's failure to purchase her art and became angry when asked for a gift of her work, after she had given two portraits by Courbet in 1912; see Biddle, *An American Artist's Story*, p. 223. For the letter in which she refused to give any of her works to the Academy, and the response, probably from Lewis, subtly asking for something of hers, see the letters cited in n. 40.

138. *Press*, January 8, 1905, Scrapbook, PAFA Archives.

139. See the Exhibition Record.

140. Letter dated February 15 (1904) from Harrison Morris to Mary Cassatt and letter dated March 15 (1904) between the same correspondents, both in the Registrar's Office, The Pennsylvania Academy of the Fine Arts. For the Academy's unsuccessful loan request of 1894, see n. 82. For a discussion of this general policy of solicitation, see the New York *Evening Post*, January 24, 1905, Scrapbook, PAFA Archives.

141. The Art Club of Philadelphia, "Fifteenth Annual Exhibition of Water Colors and Pastels," 1906 (see the *Inquirer*, March 18, 1906, p. 2), and The Pennsylvania Academy of the Fine Arts, "Seventeenth Annual Water Color Exhibition and the Eighteenth Annual Exhibition of Miniatures," 1919 (see the *Sunday Press*, November 9, 1919, Scrapbook, PAFA Archives).

142. See the entry card for *After the Bath*, "One-hundred-tenth Annual Exhibition," 1915, PAFA Archives.

143. *Daily Evening Telegraph*, June 16, 1873, p. 5.

144. These anonymous columns have been attributed to William J. Clark. See Lloyd Goodrich, *Thomas Eakins* (Cambridge, Mass., 1982), vol. 1, p. 130; see also Hendricks, *Life and Work of Thomas Eakins*, p. 96.

145. See n. 143.

146. *Daily Evening Telegraph*, April 29, 1876, p. 5.

147. Ibid.

148. Ibid., April 25, 1878, p. 4, and May 6, 1879, p. 8. For the identification of the 1879 Academy entry as *Reading Le Figaro*, see the Exhibition Record, n. 7.

149. Edward Strahan [Earl Shinn], "The Art Gallery. Works of American Artists Abroad. The Second Philadelphia Exhibition," *The Art Amateur*, vol. 9, no. 1 (December 1881), p. 2.

150. "Academy Exhibition . . . Second Notice," unidentified and undated clipping (1885), p. 15, Scrapbook, PAFA Archives. The critic may have been familiar with the actual works by Manet and Degas, perhaps from a trip to Europe, since they were not widely known in America until after 1886.

151. Segard 1913, p. 63.

152. *Daily Evening Telegraph*, October 30, 1885, p. 3. It is unknown whether this anonymous critic was Clark, although many of the comments resemble those in columns attributed to him.

153. Ibid., January 15, 1898, p. 7.

154. *Inquirer*, January 9, 1898, p. 9; *Public Ledger*, January 10, 1898, p. 14.

155. *Evening Bulletin*, January 13, 1900, p. 3; *Inquirer*, January 14, 1900, p. 10.

156. *Press*, January 14, 1900, p. 3.

157. *Inquirer*, February 3, 1904, Scrapbook, PAFA Archives.

158. Ibid.

159. *Press*, January 5, 1905, Scrapbook, PAFA Archives. The article also indicated that, given her rejection of the Lippincott Prize, Philadelphia was waiting for her reaction to the French government's announcement of her award of the prestigious Cross of the Legion of Honor; paradoxically, she accepted it, purportedly to increase her leverage with American museum directors in her efforts to place old-master paintings in this country. See Sweet 1966.

160. *Press*, January 5, 1905, Scrapbook, PAFA Archives.

161. *Inquirer*, March 18, 1906, p. 2.

162. Ibid.

163. *North American*, March 1, 1907, Scrapbook, PAFA Archives. For discussions of Alexander Cassatt's estate by the local press, see Cassatt Obituary Scrapbook.

164. Biddle, *An American Artist's Story*, pp. 201–2.

165. *Press*, December 13, 1908, p. 5.

166. Ibid.

167. *Public Ledger*, March 6, 1910, Scrapbook, PAFA Archives. Little is known about Cassatt's involvement with the Harrisburg project, which entailed massive construction and decoration in 1905. Details in the Cassatt literature conflict with those in the *Public Ledger*; Sweet (1966, pp. 172–73) claimed that she merely executed two tondos to submit to a competition for the project, but withdrew upon hearing rumors of widespread graft. Breeskin (1970, cat. 472) states that Cassatt "did not take the commission upon hearing of the corruption." The other tondo (fig. 31) is in Breeskin 1970 (cat. 471).

168. N. N., "Water Color in New York and Philadelphia," *The Nation*, vol. 109, no. 2839 (November 29, 1919), p. 696. On the contrary, most of Cassatt's French "rebel" colleagues had been severely criticized for undermining these very plastic values. For an example, see George Heard Hamilton, *Manet and His Critics* (New Haven, 1954).

169. *Inquirer*, April 18, 1920, Scrapbook, PAFA Archives.

170. *Press*, April 18, 1920, Scrapbook, PAFA Archives.

171. *Inquirer*, June 16, 1926, p. 1.

172. *Record*, May 1, 1927, p. 3.

173. *Inquirer*, May 1, 1927, p. 21.

174. Watson, "Philadelphia Pays Tribute to Mary Cassatt," pp. 289–97.

175. Ibid., p. 296.

Genealogy

Robert Simpson Cassatt (1806–1891)

m

Katherine Kelso Johnston (1816–1895)

Mary Johnston Dickinson

m

Robert M. Riddle

Mary Johnston Dickinson and Katherine Kelso Johnston were first cousins.

- Lydia Simpson Cassatt (1837–1882)

- Alexander Johnston Cassatt (1839–1906)

 m

 Maria Lois Buchanan (1847–1920)
 - Edward Buchanan Cassatt (1869–1922)
 - Katharine Kelso Johnston Cassatt (Mrs. James) Hutchinson (1871–1905)
 - Robert Kelso Cassatt (1873–1944)
 - Eliza (Elsie) Foster Cassatt (Mrs. W. Plunkett) Stewart (1875–1931)

- Robert Kelso Cassatt (1842–1855)

- Mary Stevenson Cassatt (1844–1926)

- Joseph Gardner Cassatt (1849–1911)

 m

 Eugenia Carter (1855–1929)
 - Joseph Gardner Cassatt (1886–1955)
 - Ellen Mary (Mrs. Horace B.) Hare (1894–1966)
 - Eugenia Cassatt (Mrs. Charles P. Davis; Mrs. Percy C.) Madeira (1897–1979)

- Bessie Riddle (Mrs. George) Fisher

- Anna Dyke Riddle (d. 1901)

 m

 Thomas A. Scott (1823–1881)
 - Mary D. Scott (Mrs. Clement B.) Newbold (d. 1905)
 - Edgar Thomson Scott (1871–1918)

1844 Mary Stevenson Cassatt is born on May 22 in Allegheny City, Pennsylvania, now a part of Pittsburgh.

1855 The Cassatts travel to Paris, Heidelberg, and Darmstadt to find treatment for Robert Kelso Cassatt's ultimately fatal bone disease and to enable Alexander to study at the Technische Hochschule in Darmstadt for a career in engineering.

1858 The family settles in the Philadelphia area. Cassatt studies at the Pennsylvania Academy of the Fine Arts.

1866 Cassatt goes to Paris and studies privately with Jean-Léon Gérôme.

1867 to 1868 Cassatt goes with Eliza Haldeman, a friend from the Academy in Philadelphia, to study painting at Courances and Ecouen, art colonies near Paris that emphasize figure painting. Edouard Frère and Paul Soyer are among those with whom she works. Submission to the 1867 Salon, Paris, is refused.

1868 Cassatt makes her debut in the Salon with *Mandolin Player* (fig. 1a) under the pseudonym Mary Stevenson. She studies at Villiers-le-Bel, near Ecouen, with Thomas Couture. Alexander Cassatt marries Lois Buchanan, niece of President Buchanan.

1869 Submission to the Salon is refused.

1870 Cassatt is in Rome, where she studies with Charles Bellay. The Salon jury accepts *A Peasant Woman from Fobello, Sesia Valley (Piémont)*. Because of the Franco-Prussian War, she returns to Philadelphia to live with her family at 23 South Street.

1871 The Cassatts move to Hollidaysburg, Pennsylvania, to be near Alexander Cassatt in Altoona. Cassatt exhibits two paintings at Goupil's, New York, and in Chicago, where they are destroyed in the great fire. In December she goes to Europe with Emily Sartain, a friend from the Academy who is John Sartain's daughter and a close friend of Thomas Eakins.

1872 Cassatt is in Parma, where she studies printmaking with Carlo Raimondi and the paintings of Correggio, concluding he is the greatest painter who ever lived. In fall she travels to Spain, settling from October to April 1873 in Seville, with a studio at the Casa de Pilatos. She admires Murillo's work.

1873 Cassatt's Sevillian *Torero and Young Girl* (fig. 1c) is accepted at the Salon, and she travels to Paris to see the exhibition. Her Philadelphia debut takes place with the exhibition of *On the Balcony* (no. 1) at Bailey & Co. She travels through Belgium and Holland, then goes to Rome.

1874 By summer she is studying with Couture at Villiers-le-Bel, then settles in Paris in the fall. *Torero and Young Girl* and, possibly, *On the Balcony* are exhibited in New York at the National Academy of Design.

1875 Cassatt is in Philadelphia during the summer.

1876 She makes her debut at the Academy annual that inaugurates its reopening after six years of construction.

1877 She meets Degas and accepts his invitation to exhibit with the Société Anonyme des Artistes, called the Independents, or, against her wishes, the Impressionists. Because of her new alliance with the Independents, who believe the jury system restricts artistic freedom, she stops submitting works to the Salon. Her parents and sister Lydia move permanently to France to live with her.

1878 Anticipating the Paris Impressionist show, which ultimately is not held that year, she declines J. Alden Weir's invitation to enter her work in the first exhibition of the Society of American Artists in New York.

1879 Cassatt makes her debut with the Impressionists in Paris in their fourth exhibition. She makes her debut with the Society of American Artists in New York with *Reading Le Figaro* (fig. 28) and *Mandolin Player* (fig. 1a). She becomes interested in graphics and collaborates with Degas on his proposed journal illustrated with prints, *Le Jour et la nuit*. She travels to northern Italy to study old-master paintings, taking note especially of Renaissance frescoes.

1880 Alexander and Lois Cassatt, with their four children, make their first visit to France. The parents stay in Paris, and the children, at the Cassatts' summer residence at Marly-le-Roi.

1881 The dealer Paul Durand-Ruel becomes Cassatt's agent. During summer, Cassatt rents Coeur Volant, outside Louveciennes, where she produces several paintings. She buys and sends Alexander's first Impressionist paintings, perhaps the earliest in Philadelphia and among the earliest in the United States.

1882 to 1883 Her younger brother Gardner marries Eugenia Carter. Her older sister Lydia dies November 7, 1882. Alexander retires from active management of the Pennsylvania Railroad, and he and his family arrive in Paris in December and stay until well into 1883.

1886 Two of her paintings are lent by Alexander to the Impressionist exhibition in New York organized by Durand-Ruel.

1887 Cassatt moves into an apartment at 10 rue de Marignan, which remains her Paris residence for the rest of her life. Her summer house is at Arques-la-Batailles, near Dieppe.

1890 She frequently visits the Japanese print exhibition ("Exposition de la gravure japonaise") at the Ecole des Beaux-Arts in Paris to study the prints, which influence her subsequent work.

1891 Her exclusion from the Société des Peintres-Graveurs Français exhibitions because of her American citizenship prompts her first individual exhibition of paintings, pastels, and prints. She resides at Château Bachivillers, a summer house where much of her important work is done, until 1893. Her father dies December 9.

1892 to 1893 She receives a commission for a mural for the Woman's Pavilion at the Columbian Exposition in Chicago. Executed at Château Bachivillers and shipped to Chicago early in 1893, it has since been lost. Her second individual exhibition in Paris, a major retrospective at Galeries Durand-Ruel, is in November 1893.

1894 In spring she buys and rehabilitates Beaufresne, a château at Mesnil-Théribus near Beauvais, the only property she ever owns.

1895 Durand-Ruel holds her first individual exhibition in New York. Her mother dies October 21.

1898 to 1900 She makes her second visit to America—and to Philadelphia as well. On June 9, 1899, Alexander is elected president of the Pennsylvania Railroad.

1901 She makes a collecting trip with Mr. and Mrs. Henry O. Havemeyer to Spain and Italy.

1904 In March she refuses the Lippincott Prize for figure painting from the Academy. On December 31 she accepts the Cross of the Legion of Honor in Paris, allegedly to augment her prestige and credibility with American museum directors in her efforts to place European old-master paintings in American public collections.

1905 She enters the competition for a mural project for the women's lounge of the state-house in Harrisburg, Pennsylvania, but withdraws because of alleged graft related to the commission.

1906 John G. Johnson gives *On the Balcony* to Philadelphia's municipally administered W. P. Wilstach Collection; it is the first work by Cassatt known to enter a public collection in America. Alexander dies December 28.

1908 to 1909 She makes her third and last visit to the United States, primarily to be with her brother Gardner and his family in Philadelphia.

1910 to 1911 She travels with Gardner and his family to Egypt; Gardner becomes ill and dies abroad April 5, 1911.

1914 With the outbreak of World War I, fighting near Beauvais forces Cassatt to flee Beaufresne for a villa near Nice for the remainder of the war. The Academy awards her a gold medal for eminent services.

1915 She participates in an exhibition, organized by Mrs. H. O. Havemeyer at Knoedler in New York, entitled "Suffragette Loan Exhibition of Old Masters and Works by Edgar Degas and Mary Cassatt." Cataracts in both eyes cause blindness; surgery is unsuccessful.

1917 Degas dies September 27; Cassatt mourns the loss of her longtime friend, whom she considers the last great artist of the nineteenth century.

1923 Bitter dispute with Mrs. H. O. Havemeyer over an edition of drypoints, thought by everyone but Cassatt to be re-strikes, disrupts their long friendship.

1926 On June 14 Cassatt dies at Beaufresne and is buried in the family tomb in the cemetery at Mesnil-Théribus. Buried with her are her parents, Lydia, and her brother Robert, who was moved from Darmstadt, his initial burial site of 1855.

Catalogue of the Exhibition

Editor's note: Listed exhibitions are limited
to those during Mary Cassatt's lifetime
(1844–1926) and memorial exhibitions in
1927 and 1928. Documentation has been
reproduced in its original form, without the
use of *sic*. The abbreviation *cat*. is used to
identify works in other catalogues; *no*. and
fig., works in this catalogue.

1. **On the Balcony**, 1872–73
Oil on canvas
39¾ x 21½" (101 x 54.6 cm)
Signed, lower left: M.S.C./1873 à Seville
Philadelphia Museum of Art. W. P. Wilstach
Collection. W'06-1-7

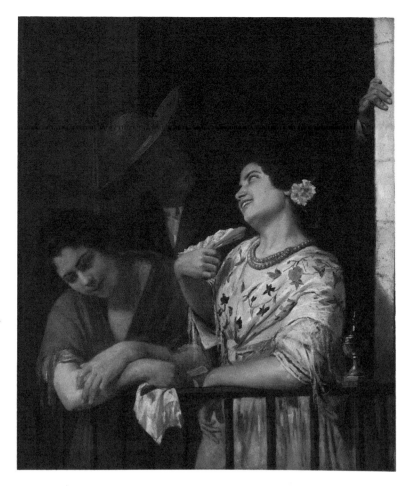

PROVENANCE: John G. Johnson, Philadelphia,
c. 1880; gift to the W. P. Wilstach Collection,
1906.

CATALOGUE RAISONNÉ: Breeskin 1970, cat. 18.

EXHIBITIONS: June–July 1873, Philadelphia,
Bailey & Co.; possibly 1874, New York,
National Academy of Design, "Forty-ninth
Annual Exhibition," cat. 286; 1895, New
York, Durand-Ruel Galleries, "Exposition of
Paintings, Pastels, and Etchings by Miss Mary
Cassatt," cat. 22; 1927, Philadelphia,
Pennsylvania Museum of Art, "Mary Cassatt
Memorial Exhibition," cat. 22.

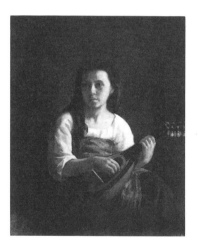

FIG. 1a. Mary Cassatt, *Mandolin Player*, c.
1868. Oil on canvas, 36¼ x 29" (92.1 x 73.7
cm). Private collection

FIG. 1b. Parlor in John G. Johnson's house at
426 South Broad Street, Philadelphia, 1880.
Photographed by Frederick Gutekunst. John
G. Johnson Collection Archives at the Phila-
delphia Museum of Art

On the Balcony is traditionally identified as *Pendant Le Carnaval*, which
Cassatt first showed in the Paris Salon of 1872 (cat. 1433) and which she
later mistakenly thought represented her professional debut in Paris.[1] However,
her early correspondence indicates that she arrived in Seville, the city given in
the inscription as the site of the painting's execution, in October 1872, long
after the Paris Salon in the spring.[2] Furthermore, a letter of January 1, 1873,
describes a newly begun work that closely resembles this one: "My present
effort is on a canvass of thirty and is three figures life size half way to the
knee—All the three heads are forshortened and difficult to pose, so much so
that my model asked me if the people who pose for me live long. I have one
man's figure the first time I have introduced a mans head into any of my
pictures."[3]

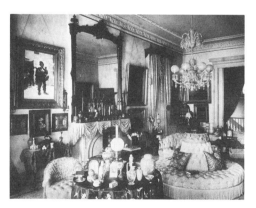

FIG. 1c. Mary Cassatt, *Torero and Young Girl*, 1873. Oil on canvas, 39⅝ x 33½″ (100.6 x 85.1 cm). Sterling and Francine Clark Art Institute, Williamstown, Mass. 1

FIG. 1d. Mariano Fortuny (Spanish, 1838–1874), *The Council House: Granada*, 1873. Oil on panel, 14½ x 19″ (36.8 x 48.3 cm). The Pennsylvania Academy of the Fine Arts, Philadelphia. Bequest of Henry C. Gibson. 1896

She intended to submit these new paintings to major European exhibitions,[4] but this one appears to have been shown for the first time during the following summer in Philadelphia, where it was one of two works sent from Europe and displayed in the west window of the jewelry store Bailey & Co. There they caught the special attention of the critic from the *Daily Evening Telegraph*, one of Eakins's champions at that time, who remarked of this work, "a group of two women and a cavalier on a balcony . . . [has] the appearance of being close studies from life . . . [and an] intense vitality. There is an ease, an unconstraint, in the attitudes of the figures, a careless grace."[5] The impact of these Spanish pictures on the critics was apparently strong, for Cassatt's mother wrote art educator Emily Sartain that there was "no end of articles in the newspapers about them. . . . Unfortunately the weather being so hot the *right sort* of people are out of town—so the chances for selling I am afraid are small."[6] The display at Bailey's in 1873 represents Cassatt's first recorded exhibition in Philadelphia.

It was purchased sometime during the next ten years by the distinguished Philadelphia collector John G. Johnson, since the painting appears in a contemporary photograph of his parlor, hanging to the right of the fireplace (fig. 1b). He was probably the anonymous lender of the painting to Cassatt's first individual exhibition in the United States, in 1895 at Durand-Ruel Galleries in New York, where it was illustrated and discussed in an extensive review of the show.[7] On October 15, 1906, Johnson gave the painting to the municipally administered W. P. Wilstach Collection, and entitled it as it is currently known.[8] As a gift to the Wilstach Collection, *On the Balcony* constitutes the first work by Cassatt known to enter a public collection in the United States.[9]

This painting is one of four extant works known by their inscriptions to have been produced during Cassatt's stay in Seville. The others are *Torero and Young Girl* (fig. 1c), shown at the Paris Salon of 1873 (cat. 1372, *Offrant le panal au torero*); *Spanish Dancer Wearing a Lace Mantilla* (National Museum of American Art, Washington, D.C.), shown also at Bailey's in 1873 and at the Paris Salon of 1874 (cat. 326, *Ida*); and *Toreador* (the Art Institute of Chicago).

On the Balcony typifies Cassatt's Seville works in its exotic genre subject. Her adherence to modern subject matter, as a repudiation of traditional mythological or historical themes, led her to the festivals, costumes, and figure types of contemporary Spain. These themes were already prevalent in Romantic and Realist literature and painting, partly because of the interest in Spain triggered by the earlier military campaigns of Napoleon I and Louis XVIII.[10] Their vast popularity reached a peak during Cassatt's early years in Europe, the 1850s to 1870s. Eakins was in Seville in 1870 and depicted its street scenes and Gypsy dancers. Works with these subjects by several contemporary Spaniards, Mariano Fortuny (fig. 1d), Raimundo Madrazo (1841–1920), and Eduardo Zamacois (1843–1871), were among the most avidly collected modern paintings in Europe and the United States.[11] Manet's guitar players, bullfights, and toreadors of the 1860s were widely exhibited in France, where they drew extensive discussion.[12] Even the subject of a balcony with figures was so common by then that Cassatt's version can no more be linked specifically with Manet's *Balcony* of 1869 (Musée d'Orsay [Galerie du Jeu de Paume], Paris), as it traditionally is, than it can to those by less-known figures, such as the Scottish painter John "Spanish" Phillip (1817–1867), who was popular in England.[13]

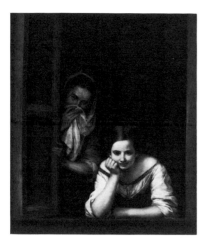

FIG. 1e. Bartolomé-Esteban Murillo (Spanish, 1617–1682), *A Girl and Her Duenna*, c. 1670. Oil on canvas, 50¼ x 41¾″ (127.6 x 106 cm). National Gallery of Art, Washington, D.C. Widener Collection. 1942

This work is exceptional among Cassatt's Spanish paintings for its elaborate anecdotal treatment and extremely foreshortened figures compressed within the balcony. Although awkwardly handled, these characteristics may embody her extensive study during that period of Spanish old-master Realists, particularly the celebrated Sevillian painter Bartolomé-Esteban Murillo, whose works she discussed at length in her letters from Spain.[14] Cassatt's expressive interest; informal, simply rendered naturalism; chiaroscuro; and rich, broadly handled, descriptive color recall Murillo's engaging genre works (fig. 1e). *On the Balcony* thus may reflect Cassatt's early adaptation of Murillo's realist idiom in much the same manner Manet's Spanish paintings assimilated that of Velázquez.

These qualities of forceful naturalism and contemporaneity are what the Philadelphia critic so vigorously applauded and what Emily Sartain perceived as differentiating Cassatt's new work from that of the Paris Salon painters: "She disdains the salon pictures of Cabanel Bonnat and all the names we are used to revere. . . . Her own style of painting and the Spanish school which she has been studying all winter is so realistic, so solid,—that the French school in comparison seems washy, unfleshlike, and grey."[15]

1. Sweet 1966, p. 26. Cassatt claimed it depicted two young women throwing bonbons on carnival day (Segard 1913, p. 7), a composition that conforms to a recently discovered painting, *Two Young Women Throwing Flowers during the Carnival* (private collection), which is signed "Mary Stevenson/1872" as in the Salon catalogue but not as on *On the Balcony*. Arguments are partly based upon Mathews 1980 (p. 25 and nn. 66, 79). Cassatt's Salon debut was in fact in 1868 with *Mandolin Player* (fig. 1a; *La Mandoline* [cat. 2335]).
2. Letter dated October 27 (1872), from Seville, from Mary Cassatt to Emily Sartain, PAFA Archives, in Mathews 1984, pp. 109–10.
3. Letter dated New Year's evening 1873 (which Cassatt identified in her text as January 1, 1873) from Mary Cassatt to Emily Sartain, PAFA Archives, in Mathews 1984, pp. 113–16.
4. Ibid.
5. *Daily Evening Telegraph*, June 16, 1873, p. 5. The anonymous critic for the *Telegraph* during these years has been identified by Eakins scholars as William J. Clark. See n. 144 of the preceding essay.
6. Letter dated July 4 (1873) from Katherine Cassatt to Emily Sartain, PAFA Archives, in Mathews 1984, pp. 122–23. Other than the *Telegraph*, names of newspapers she may have seen are not known; no further references have been located to date.

7. William Walton, "Miss Mary Cassatt," *Scribner's Magazine*, vol. 19, no. 3 (March 1896), p. 354, repr. p. 355.
8. The date and source of the gift are in Commissioners of Fairmount Park, *Catalogue of the W. P. Wilstach Collection* (Philadelphia, 1922), cat. 54. Documents concerning the gift itself are as yet unlocated. A discussion of the title is in the letter dated November 7, 1906, from John G. Johnson to Miss E. A. Shunk, custodian, Wilstach Gallery, WIL, letter file 1 (1901–17), PMA Archives.
9. The Wilstach Collection, a bequest to the Commissioners of Fairmount Park in 1893, was intended to form part of a projected public art museum; since its bequest, the collection has been cared for on behalf of the Commissioners by the Philadelphia Museum of Art (formerly the Pennsylvania Museum of Art). For a brief history of the Museum, see Henry G. Gardiner, "Introduction," in Philadelphia Museum of Art, *Check List of Paintings in the Philadelphia Museum of Art* (Philadelphia, 1965), pp. iv–viii.

10. For a brief discussion of the rise of interest in Spain, see Cristina Marinas, "Introduction," in Jeannine Baticle and Cristina Marinas, *La Galerie espagnole de Louis-Philippe au Louvre 1838–1848* (Paris, 1981), pp. 13–27.
11. This facet of nineteenth-century taste has not been seriously studied. For the popularity of the modern Spanish painters in America, see the collections described in Edward Strahan [Earl Shinn], *Art Treasures in America* (Philadelphia, 1879–80), 3 vols. For their appreciation in Europe, see the letter cited in n. 3; the letter dated May 8, 1873, from Emily Sartain to John Sartain, PAFA Archives, in Mathews 1984, pp. 117–20; and Baron Davillier, *Life of Fortuny* (Philadelphia, 1885).
12. See George Heard Hamilton, *Manet and His Critics* (New Haven, 1954).
13. For a discussion of Phillip in connection with Cassatt, see Mathews 1980, pp. 29–30.
14. See the letter cited in n. 3 and the letter dated October 13 (1872), PAFA Archives, in Mathews 1984, pp. 107–8.
15. Letter dated May 8, 1873, from Emily Sartain to John Sartain, cited in n. 11.

2. *Miss Mary Ellison Embroidering*
1877

Oil on canvas
29¼ x 23½" (74.3 x 59.7 cm)
Signed, lower left: MS Cassatt, Paris 1877
Estate of Jean Thompson Thayer, Devon, Pa.

PROVENANCE: Rodman Barker Ellison,
Philadelphia; his daughter Mary (Mrs. William
H.) Walbaum, Ithan, Pa.; the Thayer Estate,
by descent.

CATALOGUE RAISONNÉ: Breeskin 1970, cat. 48.

EXHIBITIONS: Possibly 1895, New York,
Durand-Ruel Galleries, "Exposition of
Paintings, Pastels, and Etchings by Miss Mary
Cassatt," cat. 20; 1927, Philadelphia,
Pennsylvania Museum of Art, "Mary Cassatt
Memorial Exhibition," cat. 36 (repr.); 1928,
Pittsburgh, Carnegie Institute, "Memorial
Exhibition of the Work of Mary Cassatt,"
cat. 25.

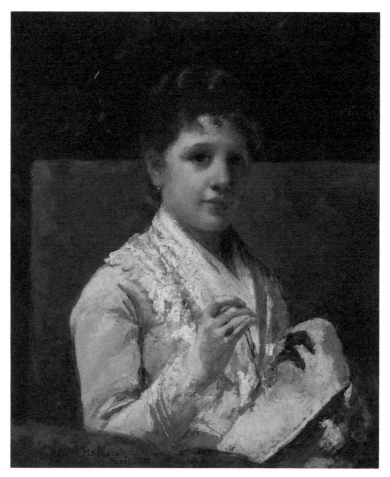

Mary Ellison (c. 1856–1936; see fig. 2a) was the daughter of Rodman Barker Ellison (1832–1907), who was in the woolen business with his father in Philadelphia.[1] According to the family, the Cassatts and the Ellisons may have known one another there. This portrait was painted when Mary Ellison, between eighteen and twenty-one years old, was staying in Paris at Marie del Sarte's pension with three friends, the Elder sisters, one of whom, Louisine, later became Mrs. Henry O. Havemeyer, the renowned American collector and lifelong friend of Cassatt.[2] Ellison herself apparently asked her father to commission the portrait. She was depicted embroidering because Cassatt wanted particularly to paint her hands.

While the sewing pose is common in portraits and images of women particularly of the eighteenth and nineteenth centuries, the device of

FIG. 2a. Mary Ellison (Mrs. William) Wal-
baum (left), age eighty, and her daughter
Evelina, c. 1936. Courtesy of the Thayer
family, Devon, Pa.

representing the sitter apparently interrupted from her task to gaze at the viewer has its own place within the tradition for the sense of psychological engagement it imparts. Gilbert Stuart was among many to use it for portraits of women (see fig. 2b).[3]

The particular richness of this portrait comes from its intense color, lively brushwork, and dense sfumato, perhaps a result of her earlier study in Parma of Correggio's works.

FIG. 2b. Gilbert Stuart (American, 1755–1828), *Mrs. Richard Yates*, 1793–94. Oil on canvas, 30¼ x 25" (76.8 x 63.5 cm). National Gallery of Art, Washington, D.C. Andrew W. Mellon Collection. 1940

1. Dates and other information on the Ellisons were provided by the family. There is conflicting information concerning her date of birth; the sitter's daughter claimed her mother was eighteen when the portrait was painted in 1877, placing her birth in 1859 (letter dated October 23 [1967] from Evelina Walbaum to Adelyn D. Breeskin, Thayer family archives). This letter is also the source of subsequent details on the commission. For a brief biography of Rodman Ellison, see *Proceedings of the Pennsylvania Society of Sons of the Revolution*, 1906–7, p. 61.

2. Letter from Evelina Walbaum cited in n. 1.
3. Nancy Mowll Mathews suggested to me the link between the Stuart and Cassatt paintings.

3. *Woman with a Pearl Necklace in a Loge*, 1879

Oil on canvas
31⅝ x 23" (80.3 x 58.4 cm)
Signed, lower left: Mary Cassatt
Philadelphia Museum of Art. Bequest of
Charlotte Dorrance Wright. 1978-1-5

PROVENANCE: Alexis Rouart, Paris; Marcel Midy, Paris, until March 1967; Mr. and Mrs. William Coxe Wright, Saint Davids, Pa.; bequest to the Museum, 1978.

CATALOGUE RAISONNÉ: Breeskin 1970, cat. 64.

EXHIBITIONS: 1879, Paris, 28 avenue de l'Opéra, "4me Exposition de peinture par M. Braquemond, Mme Braquemond, M. Caillebotte, M. Cals, Mlle Cassatt . . . ," cat. 49; 1893, Paris, Galeries Durand-Ruel, "Exposition Mary Cassatt," cat. 4; 1895, New York, Durand-Ruel Galleries, "Exposition of Paintings, Pastels, and Etchings by Miss Mary Cassatt," cat. 5; 1903, New York, Durand-Ruel Galleries, "Exhibition of Paintings and Pastels by Mary Cassatt," cat. 1; 1908, Paris, Galeries Durand-Ruel, "Tableaux et pastels par Mary Cassatt," cat. 8.

his celebrated painting, one of Cassatt's best known in Philadelphia, is considered her most distinguished work of the late 1870s and early 1880s. It is more widely known as *Lydia in a Loge* or *The Artist's Sister in a Loge*. Yet this piquant blonde, who reappears in the so-called *Lydia Leaning on Her Arms, Seated in a Loge* (fig. 3a), bears little resemblance to more surely documented images, particularly the *Woman and Child Driving* (no. 12), in which Lydia has a handsome, strong-boned face. Furthermore, their ages differ considerably; in 1879 Lydia would have been forty-two years old, unlike the evidently younger model here. Her identification as Lydia may be due to the sense of empathy that exudes from the work; Cassatt's biographer Achille Segard called this painting "a portrait of a friend."[1]

Woman with a Pearl Necklace in a Loge forms part of a large group of paintings, pastels, and prints of theater subjects within Cassatt's oeuvre, which links her iconographically and stylistically with French Independent and Impressionist colleagues. Part of their credo of depicting the truth of modern life focused upon rendering urbane society engaged in typical pursuits—a far cry from the ruralism of the Barbizon School and the historical and literary priorities of the Academy.

In Cassatt's 1879 debut with the Independents, this painting drew particular attention and, in the eyes of some critics, aligned her specifically with Degas. In an otherwise disparaging article, Georges Lafenestre praised the work of these two artists: "M. Degas and Mlle Cassatt are . . . the only artists who distinguish themselves in a group of independents. . . . Both have a lively sense of luminous arrangements in Parisian interiors; both show unusual distinction in rendering the flesh tints of women fatigued by late nights and the shimmering light of fashionable gowns."[2] Although it is difficult to discern any sense of fatigue in Cassatt's exuberant young woman, the elegant interior and gown do indeed bespeak her participation in the glittering high life of Paris. Cassatt and Degas's mutual interest in the effect of artificial light is evident in this painting. The intense, high-keyed color and dappled light spilling across the figure suggest the illumination from the chandeliers such as the one at left.

However identifiable as to general context, the specific position of the figure within the space is so ambiguous that it eludes legibility. At first glance the seated woman appears to have a mirror behind her, reflecting the tiered balconies and her own back and head. However, the "reflected" woman wears no pearl necklace, and the tilts of the shoulders in the two images do not correspond. Even the foreshortening of the primary figure is unclear; the apparent angle of the left shoulder does not conform to that suggested in the right, making her own pose difficult to interpret. In doing so, Cassatt recalls Manet, whose own paintings, such as the celebrated *Bar at the Folies-Bergère* of 1882 (Courtauld Institute, London), often constitute unsolved spatial puzzles, suggesting how both artists manipulated perceptible reality under the aegis of realism.

FIG. 3a. Mary Cassatt, *Lydia Leaning on Her Arms, Seated in a Loge*, c. 1879. Pastel on paper, 21⅝ x 17¾" (54.9 x 45.1 cm). Nelson Gallery of Art, Atkins Museum of Fine Arts, Kansas City, Mo. Anonymous gift

1. Segard 1913, p. 168.
2. Georges Lafenestre, "Les Expositions d'art: Les Indépendans et les aquarellistes," *Revue des deux mondes*, vol. 33, no. 22 (May 15, 1879), pp. 481–82; translated in Sweet 1966, p. 43.

4. *In the Box*, c. 1879
Oil on canvas
17 x 24″ (43.2 x 61 cm)
Unsigned
Mr. and Mrs. Edgar Scott, Villanova

PROVENANCE: Galeries Durand-Ruel, Paris; Mrs. Thomas A. Scott, Philadelphia and Lansdowne, purchase, November 1883; her grandson Edgar Scott, by descent.

CATALOGUE RAISONNÉ: Breeskin 1970, cat. 62.

EXHIBITIONS: 1883, London, Dowdeswell and Dowdeswell's, "Paintings, Drawings, and Pastels by Members of 'La Société des Impressionistes,'" possibly cat. 37; 1920, Philadelphia, The Pennsylvania Academy of the Fine Arts, "Exhibition of Paintings and Drawings by Representative Modern Artists," cat. 10; 1927, Philadelphia, Pennsylvania Museum of Art, "Mary Cassatt Memorial Exhibition" (not in catalogue).

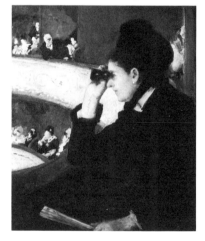

FIG. 4a. Mary Cassatt, *At the Opera*, c. 1879. Oil on canvas, 31½ x 25½″ (80 x 64.8 cm). Museum of Fine Arts, Boston. Charles Henry Hayden Fund. 10.35

A letter from Katherine Cassatt to Alexander Cassatt seems to document the purchase of *In the Box*, the only known painting by Cassatt in Mrs. Thomas A. Scott's collection, in November 1883: "By the way Annie went to Durand Ruel's the other day & bought a picture by Mary—perhaps you remember it—two young girls at the theatre."[1]

Prior to purchase, this painting was shown in an Impressionist exhibition in London, where it favorably impressed at least one critic, that of the *Evening Standard*. He viewed this work as "her most considerable contribution . . . it has a grace and refinement which her master [Degas] is not particularly anxious about," referring perhaps to Degas's realism, which was frequently maligned at the time as brutal and unflattering.[2]

In the Box is part of a group of Cassatt's theater subjects in various mediums showing spectators in profile in a box in the foreground, against a background of the vast balconied interior of the theater. Others in the group are *At the Opera* (fig. 4a), *In the Loge* (no. 5), three prints (Breeskin 1979, cat. 23–25), and their preparatory drawings (Breeskin 1970, cat. 719–25). This compositional format may have been inspired by Renoir's *Café Concert* (fig. 4b), a painting Cassatt actually copied.[3]

Narratively, this profile arrangement emphasizes the attention of spectators as directed inward toward the theater, rather than outward toward the viewer, as in *Woman with a Pearl Necklace in a Loge* (no. 3). Cassatt's *In the Box* imparts a particularly strong impression of absorption, and its psychological sense is one of total engagement in the spectacle. The mood is more serious than festive; the muted pleasure shown by the woman with binoculars contrasts with the open-mouthed excitement of Renoir's young spectator at her first theatrical event and with the ebullience of the blonde in *Woman with a Pearl Necklace in a Loge*.

Stylistically, *In the Box* takes advantage of the profile figures and horizontal format to emphasize the assertive rhythms of the foreground figure's silhouette and fan and the wide arcs of the balconies at left. Details are generalized to highlight these compositional elements, unlike Renoir's *Café Concert*.

In Cassatt's painting, the effect of artificial light cast from a specific source within the theater produces an image with rich, high-keyed color and strong chiaroscuro.

FIG. 4b. Pierre-Auguste Renoir (French, 1841–1919), *The Café Concert*, c. 1875–76. Oil on canvas, 25½ x 19¾″ (64.8 x 50.2 cm). National Gallery, London. 3859

1. Letter dated November 30 (1883) from Katherine Cassatt to Alexander Cassatt, AAA, PMA.
2. "The Impressionists," *Evening Standard*, July 13, 1883, in New York, American Art Association—National Academy of Design, *Works in Oil and Pastel by the Impressionists of Paris* (1886), p. 7.
3. For a brief discussion of the implications of Cassatt's copy of Renoir's painting as a study method, see Mathews 1980, p. 62. Cassatt's signed copy is currently in a private collection.

5. *In the Loge*, c. 1879
Pastel and metallic paint on canvas
25⅝ x 32″ (65.1 x 81.3 cm)
Unsigned
Philadelphia Museum of Art. Gift of Margarett Sargent McKean. 50-52-1

PROVENANCE: Edgar Degas, Paris, 1893; Galerie Georges Petit sale, Paris, March 26–27, 1918, lot 102 (repr.), to Monsieur Trotti, Paris; Margarett Sargent McKean, Boston, 1920s; gift to the Museum, 1950.

CATALOGUE RAISONNÉ: Breeskin 1970, cat. 61.

EXHIBITION: 1893, Paris, Galeries Durand-Ruel, "Exposition Mary Cassatt," cat. 30.

This pastel is one of several works by Cassatt that Degas owned and kept in his studio until his death.

Recent examination has revealed that *In the Loge*, previously thought to be on paper, was executed on primed canvas; this technique, which was common in Europe and America, was used by Degas and William Merritt Chase, among others.[1] The canvas was given a particularly rough surface with a primer embedded with ground pumice or marble dust and long fibers so that the pastel would adhere better. Primed canvases were available commercially, but whether or not this was one is not known. During examination of *In the Loge*, the fan was found to have several striations in a metallic paint, possibly gold, that had been applied with a brush. Originally, these stripes may have been reflective and bright, lending to the surface a rich glitter that has gradually dimmed. This information suggests a new dimension to Cassatt's known experimentation with materials and techniques that warrants further research.

Compositionally, this pastel relates to *In the Box* (no. 4) in its horizontal arrangement of a profile figure with a fan and the tiers of balconies in the background. Narratively, the psychological dimension is even more reduced.

The features of the young woman are partially obscured by the central motif, the open fan, and are turned away so that little of her physiognomy is revealed. Her features become neutral elements that merely reflect the light from the theater's interior—indeed, the colors of her face are intensely luminous.

This pastel, one of the most overridingly formal of Cassatt's works, is one of the most boldly handled of the theater group, and its details are even more generalized than those of *In the Box*. The balconies and fan produce emphatic rhythms across the canvas, punctuated by the contrasting radiating ribs of the fan. The surface richness must have been even more opulent with the original metallic gleam in the fan. The hatched areas produce flat patterns particularly in the hair and across the back, minimizing volume and space but enriching and emphasizing the flat surface.

1. Marjorie Shelley of the paper conservation laboratory of the Metropolitan Museum of Art, New York, provided this unpublished information, which she will include as part of a general survey of pastel techniques in a forthcoming exhibition catalogue by the Metropolitan; she also provided the basis for subsequent general comments on technical practices. Denise Thomas and Faith Zieske of the paper conservation laboratory of the Philadelphia Museum of Art made the examination possible and provided valuable information about the pastel itself.

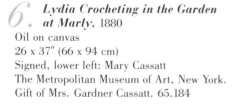

6. *Lydia Crocheting in the Garden at Marly*, 1880
Oil on canvas
26 x 37″ (66 x 94 cm)
Signed, lower left: Mary Cassatt
The Metropolitan Museum of Art, New York.
Gift of Mrs. Gardner Cassatt. 65.184

PROVENANCE: Alexander J. Cassatt, Philadelphia, after 1893; his son Robert K. Cassatt, Rosemont, Pa., c. 1906–7; his nephew Gardner Cassatt, Radnor, Pa.; gift to The Metropolitan Museum of Art, New York, 1965.

CATALOGUE RAISONNÉ: Breeskin 1970, cat. 98.

EXHIBITIONS: 1881, Paris, 35 boulevard des Capucines, "6me Exposition de peinture par Mlle Mary Cassatt, MM Degas . . . ," cat. 2; 1893, Paris, Galeries Durand-Ruel, "Exposition Mary Cassatt," cat. 7; 1895, New York, Durand-Ruel Galleries, "Exposition of Paintings, Pastels, and Etchings by Miss Mary Cassatt," cat. 18; 1916, Philadelphia, The

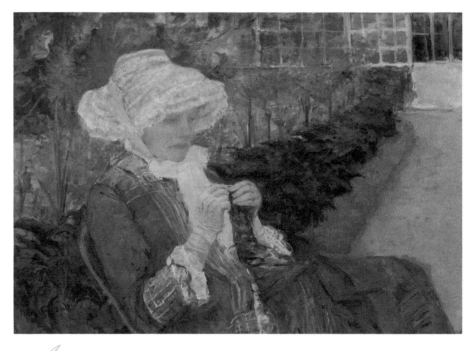

A critical favorite in Europe and America during Cassatt's lifetime, this painting probably went to Alexander Cassatt in the 1890s after appearing in Cassatt's second individual exhibition in Paris in 1893. It was one of the paintings Robert Cassatt received following the death of his father in late 1906; in February 1907, the artist, presumably referring to this painting, wrote to Robert's wife: "I am glad you have my sister Lydia's portrait."[1]

Lydia Crocheting seems to have been first exhibited in Philadelphia in 1916,

Pennsylvania Academy of the Fine Arts, "One-hundred-eleventh Annual Exhibition," cat. 134 (repr.); 1927, Philadelphia, Pennsylvania Museum of Art, "Mary Cassatt Memorial Exhibition," cat. 27.

over thirty years after it appeared in Paris, and was discussed by critics preoccupied with the radical elements of Cubism. Several judged the artistic worth of this painting implicitly from that vantage point as they investigated its relative qualities of realism and abstraction. One critic decried its conspicuous absence of scientific realism in the background, saying it presented a "beautifully painted figure ruined by false surrounding perspective."[2] Another saw only beauty and truth to nature: "The woman is intent upon her knitting—something small and inconsequent that furnishes occupation for beautiful hands—and her face is blurred and indefinite against the high color of the sunny garden. There is expression, warmth, loveliness in this woman sitting so quietly, dressed so quaintly, drawn so feelingly, and the canvas has great distinction."[3]

These characteristics in fact were exceptional within the general character of the Philadelphia show, which otherwise featured, according to the latter critic, "the abstract subject" and still life to better explore purely formal concerns, unlike the work by Cassatt. In responding positively to her seated figure, these critics, who actually supported the predominant abstraction, found they still welcomed the representational and expressive elements of a more traditional art centered on the human being. For one critic, a single lapse into abstraction in the painting seemed to disfigure it.

Realism and abstraction, however, are inextricable elements of this painting, which is the largest and most forceful of her outdoor scenes painted during the summer at Marly-le-Roi. Devoid of expanses of space and sky, the background is a nearly vertical field that fills the canvas with lush summer plants and tilts diagonally to the right, defying perceptual logic. Yet the impression of intense sunlight, the rich, descriptive hues, and the firmly modeled form of Lydia bespeak the essential realism of the painting.

These pictorial elements separate *Lydia Crocheting* from other works painted that summer, suggesting the variety of problems she explored at the time. The narrative interest, horizontal composition, and delicate, light-suffused tonality of *Family Group* (no. 7) are different aesthetic concerns even though executed at about the same time. What joins them is a new command of her craft and a pictorial strength that Degas noticed in these works, which he said were "more firm and more noble than what she did last year."[4]

1. Letter dated February 26, 1907, from Mary Cassatt to Minnie Fell Cassatt, private collection, in Sweet 1966, p. 173.
2. *North American*, February 6, 1916, p. 15.
3. *Inquirer*, February 6, 1916, p. 17.
4. Sweet 1966, p. 57.

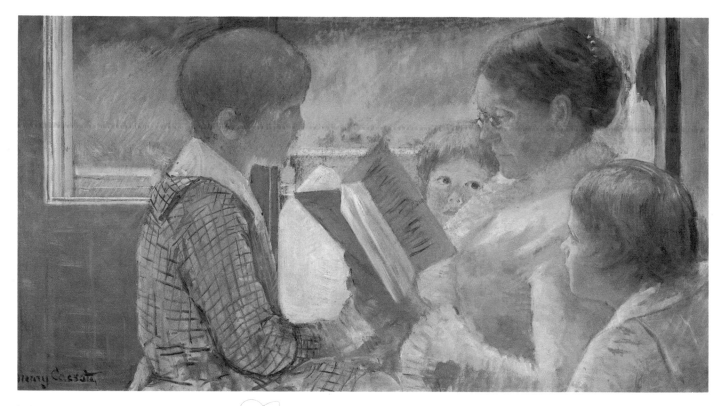

7. *Family Group: Mrs. Cassatt Reading to Her Grandchildren*, 1880
Oil on canvas
22 x 39½″ (55.9 x 100.3 cm)
Signed, lower left: Mary Cassatt
Private Collection

PROVENANCE: Moyse Dreyfus, Paris, after December 1881; Alexander J. Cassatt, Haverford or Philadelphia, probably by January 1884; his son Robert K. Cassatt, Rosemont, Pa., by 1920; his son Anthony D. Cassatt, New York and Philadelphia; private collection.

CATALOGUE RAISONNÉ: Breeskin 1970, cat. 77.

EXHIBITIONS: 1881, Paris, 35 boulevard des Capucines, "6me Exposition de peinture par Mlle Mary Cassatt, MM Degas . . . ," cat. 1; 1885, Philadelphia, The Pennsylvania Academy of the Fine Arts, "Fifty-sixth Annual Exhibition," cat. 62; 1886, New York,

Cassatt favored reading subjects throughout her life (see nos. 29, 30, 36; figs. 7a, 19, 28). This apparently straightforward, informal narrative portrait has added dimensions that are revealed in contemporary documents.

Family Group was a favorite of the artist's family because it depicted three of the four children of Alexander and Lois Cassatt with their grandmother. The painting fixed moments of reunion that seemed fugitive with family on opposite sides of the Atlantic and together only when the Philadelphia branch came to visit. Writing to her granddaughter, who is part of *Family Group*, Katherine Cassatt stressed its sentimental value as prevailing over the temptation of a buyer in hot pursuit: "Do you remember the one she painted of you & Rob & Elsie listening to me reading fairy tales? She finished it after you left & it is now at the exhibition [Sixth Impressionist Exhibition of 1881]—A gentleman wants to buy it but I don't think your Aunt Mary will sell it—she could hardly sell her mother & nieces & nephew I think."[1]

The painting was not sold at that time and hung prominently in their apartment as a memento of the absent children. In an unpublished letter written later that year, Robert Cassatt wrote his granddaughter about its evocative effect on the family: "We have it hanging up in our dining room and it keeps us always in mind of you & makes me wish often & often that I could hear your little voices call as I heard them when the picture was being painted."[2]

Some time during the next two years, however, the painting entered the collection of the artist's friend Moyse Dreyfus. The family is thought to have objected so forcefully that she was compelled to ask for its return. Dreyfus finally agreed in June 1883, with the stipulation that she replace it with another of her works, and implied that *Family Group* should go only to the family in Philadelphia, not to the artist, who admitted to Alexander: "I would rather keep it myself but I know he would not be pleased if I made him give it up to anyone but you."[3]

National Academy of Design–The American Art Association, "Special Exhibition: Works in Oil and Pastel by the Impressionists of Paris," cat. 309; 1920, Philadelphia, The Pennsylvania Academy of the Fine Arts, "Exhibition of Paintings and Drawings by Representative Modern Artists," cat. 46; 1927, Philadelphia, Pennsylvania Museum of Art, "Mary Cassatt Memorial Exhibition," cat. 6.

FIG. 7a. Mary Cassatt, *Three-quarter View of Mrs. Cassatt with Pince-nez*, c. 1878–80. Pencil on paper, 6¼ x 9″ (15.9 x 22.9 cm). Collection of Mr. and Mrs. J. Robert Maguire, Shoreham, Vt.

The painting, long delayed in transit to Philadelphia, apparently was lost for months on the docks of Liverpool.[4] It seems to have reached them before January 1884, which is when Cassatt wrote: "I suppose you have the pictures by this time, & I hope they are not spoiled by their long journey. I have no doubt that the one of Mother and the children is rather black, with being shut up so long."[5]

Cassatt's letter to Alexander suggesting its optimal placement in their house is the principal and best-known source about her artistic intentions for this work. She recommended that the painting be hung "perhaps over a door; it is painted to look as much like frescoe as possible so that it would be appropriate over a door as the Italian painters used to do."[6]

This proposal was neither casual nor isolated. Cassatt was particularly interested in the relationship between tradition and innovation during these early years in Paris, as she simultaneously studied old-master paintings and the work of her new colleagues, Manet, Degas, and the Impressionists. Unlike certain advocates of Impressionism who felt these artists had finally overthrown the burden of the centuries and created a new art, Cassatt perceived intimate links with tradition. After studying frescoes during a trip to northern Italy in 1879, she observed to Berthe Morisot: "I have seen admirable things, frescoes of consummate beauty, really I do not perceive the discovery made by moderns in color. It seems to me that nothing more has been learned in color than in composition."[7] It is by now a commonplace that Impressionists returned to the use of intense primary colors, a palette that can be found in early Renaissance frescoes. However, she was implying that certain traditions were not merely part of the existing fabric of modern art, but should be actively studied by modern artists as well. That, by her own admission, is apparently what she set out to do in the *Family Group*.

Her precise models, if any, are not known, but affinities in this painting can be found in the frescoes of Giotto, particularly those in the celebrated Arena Chapel in Padua, a time-honored pilgrimage site in northern Italy for connoisseurs and artists. Both have a similar, high viewpoint, frieze-like classical composition, expressive naturalism, and luminous, primary colors in spaces with little light—the Cassatt interior is dim, yet colors are filled with light even where the soft summer sun from the window fails to touch, as in the blue shirt and red book.

This overall kinship with tradition was what the critic from the *Daily Evening Telegraph*, who reviewed the painting at the Academy annual of 1885, felt caused Cassatt's Impressionism to be "that of a school that is a good deal older" than that currently produced in France.[8] He had only praise for the color in this work as "particularly beautiful," but the dense-colored atmosphere confused him: "[We] do not see what has been gained of value by the vapors in which the old lady and the pretty children have been enveloped." That chromatic haze links Cassatt with the Impressionists and old masters, such as Correggio and Giotto, who, like Cassatt, retained defined forms in space despite this sense of ether.

While critics in Philadelphia in 1885 were concerned with her Impressionism in this painting, others in Paris in 1881 emphasized and applauded her expressive naturalism. In one of the most famous quotations that has since been used to claim Cassatt as an expressive painter of children without mawkishness, J.-K. Huysmans, on seeing this painting among her entries that year, claimed: "For the first time, thanks to Miss Cassatt, I have

seen the effigies of ravishing youngsters, quiet bourgeois scenes painted with a delicate and charming tenderness."[9] He felt Cassatt stood alone among women artists, the only ones that could paint infancy at all, for not turning to "affectation or tears. . . . Miss Cassatt, thank heavens, is [not among those] and the room where her paintings are hung contains a mother reading surrounded by urchins. . . . This is family life painted with distinction and with love."[10]

Family Group has almost exact counterparts in two prints (Breeskin 1979, cat. 58 and 59) and a finished preparatory drawing (probably for Breeskin 1979, cat. 58), which is in a private collection.

1. Letter dated April 15 (1881) from Katherine Cassatt to Katharine Cassatt, AAA, PMA, in Mathews 1984, pp. 159–60.
2. Letter dated December 20, 1881, from Robert S. Cassatt to Katharine Cassatt, Estate of Mrs. John B. Thayer.
3. Letter dated June 22 (1883) from Mary Cassatt to Alexander Cassatt, AAA, PMA, in Mathews 1984, pp. 169–70. Cassatt executed a handsome pastel of Dreyfus in 1879, now at the Petit Palais, Paris (Breeskin 1970, cat. 66). Mathews 1984 (pp. 169–70) is the source of the speculation about the family's reaction to its sale.

4. Letter dated October 14 (1883) from Mary Cassatt to Alexander Cassatt, AAA, PMA, in Mathews 1984, pp. 172–73.
5. Letter dated January 5 (1884) from Mary Cassatt to Alexander Cassatt, AAA, PMA, in Mathews 1984, pp. 176–77.
6. See the letter cited in n. 3.
7. Author's translation of the passage in a letter, c. October 1, 1879, from Mary Cassatt to Berthe Morisot, in Mathews 1980, p. 67.
8. Daily Evening Telegraph, November 6, 1885, p. 3.
9. Translation from Sweet 1966, p. 60, of J.-K. Huysmans, "Exposition des Indépendants en 1881," L'Art moderne (Paris, 1883), p. 256.
10. Ibid. (of Huysmans, p. 257).

8. *Elsie in a Blue Chair*, 1880
Pastel on paper
35 x 25" (88.9 x 63.5 cm)
Unsigned
Private Collection

PROVENANCE: Artist's family, Paris; Alexander J. Cassatt, Haverford or Philadelphia; Elsie Cassatt (Mrs. W. Plunkett) Stewart, Haverford; private collection.

EXHIBITIONS: Possibly 1920, Philadelphia, The Pennsylvania Academy of the Fine Arts, "Exhibition of Paintings and Drawings by Representative Modern Artists," cat. 12; 1927, Philadelphia, Pennsylvania Museum of Art, "Mary Cassatt Memorial Exhibition," cat. 32.

assatt is known to have executed two portraits of Elsie (fig. 8a), which she prized. One, *Elsie with a Dog* (Breeskin 1970, cat. 81), was exhibited in London in 1883 and then went to Alexander Cassatt that year; it was shown to high critical acclaim at the Academy in 1885.[1] The other, almost surely this one, Cassatt kept for herself and her family in the Paris apartment. When they moved to a new apartment at 14 rue Pierre Charron in 1884, it was the first work on the wall, presumably in a place of honor. Cassatt reported to the child's father: "Elsie's portrait was the first picture hung in the new apartment & looks much better there than in the old one."[2] The pastel may have come to Philadelphia before Cassatt's death, since it was perhaps in the 1920 Academy exhibition, listed as *Portrait of a Child* and loaned by the sitter herself, who also lent the variant, *Child with a Dog* (cat. 14).

This portrait differs from its companion in its larger scale and bolder composition and color. Elsie is represented full-length, seated in a large armchair, looking off to the right. This format was widely used for children in nineteenth-century formal portraiture, both in photography and painting. However, the impact of this portrait is largely due to the frontal, almost emblematic, curved armchair that envelops the child, herself rendered as a contrasting living presence. These mixed qualities suggest the kinship of this work with varying types of much earlier portraiture. It recalls in its naturalism the vivid portraits of Maurice-Quentin de La Tour at the same time as its extremely simplified composition of a tranquil seated figure has affinities with hieratic Byzantine seated portraits.

The quasi-iconic manner seen here recurs in Cassatt's work in various mediums as a counterpoint to the images of active children and can be seen in the exhibition itself in *Baby in a Striped Armchair* (no. 11) and *The Pink Sash* (no. 28).

FIG. 8a. Elsie Cassatt at about age ten, c. 1885. Private collection

1. The inclusion of this pastel in the London exhibition is suggested by its mention in a handwritten copy of the catalogue in the Bibliothèque Doucet, Paris; it was known to have traveled to London. (This information was provided by Nancy Mowll Mathews.) For the appearance of the pastel in the 1885 Academy annual, see the Exhibition Record herein and the unidentified clipping on portraits in the exhibition in the Scrapbook, PAFA Archives.
2. Letter dated April 27 (1884) from Mary Cassatt to Alexander Cassatt, AAA, PMA, in Mathews 1984, pp. 183–84.

9. *Elsie and Robert Cassatt*, c. 1880
Oil on canvas
25 x 21″ (63.5 x 53.3 cm)
Unsigned
Private Collection

PROVENANCE: Elsie Cassatt (Mrs. W. Plunkett) Stewart, Haverford; private collection.

CATALOGUE RAISONNÉ: Breeskin 1970, cat. 76.

According to the present owner, this double portrait sketch was only discovered in the 1930s during conservation treatment of the pastel portrait *Elsie with a Dog* (Breeskin 1970, cat. 81), for which this painting was appropriated as a support and therefore lost to sight. The sketch was executed on top of another bust-length figure of a woman that can be seen, barely sketched in, upside down under the two heads. It nonetheless may account for the mass of brushwork on the upper half of the background. Although no finished related work in oil or pastel is known, there are two variant sketches among Cassatt's drypoints (Breeskin 1979, cat. 38 and 39).

The conjoining of Elsie and Robert relates to an observation in an unpublished letter from Robert Cassatt to the children's mother: "What you tell me of Robbie and Elsie's affection for each other pleases me *very much*. I hope all your children will grow up knit together in natural affection. It will be a great support to them against the troubles of life."[1]

1. Letter dated May 22, 1882, from Robert S. Cassatt to Lois Cassatt, Estate of Mrs. John B. Thayer.

10. Woman by a Window, Feeding Her Dog, c. 1880
Oil, gouache, and pastel on paper
24 x 16″ (61 x 40.6 cm)
Signed, lower right: Mary Cassatt
Private Collection

PROVENANCE: Mathilde Valet, Paris; Mathilde X sale, Hôtel Drouot, Paris, March 30, 1927; Galeries Durand-Ruel, Paris; Acquavella Galleries, New York; private collection.

CATALOGUE RAISONNÉ: Breeskin 1970, cat. 84.

This work is unusually delicate and rococo for Cassatt with its elegant, slender figure and nervous, translucent surface. However, the simple structure that anchors the composition, the almost emblematic rendering, and the rich, deep hues of the figure are characteristic, embodying the so-called virile force of her work.

11. *Baby in a Striped Armchair*
1880–81
Pastel on paper
25 x 26½" (63.5 x 67.3 cm)[1]
Signed, lower right: Mary Cassatt
Private Collection

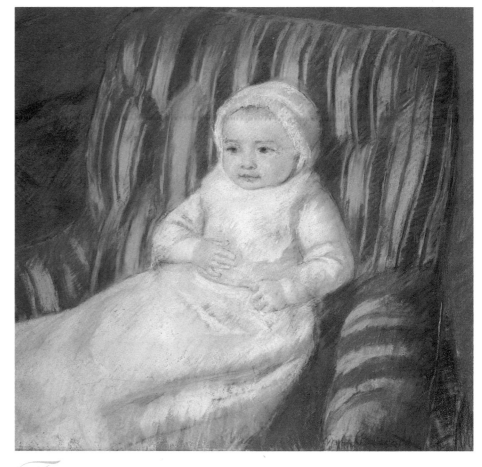

PROVENANCE: Clément Rouart, Paris; Galerie Charpentier sale, Paris, April 4, 1957; O'Hana Galleries, London; Findlay Galleries, Palm Beach; Stephen Hahn, New York, 1967; Wally F. Galleries, New York, 1968; Wally Findlay; private collection.

CATALOGUE RAISONNÉ: Breeskin 1970, cat. 53.

The infant has been identified as Lucie Berard, the third daughter and youngest child of Cassatt's friend Marguerite Berard, wife of Renoir's patron Paul Berard.[2] If that information is correct, the portrait does not date from 1878, as is currently thought, but from the year of Lucie's birth, 1880, to perhaps summer 1881, the date of a group portrait of the Berard children by Renoir, which represents Lucie at about the same age (fig. 11a).[3]

This information suggests a much earlier association between Cassatt and the Berards than the standard references indicate; the Berards are first mentioned in the published Cassatt correspondence in 1885. However scant the details, the letters suggest that relations between the artist and the family were warm and that she saw them frequently at home in Paris and in 1886 in the country, where she took a summer house near the Berards.[4]

FIG. 11a. Pierre-Auguste Renoir, *Studies of the Berard Children*, 1881. Oil on canvas, 24⅝ x 32¼" (62.5 x 81.9 cm). Sterling and Francine Clark Art Institute, Williamstown, Mass. 590

Cassatt's and Renoir's portrayals of the same individual highlight the differences in their approaches in these two works. Whereas Renoir's portrait shows the children in natural attitudes, Cassatt's is utterly static. The infant is isolated in an adult's chair and immobile in its finery.

Unique in Cassatt's work as a formal individual portrait of a newborn, this format comes closest within the tradition of painting to the mortuary portrait, in which a dead child appears most typically alone, laid out in state in its burial attire. However, the portrait type for living infants had already been established in nineteenth-century photography. A photograph from the family of Alexander Cassatt, possibly of Robert as an infant (fig. 11b), is characteristic of what Cassatt is likely to have seen. The pastel and photograph may draw upon an unknown common source, but the prevalence of this portrait type in nineteenth-century photography may have suggested the approach for this exceptional subject by Cassatt.

The revised date of this work is tentative because it rests entirely upon the chronology of the sitter. At first glance, the portrait seems a stylistic anomaly among her known works of 1880; its composition relates to her paintings of seated or reclining women of the late 1870s (figs. 19 and 28).

The pastel, however, has both a mastery and a boldness that relate to her works around 1880. The rigid pose of the baby may be due to its constrictive apparel, for the modeling of the visible anatomy is sure. The hands in slight motion are well articulated and subtly distinguished from the white gown. There is force in the pastel's asymmetrical composition and intense, mottled vermilions and blues. The modulation of the muted hues of the gown and hands is equally authoritative. These features have affinities with the pastel portrait *Elsie in a Blue Chair*, executed in 1880 (no. 8).

1. The pastel was originally 25¾ x 36¼" (65.4 x 92 cm).
2. The identification of the baby as Lucie Berard is based upon information in the Durand-Ruel archives, Paris, the main source on the pastel; this work is not known to have belonged to the Berard family itself (see Breeskin 1970, cat. 53). Nancy Hale (1975, p. 114) claimed that Cassatt's friendship was primarily with Mme Berard. For Renoir's association with the Berards, see "Renoir à Wargemont et la famille Berard," *L'Amour de l'art*, or *Renoir à Wargemont*, both published by M. Berard in Paris in 1938; cited in Françoise Daulte, *Auguste Renoir* (Lausanne, 1971), vol. 1, cat. 285.

3. Daulte (*Auguste Renoir*, p. 409) places Lucie's birth in 1880; Renoir's portrait, which is dated 1881, was painted during his visit that summer at Wargemont. Cassatt's pastel probably predates that summer, since she is not known to have visited the Berards there and was instead near Louveciennes.
4. Letter dated March 1 (1885) from Mary Cassatt to Lois Cassatt, AAA, PMA, in Mathews 1984, pp. 190–91, which discusses Mme Berard's chef. See also the letter dated June 30 (1886) between the same two correspondents (AAA, PMA, in Mathews 1984, pp. 199–200) on the issue of the anticipated reunion of Lois and Alexander Cassatt's children and the Berards' the following summer.

FIG. 11b. One of Alexander Cassatt's children, possibly Robert, c. 1873. Private collection

12. **_Woman and Child Driving_**, 1881
Oil on canvas
35¼ x 51½″ (89.5 x 130.8 cm)
Signed, lower right: Mary Cassatt
Philadelphia Museum of Art. Purchased for
the W. P. Wilstach Collection. W'21-1-1

PROVENANCE: Alexander J. Cassatt, Haverford;
W. P. Wilstach Collection, 1921.

CATALOGUE RAISONNÉ: Breeskin 1970, cat. 69.

EXHIBITIONS: 1895, New York, Durand-Ruel
Galleries, "Exposition of Paintings, Pastels,
and Etchings by Miss Mary Cassatt," cat. 28;
1927, Philadelphia, Pennsylvania Museum of
Art, "Mary Cassatt Memorial Exhibition,"
cat. 40 (repr.).

It is unknown when this celebrated painting arrived in Philadelphia, but it was with Alexander Cassatt by the 1890s, hung prominently opposite the mirrored mantelpiece in the living room at Cheswold (fig. 12a), the family's preferred home. It apparently was not shown in Philadelphia until the 1927 memorial exhibition.

The date of its execution has been proposed as 1879 for many years, despite documentary evidence placing it in 1881. In a letter written late in 1881, Katherine Cassatt described the painting and its models to her grandson Robert: "She also painted a picture of your Aunt Lydia and a little niece of Mr. Degas and the groom in the cart with Bichette [the pony] but you can only see the hind quarters of the pony. I am going to send your Uncle Gard a photograph of the picture and he will show it to you."[1]

Among those who date it 1879, Sweet is one of the few to discuss that decision; he argued that by 1881 Lydia was too ill to pose and that the picture must date from a time closer to the purchase of the pony and cart in 1879, when they would have been novelties.[2] However, if even begun that year, Robert and his family's summer sojourn in France in 1880 would have undoubtedly exposed them to the painting and they would not have needed a photograph to learn of it by 1881, as the letter indicates was actually the case. Furthermore, Lydia's illness was apparently episodic, and there are numerous works dating from 1880 and 1881 for which she posed. The letter describing it suggests it was a work executed outdoors during the summer at Coeur Volant that year.[3]

This painting is frequently likened to Degas's carriage scenes, which are similarly cropped. However, there are marked differences between Cassatt's treatment and that of Degas; whereas Degas's carriage scenes capture

1. Letter dated December 16 (1881) from Katherine Cassatt to Robert K. Cassatt, AAA, PMA, in Sweet 1966, p. 64. The date given in Breeskin 1970 (cat. 69) as December 18, 1879, is erroneous.
2. Sweet 1966, p. 65.
3. Mathews (1980, p. 71) supports the date of the work as 1881, based on the letter.

movement, Cassatt's picture, for all its rendering of apparent anticipation of action, is a study in immobility. The manner of composition reduces any sense of narrative. All figures, including the pony, are stock-still. There is little psychological life. The painting conveys the impression of a posed arrangement. This sense is heightened by Cassatt's treatment of the background; instead of providing a convincing sense of depth, the broadly handled forest departs so radically from the foreground in tonality, finish, and lighting that it suggests a stage backdrop.

Woman and Child Driving is compelling in its broad, balanced, frieze-like composition and fresh color of Lydia's and the child's apparel. Cassatt's capacity to render figures convincingly alive has brought these two to vivid, albeit motionless, immediacy.

FIG. 12a. Parlor in Alexander Cassatt's Haverford house, Cheswold, c. 1900. Seated at left is Katharine Cassatt; across from her, at the piano, are Elsie Cassatt (standing) and Lois Cassatt (sitting). Mary Cassatt's *Woman and Child Driving* (no. 12) is on the left wall. To its right, on the rear wall, is Edouard Manet's *Italian Woman*. To the right of the doorway is Mary Cassatt's *Mandolin Player* (fig. 1a). On the right wall are two unidentified works by Claude Monet. Estate of Mrs. John B. Thayer

13. Master Robert K. Cassatt
c. 1882–83
Oil on canvas
19¾ x 24³⁄₁₆″ (50.2 x 61.4 cm)
Unsigned
Robert K. Cassatt

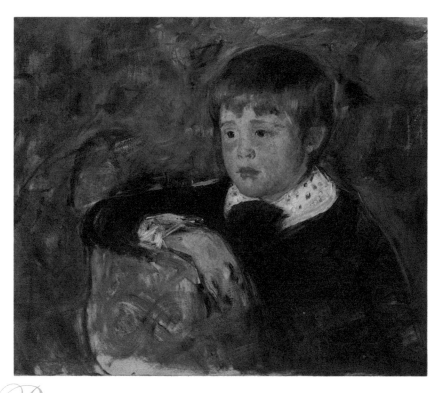

PROVENANCE: Possibly Alexander J. Cassatt, Haverford or Philadelphia; his son Robert K. Cassatt, Rosemont, Pa.; his son Alexander J. Cassatt, initially Rosemont, Pa.; his son Robert K. Cassatt, Brooksville, Maine, c. 1981.

CATALOGUE RAISONNÉ: Breeskin 1970, cat. 119.

EXHIBITIONS: 1920, Philadelphia, The Pennsylvania Academy of the Fine Arts, "Exhibition of Paintings and Drawings by Representative Modern Artists," possibly cat. 41; 1927, Philadelphia, Pennsylvania Museum of Art, "Mary Cassatt Memorial Exhibition," cat. 35.

Robert's age in this work seems to fall between that in the *Family Group* of 1880 (no. 7) and in the double portrait with his father of 1884 and 1885 (no. 16). The date is therefore assigned to a family visit to Paris in November 1882, a time during which other portraits, such as that of Alexander Cassatt (no. 15), are known to have been painted.

Robert's quiet, distant demeanor is unlike that in most portraits showing the sitter leaning in this fashion against the back of an armchair. The pose usually was intended to create the impression of arrested activity and vivacious presence, as in eighteenth-century informal portraiture. Instead, Cassatt's painting suggests the dignity of formal eighteenth-century portraiture in the elegiac mood, with sitters leaning against columns.

It is unknown whether the portrait was considered unfinished. The head reveals her typically careful execution, but the rest emerges from a fiery, mobile field of brushwork and vibrant color, creating an extraordinarily free and densely atmospheric painting.

14. ***Robert and His Sailboat,*** c. 1882
Pastel on wove paper
25³⁄₁₆ x 19¼″ (64 x 48.9 cm)
Unsigned
Private Collection

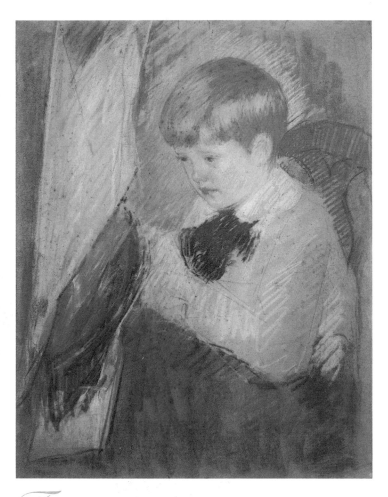

PROVENANCE: Possibly Alexander J. Cassatt, Haverford or Philadelphia; his son Robert K. Cassatt, Rosemont, Pa.; his son Anthony D. Cassatt, New York and Philadelphia; private collection.

CATALOGUE RAISONNÉ: Breeskin 1970, cat. 118.

The sketchy state of this pastel is atypical in that Cassatt used a broad hatching method to develop the overall rhythms and tonal masses at one time, after laying out the composition on the page. The resulting arrangement is energetic, drawing upon the asymmetrical contours of the boy, seated in a curved, open-backed chair and playing with a dramatically foreshortened sailboat cropped at the top. Its blues and oranges are unusually muted and burnt in tonality.

15. ***Alexander J. Cassatt***, 1882–83
Oil on canvas
40 x 32″ (101.6 x 81.3 cm)
Signed, lower left: Mary Cassatt
Private Collection

PROVENANCE: Alexander J. Cassatt or his
family, Haverford or Philadelphia, perhaps
prior to 1920; his son Robert K. Cassatt,
Rosemont, Pa.; his son Anthony D. Cassatt,
New York and Philadelphia; private collection.

CATALOGUE RAISONNÉ: Breeskin 1970, cat. 79.

EXHIBITION: Possibly 1920, Philadelphia,
The Pennsylvania Academy of the Fine Arts,
"Exhibition of Paintings and Drawings by
Representative Modern Artists," cat. 43.

The sequence of the three existing portraits of Alexander J. Cassatt (nos. 15, 17; fig. 15a) has been difficult to establish. It is known from Cassatt's correspondence that she executed a portrait during the summer of 1880 at their country house at Marly-le-Roi, and another portrait in 1883 that she felt might be inferior to the first. Breeskin has identified this portrait as the favored Marly portrait and the unfinished half-length (fig. 15a) as the later, less satisfactory one.

Cassatt's letters indicate that the sequence may be reversed and that the prized portrait was in fact the unfinished one. Shortly after Alexander Cassatt's death, she wrote to Robert's wife about the Marly portrait: "I have a picture I think Rob may like to have, a portrait of his father done at Marly and very like what he was in those days. The picture was never finished but the hair and

FIG. 15a. Mary Cassatt, *Alexander J. Cassatt*, 1880 (formerly dated 1883). Oil on canvas, 25½ x 35¼″ (64.8 x 89.5 cm). Private collection

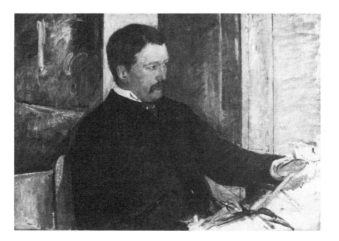

shoulders are. Last summer a dealer came out and rummaged in the garret at Beaufresne carrying off a lot of canvases, and I burned the rest but kept this portrait, too good to destroy."[1]

This description so closely conforms to the unfinished one that it is most surely that painted at Marly. Furthermore, the correspondence of 1880 establishes that the portrait of that year was intended for the Cassatts in Paris, which would explain its presence in France at that time. Lois Cassatt wrote her sister during the 1880 visit that "Mary is painting a portrait of him now for his mother & he has to stay out there [at Marly—Alexander and Lois stayed in Paris]."[2]

The possibility that the portrait in the exhibition is the later one is further suggested by its highly finished state, a condition that corresponds logically with the number of sittings recorded in Lois Cassatt's journal and letters of 1882 and 1883 from Paris. Beginning on December 16, 1882, at the Paris apartment, there were at least twenty-eight sittings mentioned in her journal through the end of March.[3] The portrait received its finishing touches long after the departure of the sitter.[4] Cassatt did not send it immediately to Philadelphia because she felt the Marly portrait was better: "I did not send your portrait in the box [with the other paintings] because I really was not satisfied with it, I like much better the head I painted of you at Marly, & I could not bear to send you a poor thing."[5]

In a later, unpublished letter to Lois Cassatt Thayer, Alexander Cassatt's granddaughter, Cassatt revealed that the problem for her was in the likeness: "I found a portrait of your Grandfather which I had discarded. . . . I now consider it (and others do also) the best likeness of your Grandfather."[6]

If Cassatt despaired of the physical resemblance in the portrait done in 1882 and 1883, she should not have been disappointed in its psychological life. Although posed more formally than in the 1880 sketch, here Alexander Cassatt conveys the impression of an alert, even preoccupied, individual. This portrait, which suggests both the humanity and reserve that were attributed to him, defies the claim that Cassatt could not paint men.[7]

The portrait is solid and balanced in structure. The asymmetry of the figure is countered by the frontality of the armchair and bookcase. Her modeling of visible anatomy is three-dimensional, contrasting with the clothed areas. Although she attempted to modulate the black garment with passages of dark blue, it remains a forceful opaque counterpoint in the style of Manet to the liquid handling and rich color of the rest of the painting.

1. Letter dated February 26, 1907, from Mary Cassatt to Minnie Fell Cassatt, private collection, in Sweet 1966, p. 173.
2. Letter dated August 6, 1880, from Lois Cassatt to Harriet Buchanan, Estate of Mrs. John B. Thayer. Cassatt's plan to paint a portrait of Alexander was announced in an earlier letter, dated July 10, 1880, from Lois Cassatt to her mother, Estate of Mrs. John B. Thayer.
3. Lois Cassatt, "Account of Our Trip to Europe in 1882," Estate of Mrs. John B. Thayer.

4. Letter dated May 25 (1883) from Robert Cassatt to Alexander Cassatt, AAA, PMA, in Mathews 1984, pp. 166–67. Because of its relatively complete state, Mathews (1980, pp. 71–72) proposed the pastel portrait of Alexander Cassatt (no. 17) as the 1883 version.
5. Letter dated October 14 (1883) from Mary Cassatt to Alexander Cassatt, AAA, PMA, in Mathews 1984, pp. 172–73. See also the letter dated June 22 (1883) between these correspondents, AAA, PMA, in Mathews 1984, pp. 169–70.

6. Transcription of a missing letter dated September 8, 1921, from Mary Cassatt to Lois Cassatt (Mrs. John B.) Thayer, Estate of Mrs. John B. Thayer.
7. The widely held belief that Cassatt's proficiency was limited to depictions of women and children, the subjects in the majority of her work, is based on their prevalence and the alleged expressive woodenness of her portraits of men. See Hale 1975, pp. 134–35.

16. Alexander Cassatt and His Son Robert, 1884–85

Oil on canvas
39½ x 32″ (100.3 x 81.3 cm)
Signed and dated, lower left:
Mary Cassatt 1884
Philadelphia Museum of Art. Purchased for
the W. P. Wilstach Collection and Gift of Mrs.
William Coxe Wright. W'59-1-1

PROVENANCE: Alexander J. Cassatt, Haverford
or Philadelphia; his son Robert K. Cassatt,
Rosemont, Pa.; his son Alexander J. Cassatt,
initially Rosemont, Pa.; Parke-Bernet Galleries
sale, New York, April 15, 1959, lot 68 (repr.),
to the W. P. Wilstach Collection.

CATALOGUE RAISONNÉ: Breeskin 1970, cat. 136.

EXHIBITION: 1927, Philadelphia, Pennsylvania
Museum of Art, "Mary Cassatt Memorial
Exhibition," cat. 28.

This double portrait of Alexander and Robert Cassatt is one of the best-known paintings by Cassatt in Philadelphia. Yet during the artist's life, it received no known exposure and was apparently a private family work. After its inclusion in the 1927 memorial exhibition in Philadelphia, it became one of the most frequently published and exhibited of her works.

The sittings for this portrait are among the best documented in the family correspondence. Father and son made an impromptu trip to Paris in December 1884; the sittings began that month, and the pose was established almost immediately. In writing to his wife in Philadelphia, Alexander Cassatt reported that he took the major burden of the sittings himself: "I dont mind the posing, as I want to spend several hours a day with Mother any how—and Rob will not have to pose very much or long at a time."[1] Eleven-year-old Robert was apparently an uncooperative sitter; his grandmother, writing to his older sister, observed that he was not at all like a two-year-old who was posing patiently for another work in progress: "I wish Robbie would do half as well—I tell him that when he begins to paint from life himself, he will have great remorse when he remembers how he teased his poor Aunt wriggling about like a flea—he laughs & says he isn't afraid of the remorse—he has just this instant opened the door to say, 'Aunt Mary would like you to come here Grandmother' & I know it is to try to make him pose a little as his father has just gone out."[2]

By January 22, Alexander stated that the portrait was far enough along for Cassatt to continue without them.[3] She was satisfied, claiming the likenesses were "not bad."[4] By March, perhaps referring to this portrait, she said she was using "all the sketches I ever made & all the old pastels . . . [Robert] is very like himself."[5] By May it was finished but not yet photographed as planned.[6]

This portrait, exceptional in Cassatt's work in combining two males, suggests the family bond of the father and son. Alexander Cassatt was particularly attached to his children and grandchildren, who surround him in numerous photographs (fig. 16a), and is known to have been deeply lonely in their absence.[7]

Although the heads are individualized and direct a powerful gaze to a common focus at right, they reveal no psychological life. The painting instead emphasizes their physical union by generalizing details to such an extreme that the two seated figures are fused into a single black form that dominates the canvas. Unlike the portrait of Alexander Cassatt done in 1882 and 1883 (no. 15), there is no attempt to distinguish colors or anatomical details within the clothing. The foreshortening of the figures is in fact so ambiguous that they seem distorted. The almost abstract character of the painting is enhanced by the rich painterliness of the surface, drawing upon the free brushwork and fresh color. However, the human and aesthetic dimensions remain essentially balanced through the equal assertiveness of the likenesses and formal qualities within the painting.

FIG. 16a. Alexander (center) and Lois Cassatt (far left) and their family on the veranda of their Haverford house, Cheswold, c. 1904. At right, their daughter Elsie holds her daughter Katherine; Alexander is flanked by two of his grandchildren, Elsie's son Cassatt (right), and Edward's daughter Lois (left). Private collection

1. Letter dated December 30 (1884) from Alexander Cassatt to Lois Cassatt, AAA, PMA, in Sweet 1966, p. 92 (erroneously as January 1885).

2. Letter dated January 21, 1885, from Katherine Cassatt to Katharine Cassatt, AAA, PMA, in Mathews 1984, p. 187.

3. Letter dated January 22, 1885, from Alexander Cassatt to Lois Cassatt, Estate of Mrs. John B. Thayer.

4. Letter dated January 28 (1885) from Mary Cassatt to Lois Cassatt, AAA, PMA, in Mathews 1984, pp. 188–90.

5. Letter dated March 1 (1885) from Mary Cassatt to Lois Cassatt, AAA, PMA, in Mathews 1984, pp. 190–91. For related sketches, see Breeskin 1970, cat. 135 and 766. The "old pastels" might have included *Robert and His Sailboat* (no. 14).

6. Letter dated May 17 (1885) from Mary Cassatt to Alexander Cassatt, AAA, PMA, in Mathews 1984, pp. 193–95.

7. See Patricia T. Davis, *End of the Line: Alexander J. Cassatt and the Pennsylvania Railroad* (New York, 1978).

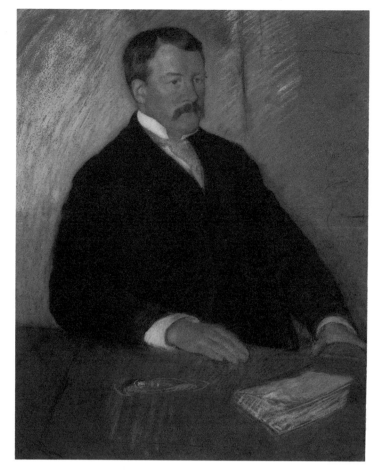

A letter of June 1888 from Lois Cassatt in Paris may describe sittings for this portrait, providing the first documentary evidence of its date: "Mary has painted a very good portrait of Aleck for which he has been posing every morning for two hours for two weeks. It is in pastel which is more quickly done than oil painting. The sitting business is a nuisance and I am glad to be done with it."[1]

This pastel, perhaps dating five years after the finished portrait in oil (no. 15), may be last in the sequence of three individual portraits by Cassatt of Alexander.

Compared with the other two, this portrait is extraordinarily reserved. Alexander Cassatt appears in formal attire, distanced from the viewer by his closed, static attitude and the draped table in front. It is unclear whether Cassatt intended any specific iconographic interpretation, despite the prominence given to the objects on the table, a book and perhaps a large letter opener, which might suggest the man of affairs.

A compelling pictorial austerity accompanies the formality of mood. The image is compressed into a particularly flat surface. The tilted table is nearly vertical. One of Cassatt's favorite tactics, the line demarcating the corner at Alexander's left shoulder merely divides the background, creating no sense of space. The economy of iconographic detail is echoed in the chromatic subtlety; the cool pink background and raspberry cloth give this portrait its muted, yet arresting, impact. Cassatt's differentiation in handling in various areas lends the

only richness to the image, a textural one; the solidity and the fastidious finish of the figure play against the loosely stroked foreground, and the book and oblong object are treated so summarily that they float like translucent phantoms on the mobile surface. The background is hatched in sharp, diagonal strokes that contrast with the comparative freedom of the handling of the table.

1. Letter dated June 23, 1888, from Lois Cassatt to E. Y. Buchanan, Estate of Mrs. John B. Thayer. Breeskin (1970, cat. 150) dates it c. 1887.

18. *Mrs. Alexander J. Cassatt Seated at a Tapestry Frame*, c. 1888

Pastel on paper
32 x 25″ (81.3 x 63.5 cm)
Unsigned
Private Collection

PROVENANCE: Alexander J. Cassatt, Haverford or Philadelphia; his daughter Elsie Cassatt (Mrs. W. Plunkett) Stewart, Haverford; private collection.

CATALOGUE RAISONNÉ: Breeskin 1970, cat. 127.

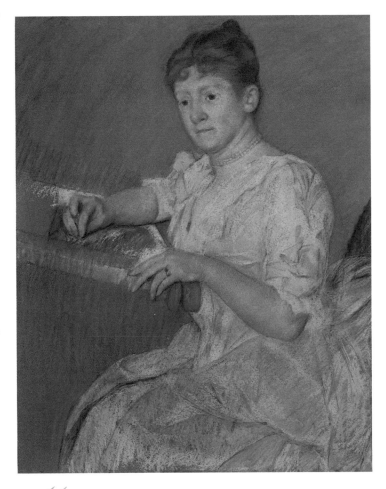

Mathews has proposed that this pastel and the preceding portrait of Alexander Cassatt (no. 17) are pendants.[1] If they are, they may be so only distantly because the dimensions generally conform, but the proportions of the figures within each image differ perceptibly. Furthermore, their respective accessories, a table and a tapestry frame, do not correspond compositionally. The openness and energy of Lois Cassatt's portrait, due to her outward gaze and the lateral placement and radical cropping of the tapestry frame, are unlike the psychological and compositional closure and stability of her husband's. Despite these disparities and differences in handling, in mood and overall style they are so similar that the date proposed for this one is the same as for Alexander Cassatt's.[2]

This work has many affinities with French Rococo portraiture. The lush pastel, elaborating the shimmering silk finery of the sitter, in an ostensibly informal domestic activity, seems to synthesize an almost ornamental beauty with a fundamental contemporaneity and naturalism.

That Cassatt aimed for a significant degree of realism in the portrait can be discerned in the radical difference between it and that by Whistler (fig. 18a), which Cassatt herself described as a purely artful arrangement based on the figure.[3] The diaphanous, willowy figure and the elegant face in the Whistler portrait have little in common with Cassatt's depiction, which instead shows the palpable, stocky—albeit beautifully clad—body and the obdurate face that appear in many photographs (fig. 18b). Indeed, the force of Cassatt's unflattering representation has moved many to remark that it reveals the animosity between the strong-willed painter and her elder brother's prickly wife.[4] Whatever the truth of that observation, Cassatt's portraits and figure compositions in general share a propensity for realism, as can be seen in the various examples in the exhibition, indicating that it was not reserved for an antagonist.

1. Mathews 1980, p. 72.
2. Breeskin (1970, cat. 127) dates this pastel c. 1883.
3. Letter dated October 14 (1883) from Mary Cassatt to Alexander Cassatt, AAA, PMA, in Mathews 1984, pp. 172–73.
4. Sweet 1966, pp. 55–56; Breeskin 1970, cat. 127; and Hale 1975, p. 44. That observation is also a family tradition.

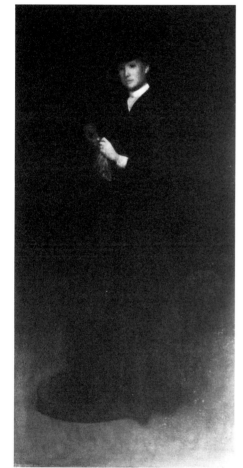

FIG. 18a. James Abbott McNeill Whistler (American, 1834–1903), *Arrangement in Black (No. 8): Mrs. A. J. Cassatt*, 1883–85. Oil on canvas, 75¼ x 35¾" (191.1 x 90.8 cm). Private collection

FIG. 18b. Lois Cassatt (back row, second from left) with family and friends in the Bois de Boulogne, Paris, May 1888. Family includes Katharine (back row, far right), Elsie (front row, left), and Edward (front row, center). Friends are H. and G. Thomas and "Vacherio." Estate of Mrs. John B. Thayer

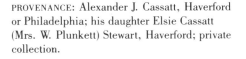

19. ***Katharine Kelso Cassatt***, 1888
Oil on canvas
39 x 26″ (99.1 x 66 cm)
Unsigned
Private Collection

PROVENANCE: Alexander J. Cassatt, Haverford or Philadelphia; his daughter Elsie Cassatt (Mrs. W. Plunkett) Stewart, Haverford; private collection.

CATALOGUE RAISONNÉ: Breeskin 1970, cat. 469.

EXHIBITIONS: Possibly 1888, London, Grossman Gallery; 1920, Philadelphia, The Pennsylvania Academy of the Fine Arts, "Exhibition of Paintings and Drawings by Representative Modern Artists," cat. 11; 1927, Philadelphia, Pennsylvania Museum of Art, "Mary Cassatt Memorial Exhibition," cat. 34.

his painting has previously been identified as a posthumous portrait from about 1905 of the artist's mother, Katherine, as a young girl.[1] However, the family believes it depicts Alexander Cassatt's oldest daughter and namesake of her grandmother Katherine: Katharine Kelso Cassatt, known at the time as "Sister."[2] Photographs seem to substantiate that claim (fig. 19a). Furthermore, an unpublished letter from Lois Cassatt dated 1888, written during the family's visit to France that year, describes the sittings for a portrait by Cassatt, which may be this one: "The very last sitting for the portrait is going [to be] today and Aleck thinks it is very good. I am thinking that if we had not been going away it would have dragged on indefinitely. . . . Sistèr would not smile for her and it made no difference what we said she still wore the solemn expression you will see in the photo Rob took."[3]

With a date of 1888 instead of 1905, the apparent age of the sitter conforms with that of Katharine. Born July 30, 1871, she would have been thirty-four in 1905, considerably older than the adolescent in the painting. Furthermore, the solemn expression of the young woman reflects that which so frustrated Lois Cassatt. Finally, both the degree of finish and the number of existing sketches suggest the effort this undertaking involved, perhaps reflecting Lois Cassatt's complaint that it seemed to drag on: a half-length oil sketch (Breeskin 1970, cat. 468), three pencil sketches (Breeskin 1970, cat. 911–13), and a drypoint (Breeskin 1979, cat. 198 +) are associated with the portrait.

If it dates to 1888, this painting joins the pastel portraits of Alexander and Lois Cassatt (nos. 17 and 18) as a group of works of a kindred spirit, apparently even predating them by some months. All are formal in attire and mood, with highly finished figures.

On a more general level, the artist evaluated the portrait of Katharine described in the letter of 1888 in very specific terms that were transmitted by Lois Cassatt: "It is going to be exhibited at the Grossman Gallery in London if it is satisfactory to the *artist* and her fellow artists here as a work of art. The likeness from this standpoint is, of course, not important. I think Mary has tried her best to make it good in every respect."[4] It is unknown whether the painting met that criterion and went to London. However, the values expressed are revealing. This dual priority of likeness and artfulness, which would allow a portrait to serve both as effigy and pure figure painting, is what separates Cassatt's artistic view of her own portraiture from her view of Whistler's (see no. 18 and fig. 18a).

Katharine Cassatt was a lesser figure in Cassatt's work,[5] but a prominent and tragic one in the family correspondence. She and a young physician, James Hutchinson, fell in love but did not marry for many years, ostensibly because military service in the Spanish-American War prevented him from securing a professional position until very late. They finally married in June 1903, when Katharine was thirty-two.[6] In her first year of marriage, she was stricken with fatal goiter disease and died in April 1905.[7] Her death is said to have dealt a particularly severe blow to her father, who died the following year of heart failure.[8] Lois Cassatt wrote much later in a memoir for the family: "[Sister's] loss to us . . . was irreparable, and I feel now that your father was never able to get over the shock of her death."[9]

FIG. 19a. Katharine Kelso Cassatt, c. 1900. Estate of Mrs. John B. Thayer

1. Breeskin 1970, cat. 469.
2. Alexander and Mary Cassatt's mother was Katherine Kelso Cassatt; her granddaughter was given the name Katharine to distinguish the two.
3. Letter dated March 15, (18)88, from Lois Cassatt to Katharine Cassatt, Estate of Mrs. John B. Thayer.
4. Ibid.
5. As in the case of Edward Cassatt, few individual portraits of Katharine are known. A portrait of Katharine in Breeskin 1970 (cat. 87) is dated 1880, but the child is too young if the date is right; the family owns a small, early unpublished painting of a child's head, inscribed to "Kathrine," which may be an early portrait. Cassatt is documented as having started, but not finished, a portrait of Katharine in action, an unusual choice for her, in 1880: "Aunt Mary never finished the picture of you coming up the stairs, as she had no model" (letter dated December 21, 1881, from Robert Cassatt to Katharine Cassatt, Estate of Mrs. John B. Thayer).

6. Patricia T. Davis, *End of the Line: Alexander J. Cassatt and the Pennsylvania Railroad* (New York, 1978), pp. 178–79.
7. See the letters dated January 19, 1904, and March 3, 1904, from Henrietta Buchanan to Lois Cassatt, and July 20, 1905, from Anne Eliza Buchanan to Lois Cassatt, all Estate of Mrs. John B. Thayer.
8. Alexander Cassatt suffered heart problems toward the end of his life. His obituaries dwell upon his extended respiratory illness, presumably caught as a result of his grandchildren's whooping cough the previous summer, during which time he became gradually semi-invalid and died of cardiac arrest.
9. Memoir, Estate of Mrs. John B. Thayer, cited in Davis, *End of the Line*, p. 179.

20. *Head of Mrs. Robert S. Cassatt*, c. 1889

Pastel on paper
13⅞ x 15″ (35.2 x 38.1 cm)
Unsigned
Private Collection

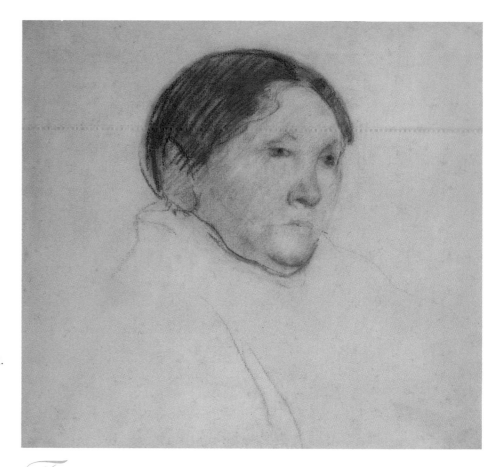

PROVENANCE: From the artist to Mathilde Valet; sale, collection of Mademoiselle X, Oeuvres de Mary Cassatt. . . . Galerie A.-M. Reitlinger, March 29, 1927, lot 65 (repr.); Mr. Stoneborough, London, purchase; private collection, Philadelphia, purchase.

CATALOGUE RAISONNÉ: Breeskin 1970, cat. 161.

This delicate portrait sketch was recently discovered in a private collection in Philadelphia. It is probably a study for the celebrated full-length portrait of Katherine (Mrs. Robert S.) Cassatt, now in the Fine Arts Museums of San Francisco, which, until recently, belonged to the Cassatt family.

21. ***The Long Gloves,*** 1889
Pastel on paper
25½ x 21" (64.8 x 53.3 cm)
Signed, lower right: Mary Cassatt
Private Collection

PROVENANCE: Eugenia Cassatt (Mrs. Percy C.)
Madeira, Berwyn, Pa.; private collection.

CATALOGUE RAISONNÉ: Breeskin 1970, cat. 157.

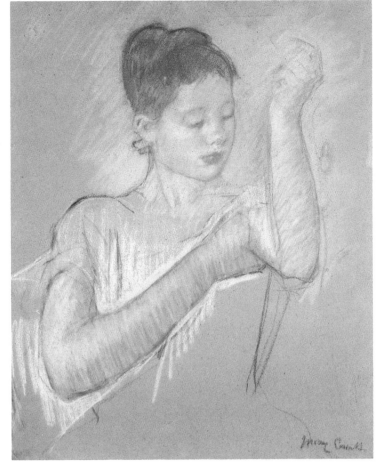

The subject of a young woman pulling on gloves is common in
Impressionist works and recurs in Cassatt's own. In modeling this figure
only to the arms, Cassatt has developed the problem of a study of a specific
anatomical area to an extreme. The truncated figure, neither bled away at the
edges nor cropped by the edge of the image (a time-honored artistic device),
appears to float fully formed, despite the linear suggestion of a supportive torso.
Because it represents an animated head and arms, this fragmentary figure
seems alive, an impression heightened by Cassatt's realism.

The figure type is wholly Cassatt's in the auburn hair, wholesome
appearance, snub nose, and very red, full mouth. These features can be seen
particularly in the homely model of Cassatt's celebrated *Girl Arranging Her Hair*
(fig. 21a), which belonged to Degas.

FIG. 21a. Mary Cassatt, *Girl Arranging Her
Hair*, 1886. Oil on canvas, 29½ x 24½" (74.9
x 62.2 cm). National Gallery of Art, Wash-
ington, D.C. Chester Dale Collection. 1962

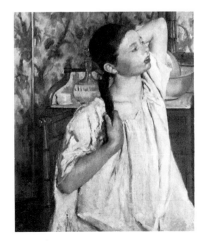

22. **Woman Arranging Her Veil**, c. 1890
Pastel on paper
25⅞ x 21⁷⁄₁₆″ (65.7 x 54.5 cm)
Signed twice, lower right: Mary Cassatt
Philadelphia Museum of Art. Bequest of Lisa
Norris Elkins. 50-92-3

PROVENANCE: Eugenia Cassatt (Mrs. Percy C.)
Madeira, Berwyn, Pa.; Lisa Norris (Mrs.
William M.) Elkins, Philadelphia and
Narragansett, purchase; bequest to the
Museum, 1950.

CATALOGUE RAISONNÉ: Breeskin 1970, cat. 174.

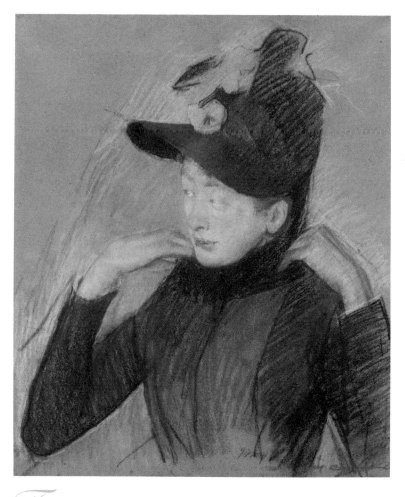

This same model, in a black, flowered poke bonnet, appears in two other works dated around 1890, an oil painting entitled *Young Woman Sewing* (Breeskin 1970, cat. 172, the Art Institute of Chicago) and a pastel called *Young Woman in a Black and Green Bonnet, Looking Down* (Breeskin 1970, cat. 173, the Art Museum, Princeton University). In all three works, Cassatt has explored the bold asymmetry of the black bonnet tilted in various positions.

This pastel has strong affinities with Degas's work of the 1880s and 1890s. The subject resembles his millinery scenes, some of which Cassatt seems to have posed for. This thin-featured, faintly cynical woman, a departure from Cassatt's full-featured figure types, is starkly silhouetted and subtly modeled.

Two features suggest that this pastel was reworked later in Cassatt's career. First, the work was signed twice, in different colors (dark blue and vermilion) and handwriting. Second, despite the intense hue of the auburn hair that is characteristic of her work, the luminous goldenrod hatching around the figure recalls the broad stroke and aggressive colors of her late works, rather than those of the late 1880s or early 1890s to which the figure corresponds. Cassatt is known to have highlighted early works in luminous blue, but the delicate lines lie on the uppermost surface and are intermixed with the yellow hatched areas around the figure, suggesting both were executed long after the initial work.

23. *Baby on Mother's Arm*, c. 1891

Oil on canvas
25 x 20″ (63.5 x 50.8 cm)
Signed, lower left: to Adolph [*sic*] Borie/Mary Cassatt
Peter Borie, New York

PROVENANCE: Adolphe E. Borie III, Philadelphia; his son Peter Borie, New York.

CATALOGUE RAISONNÉ: Breeskin 1970, cat. 191.

EXHIBITIONS: 1927, Philadelphia, Pennsylvania Museum of Art, "Mary Cassatt Memorial Exhibition," possibly cat. 16; 1928, Pittsburgh, Carnegie Institute, "Memorial Exhibition of the Work of Mary Cassatt," possibly cat. 14, 15, or 16.

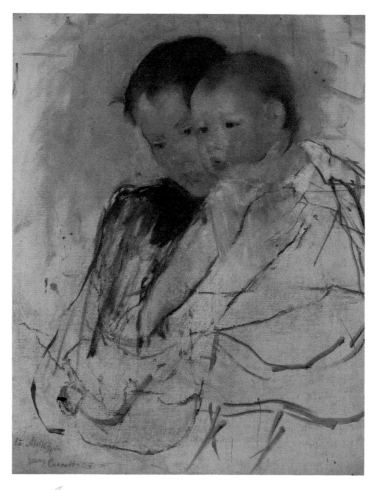

FIG. 23a. Mr. and Mrs. Adolphe E. Borie, c. 1922. Collection of Peter Borie, New York

According to Peter Borie, who remembers the event from childhood, his father selected this painting as a memento from Cassatt's holdings at Beaufresne, at her instigation, while they lived in Paris from 1921 to 1924. Because Cassatt was almost totally blind at the time, the inscription is possibly by another hand, though under her guidance. This gift attests to a long-standing relationship between two Philadelphia expatriates who lived in Paris.

Born in Philadelphia in 1877, Adolphe E. Borie III (fig. 23a) was a grandnephew and namesake of Adolph E. Borie, the distinguished merchant, diplomat, and collector of the early nineteenth century.[1] He was a student at the Academy between 1896 and 1899 and met Cassatt, perhaps through Philadelphia painter Carroll Tyson, when he and his wife went to Paris for a year in 1907. Cassatt, apparently an important force in shaping his mature style, attempted to arrange visits for Borie and Tyson to private collectors such as Henri and Alexis Rouart.[2] Borie subsequently became an established portraitist in Philadelphia, though he exhibited a wide range of figure and still-life compositions that gained national attention. He died of pneumonia in 1934, eight years after the death of Cassatt.

The color in this painting is unusually subtle, and the figure types are exceptionally delicate. The painting derives its strength from the animation of the mother and child, however sketchy, and the boldness of the frame-filling, asymmetrical, cropped composition.

1. For information on Borie's life and works, see George Biddle, *Adolphe Borie* (Washington, D.C., 1937).

2. Letter dated May 4, 1908, from Mary Cassatt to Carroll Tyson, AAA, PMA, in Sweet 1966, pp. 176–77. For Cassatt's influence on Borie's painting, see Biddle, *Adolphe Borie*, p. 10.

24. *The Church at Jouilly*, c. 1892
Oil on canvas
21½ x 25½″ (54.6 x 64.8 cm)
Signed, lower right: Mary Cassatt
Private Collection

Not Illustrated

PROVENANCE: J. Gardner Cassatt,
Philadelphia; his daughter Ellen Mary (Mrs.
Horace B.) Hare, Radnor, Pa.; private
collection.

CATALOGUE RAISONNÉ: Breeskin 1970, cat. 206.

This work is one of the rare landscapes that is firmly attributed to Cassatt. Consequently, it is difficult to date but has been associated with her works of the 1890s, such as *Maternal Caress* (no. 26), that likewise present an outdoor setting with cool tonality, relatively deep space, and strong lighting.

The Church at Jouilly suggests that Cassatt may have assimilated aspects of landscape painting by her friend and mentor Camille Pissarro.[1] Like his work of the 1870s, this painting depicts an expansive foreground space, with architectural elements as its focus in the background, rendered in cool green and with an almost architectonic sense of structure.

1. See Sweet 1966 for discussions of their personal and professional relations.

25. *The Sailor Boy:*
Gardner Cassatt, 1892
Pastel on paper
25 x 19″ (63.5 x 48.3 cm)
Signed, lower left: Mary Cassatt/Paris 1892
Philadelphia Museum of Art. Gift of Mrs.
Gardner Cassatt, reserving life interest.
61-175-1

PROVENANCE: Mrs. J. Gardner Cassatt,
Philadelphia; her son, the sitter, Gardner
Cassatt, Radnor, Pa.; gift to the Museum,
1961.

CATALOGUE RAISONNÉ: Breeskin 1970, cat. 208.

EXHIBITIONS: 1927, Philadelphia, Pennsylvania
Museum of Art, "Mary Cassatt Memorial
Exhibition," cat. 33 (cover); 1928, Pittsburgh,
Carnegie Institute, "Memorial Exhibition of
the Work of Mary Cassatt," cat. 22.

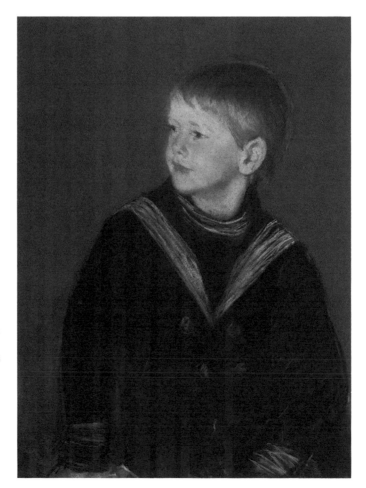

orn in September 1886, Gardner was the eldest of three children of the artist's younger brother. He was represented as an infant in a drypoint by Cassatt (no. 37) and was about six when this portrait was executed during one of the frequent family visits to Paris.

The Sailor Boy's vitality comes from the sense of arrested movement and absorption given by the torsion of the body to the right and the child's keen leftward gaze. This long-familiar device for giving just such a living presence to a sitter was a favorite in informal eighteenth-century French portraiture. Even Cassatt's much-admired pastellist Maurice-Quentin de La Tour, who is best known for his sitters' lively direct gaze to the viewer, used this strategy in portraits.

Its animation notwithstanding, this portrait of Gardner stands out for its special sense of grandeur, suggested both by the absence of surrounding accessories and by the low viewpoint. Gardner seems to loom within the empty space as if seen slightly from below. The portrait thereby imparts a monumentality to the child and celebrates his youthful energy.

26. *Maternal Caress*, c. 1896
Oil on canvas
15 x 21¼" (38.1 x 54 cm)
Signed, lower right: Mary Cassatt
Philadelphia Museum of Art. Bequest of Aaron E. Carpenter. 70-75-2

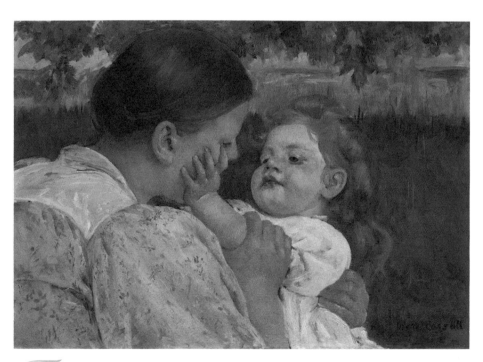

PROVENANCE: Durand-Ruel, Paris, New York, 1896; C. J. Lawrence, 1897; C. J. Lawrence sale, American Art Association, New York, January 21, 1910, lot 64; Durand-Ruel Galleries, New York, 1920; Aaron E. Carpenter, Philadelphia, 1942; bequest to the Museum, 1970.

CATALOGUE RAISONNÉ: Breeskin 1970, cat. 262.

EXHIBITIONS: 1927, Philadelphia, Pennsylvania Museum of Art, "Mary Cassatt Memorial Exhibition," cat. 14 (repr.); possibly 1928, Pittsburgh, Carnegie Institute, "Memorial Exhibition of the Work of Mary Cassatt," cat. 35.

his painting is part of a group of easel paintings from the 1890s that have as their conceptual pivot the lost allegorical mural of the modern woman for the Woman's Building at the World's Columbian Exposition in Chicago, 1893. These paintings grew out of Cassatt's dissatisfaction with the realist or Impressionist principle of rendering the purely physical world. Turning instead to Italian Renaissance frescoes, she sought to amalgamate realist imagery of the

modern world with allegorical content in order to forge an art that conveyed meaning to contemporary society. The term coined for this effort, which she shared with French colleagues such as Gauguin and Puvis de Chavannes, was "Neo-traditionism." Her endeavors, particularly for the Chicago Woman's Building, were not widely appreciated at the time. Related works such as *Young Women Picking Fruit* (Breeskin 1970, cat. 197, Carnegie Institute, Pittsburgh) and *Woman with a Red Zinnia* (fig. 26a) seemed jarring because, unlike those by Puvis and Gauguin, their assertive realism obscured her symbolist intent. Her drawing merely looked distorted, and her subject matter appeared illogical and inscrutable. In *The Family* (fig. 26b), one of her more accepted attempts, she seems to have reconciled these elements in their more recognizable Renaissance source.[1]

The *Maternal Caress* is like these works in its closeup view, simplified yet naturalistic figures and landscape (probably the banks of Cassatt's pond at Beaufresne), nearly vertical landscape, and immobile figures. However, the collision of realism and idealism is minimized in this painting's identifiable action—a shared caress—and its strongly modeled volumes. Emphasized by the intimate vantage point and palpable, interlinked figures, the intense engagement of a modern mother and child conveys an image of bonding that is as timeless as it is contemporary.

1. For a recent discussion of Cassatt's relationship to Neo-traditionism, see Mathews 1980, pp. 82–95.

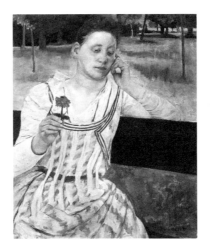

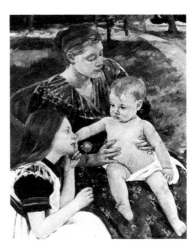

FIG. 26a. Mary Cassatt, *Woman with a Red Zinnia*, 1891. Oil on canvas, 29 x 23¾" (73.7 x 60.3 cm). National Gallery of Art, Washington, D.C. Chester Dale Collection. 1962

FIG. 26b. Mary Cassatt, *The Family*, 1887. Oil on canvas, 32¼ x 26⅛" (81.9 x 66.4 cm). The Chrysler Museum, Norfolk, Va. Gift of Walter P. Chrysler, Jr. 71.498

27. ***Maternal Kiss***, 1897
Pastel on paper
22 x 18¼″ (55.9 x 46.4 cm)
Signed, lower left: Mary Cassatt
Philadelphia Museum of Art. Bequest of Anne
Hinchman. 52-82-11

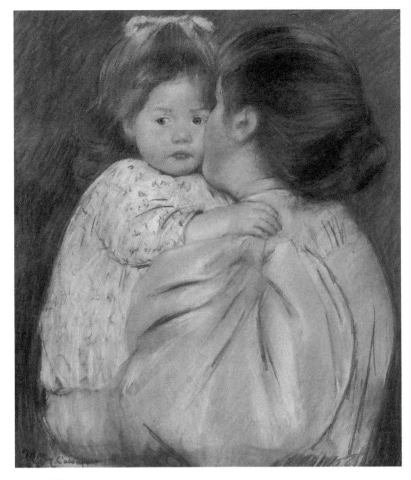

PROVENANCE: Durand-Ruel, Paris, New York;
bequest to the Museum, 1952.

CATALOGUE RAISONNÉ: Breeskin 1970, cat. 279.

The psychological focus of this pastel is the child, emphasized by the fact that the mother's features are lost in her daughter's cheek. This work has the repose and monumentality of the 1890s, and a subtle richness of color and pattern in the iridescent salmon-hued mutton sleeve of the mother's dress and delicate sprigged fabric of the auburn-haired child.

28. ***The Pink Sash***, c. 1898
Pastel on paper
24 x 20″ (61 x 50.8 cm)
Unsigned
Private Collection

Not Illustrated

This pastel portrait, perhaps executed during Cassatt's second visit to Philadelphia, embodies her iconic manner carried to a particularly bold extent. The quiet reserve of the seated child, extreme compositional simplicity, austere color, and broad draftsmanly handling give this portrait a special dignity and physical richness.

PROVENANCE: J. Gardner Cassatt, Philadelphia; his daughter Ellen Mary (Mrs. Horace B.) Hare, Philadelphia; private collection.

CATALOGUE RAISONNÉ: Breeskin 1970, cat. 287.

EXHIBITIONS: 1920, Philadelphia, The Pennsylvania Academy of the Fine Arts, "Exhibition of Paintings and Drawings by Representative Modern Artists," possibly cat. 16; 1927, Philadelphia, Pennsylvania Museum of Art, "Mary Cassatt Memorial Exhibition," cat. 31 (repr.).

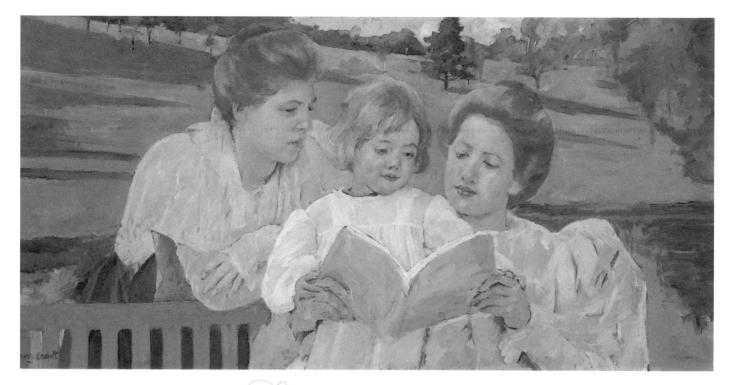

29. *Family Group—Reading*, c. 1901
Oil on canvas
22¼ x 44¼" (56.5 x 112.4 cm)
Signed, lower left: Mary Cassatt
Philadelphia Museum of Art. Gift of Mr. and
Mrs. J. Watson Webb. 42-102-1

PROVENANCE: Mr. and Mrs. Henry O.
Havemeyer, New York; their daughter Electra
Havemeyer (Mrs. J. Watson) Webb, New York;
gift to the Museum, 1942.

CATALOGUE RAISONNÉ: Breeskin 1970, cat. 343.

EXHIBITIONS: 1916, City Art Museum of Saint
Louis, "Eleventh Annual Exhibition of
Selected Paintings by American Artists";
possibly 1928, Pittsburgh, Carnegie Institute,
"Memorial Exhibition of the Work of Mary
Cassatt," cat. 36.

Like her parents, Electra Havemeyer Webb maintained a long and warm relationship with Cassatt that is revealed in the correspondence between them late in the artist's life.[1] This painting was in the celebrated collections of both generations and has been given the title by which it was known while in their hands, although it has many others as well.

This outdoor reading scene suggests that Cassatt may have turned once again to Italian Renaissance painting for inspiration. Its frieze-like composition; monumental, well-modeled figures; light-suffused atmosphere; and high-keyed color recall her earlier works derived from this source, particularly those related to the 1893 Chicago mural (see no. 26). As with her suggestion for the fresco-inspired *Family Group* of 1880 (no. 7), this horizontal image seems to invite high placement on a wall, perhaps as an overdoor.

The realism of this scene is nonetheless compelling. The setting strongly resembles the pondside park at Beaufresne. The figures are likewise credibly modern and animated despite the classical composition. This frieze-like triad may have an iconographic function as well as an aesthetic one: flanked by the larger adults, the tiniest member of the group forms its center, stressing the psychological and narrative importance of the child.

Cassatt is frequently celebrated as a draftsman, but this painting demonstrates her most consistent fault in this regard: difficulty with hands in foreshortened positions.

1. See the Cassatt–Havemeyer Webb
correspondence in the archives of the
Shelburne Museum, Vt., and at the
Metropolitan Museum of Art, New York.

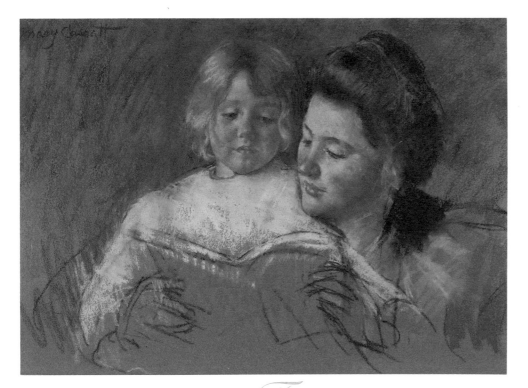

30. Looking at a Picture Book, No. 2, c. 1901

Pastel on paper
18 x 25" (45.7 x 63.5 cm)
Signed, upper left: Mary Cassatt
Private Collection

PROVENANCE: Roger Marx, Paris; Roger Marx estate sale, Galerie Manzi, Joyant, Paris, May 11–12, 1914, cat. 101; Sotheby & Co., London, November 24, 1964, lot 27 (repr.); O'Hana Gallery, London; Acquavella Galleries, New York; private collection.

CATALOGUE RAISONNÉ: Breeskin 1970, cat. 341.

EXHIBITIONS: 1908, Paris, Galeries Durand-Ruel, "Tableaux et pastels par Mary Cassatt," November 3–28, cat. 33; 1928, Pittsburgh, Carnegie Institute, "Memorial Exhibition of the Work of Mary Cassatt," cat. 37.

This pastel is one of several works by Cassatt that belonged to the distinguished French critic and collector of the turn of the century, Roger Marx (1859–1913). He was a champion of, among others, Monet and Toulouse-Lautrec. Cassatt, who knew Marx personally, made arrangements for Philadelphia painter Carroll Tyson to see his collection and, as she was noted for doing, engaged Marx in a lengthy debate on art.[1]

This pastel is closely related in subject, composition, and handling to the *Family Group—Reading* (no. 29). Using perhaps the same models, it focuses on the woman and child engrossed in a book, seen from the front at an even closer angle than in the painting. Although the pastel is devoid of background, an outdoor setting is suggested by the light spilling across the heads and by the high-keyed, luminous colors. The two works are similar in their horizontal alignment and monumental scale.

1. Letter dated April 28 (1904) from Mary Cassatt to Carroll Tyson, AAA, PMA. For her conversations with Marx, see the letter dated Christmas evening (1902) from Mary Cassatt to Louisine Havemeyer, in Mathews 1984, pp. 275–78.

31. *Head of Simone in a Large Plumed Hat, Looking Left*

c. 1903
Pastel on paper
17 x 18¼″ (43.2 x 46.4 cm)
Signed, lower left: Mary Cassatt
Private Collection

PROVENANCE: Galeries Durand-Ruel, Paris; Mrs. Montgomery Sears, Boston; her daughter Mrs. J. D. Cameron Bradley; M. Knoedler & Co., New York; private collection, January 1952.

CATALOGUE RAISONNÉ: Breeskin 1970, cat. 443.

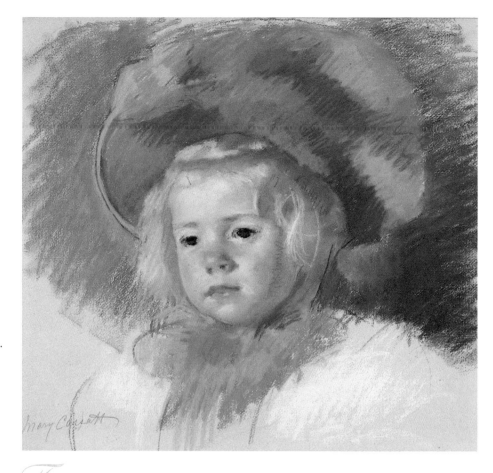

This pastel was one of several works by the artist belonging to Mrs. Montgomery Sears, an art collector who was a close friend of Cassatt.

Head of Simone is part of a group of pastels, paintings, and prints done after 1900 and based upon children of Mesnil-Théribus, the village near Cassatt's summer house, Beaufresne, of whom Simone, Sara, and the dark-haired Margot are among the most identifiable. These works explore variations on the seated child, often attired in a woman's fancy hat, one of Cassatt's signature accessories. These hats, perhaps part of the artist's inventory of costume pieces for painting, often recur in her works. This elaborate blue-plumed hat appears on Simone in at least eight known pastels.

32. ***Mother Nursing Her Baby,*** 1908
Pastel on canvas
32 x 25½" (81.3 x 64.8 cm)
Signed, lower right: Mary Cassatt
Private Collection

PROVENANCE: Christie's, New York, May 18, 1983, lot 39a.

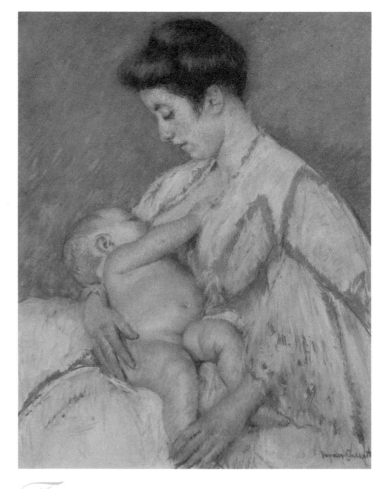

his previously unknown pastel is similar in composition (to the point of being a close variant in reverse), in the mother's features, and in the color and style of her apparel to a painting dated about 1908 entitled *Sketch of Mother Jeanne Nursing Her Baby* (Breeskin 1970, cat. 503). Both works relate to the large finished painting at the Art Institute of Chicago (Breeskin 1970, cat. 504), which was loaned to the 1927 memorial exhibition at the Pennsylvania Museum of Art by Durand-Ruel (see fig. 33).

*M*ary Cassatt is justly renowned for her prints as well as for her paintings and pastels. Over two hundred graphic works, most of which are intaglio prints from metal plates, have been identified thus far.[1] Among them are sixteen known color prints and a large group of etchings and drypoints.

Yet Cassatt was not strictly a painter-engraver. She may have regarded herself as a painter working secondarily in prints to improve her art.[2] Indeed, a rich cross-fertilization of subjects and compositional devices can be found in both areas of her work. Likewise, her prints seem to distill and highlight her essential aesthetic concerns. Her ability to compose tonal areas and to articulate form through line shines forth unobscured by her painterly values.

She, like Degas, appears not to have distributed her prints extensively. The editions of her best-known works, including the color prints, number only twenty-five. Other prints, some of which may have included as many as fifty impressions in each edition, did not circulate widely on the market.[3]

Etchings and Drypoints

Cassatt studied printmaking with Carlo Raimondi in Parma in 1872. However, her graphic activity apparently began in Paris in the late 1870s, when she became acquainted with Degas. She was one of several who were to collaborate on his proposed journal illustrated with prints, *Le Jour et la nuit* of 1879, a project that was never executed.[4] Although the dates of her prints are largely unknown, it seems that Cassatt began working first in aquatint and soft-ground etching for a densely textured, atmospheric chiaroscuro in works such as *In the Opera Box, No. 3* (no. 34), executed for *Le Jour et la nuit*.[5] She soon turned to drypoint, a technique of drawing with a metal stylus on an uncoated, highly polished metal plate, for the discipline it offered in draftsmanship. Its directness of handling was attractive because it left no room for correction.[6] Despite their affinity with her paintings and pastels, Cassatt's drypoints, executed as drawing exercises, often represent subjects that do not appear elsewhere in her work, such as her sketches of the Pantheon in Rome (Breeskin 1979, cat. 79²), the Irish poet and critic George Moore (Breeskin 1979, cat. 27), her brother Gardner (Breeskin 1979, cat. 77), and Gardner's wife (no. 37 and Breeskin 1979, cat. 112). Her major works in this medium were a series of twelve drypoints produced between the late 1880s and 1891, which she included in her first individual exhibition in Paris, in 1891. The force of the hatched tonal areas, the delicacy of modeling, and the extraordinary freedom and rhythm of line serve to render these drypoints consummate examples of her skill as a draftsman.

Color Prints

Cassatt's greatest graphic achievement was her color prints. They represent her response to what constituted an artistic epiphany when she saw the Japanese prints in the "Exposition de la gravure japonaise" at the Ecole des Beaux-Arts in 1890.[7] Their informal domestic subjects gave new direction to her long-time interest in modern genre themes. More important, their angled viewpoint, nearly flat modeling, and almost decorative, highly patterned composition gave a slightly different focus to her pursuit in the 1890s of a reductive, linear approach to form otherwise derived from early Renaissance painting. Her unique contribution in these prints, however, lay in initially trying to simulate the appearance of a colored Japanese woodcut in an intaglio metal plate. The

first result was the set of ten color prints (nos. 41–50) exhibited for the first time in her individual exhibition of 1891. They earned the admiration of Pissarro and Degas, but were neither critical nor financial successes.[8]

The ten color prints may not have been shown in Philadelphia until 1905, in the watercolor annual at the Pennsylvania Academy of the Fine Arts. The prints on view belonged to her brother Gardner; two of them are shown here (nos. 45, 47). The Philadelphia *Press* applauded their style and technique: "They master difficulties so serious, they express their precise image so simply."[9] However, they were not regarded as objects that would appeal to the public. The critic from the *Press* claimed only artists would appreciate them. The Philadelphia *Record* declared that only those who were highly educated in Oriental art would understand them to be modern Western adaptations: "They might be taken at first glance [as] a group of Japanese woodcuts. In them one finds the flat tones and simplicity of line which are essential to Oriental art."[10]

Today these works are considered among Cassatt's greatest accomplishments in any medium. They are not only rare, but also unique among themselves. Few of these prints—even in final state—are like another. She continued to explore chromatic possibilities even after establishing the composition. Using no known preparatory color sketches, Cassatt applied colored inks directly to the plate with stumps of twisted rag,[11] and sometimes varied both the color and manner of inking when the individual plates were prepared for printing. By her own admission she altered her procedure as she mastered it and opted for differing effects.[12]

Her capacity to experiment technically for variable results suggests how little interest the traditional reproductive character of prints had for her as for many of her colleagues, and stresses once again her involvement primarily with the pictorial possibilities of the medium.

1. See Breeskin 1979.
2. Ibid., p. 31.
3. Ibid.
4. Ibid., p. 19.
5. Ibid.
6. Segard 1913, p. 86.
7. Breeskin 1979, pp. 22–24. For an extended discussion of Cassatt's prints within Japanism, see the Cleveland Museum of Art, *Japonisme: Japanese Influence on French Art 1854–1910* (July 9, 1975–January 26, 1976), cat. 114–19.
8. Breeskin 1979, pp. 23–24.
9. *Press*, April 2, 1905, Scrapbook, PAFA Archives.
10. *Record*, April 2, 1905, Scrapbook, PAFA Archives.
11. The method was called "à la poupée" (with rag dolls).
12. Letter dated May 18, 1906, from Mary Cassatt to Frank Weitenkampf, New York Public Library, in Breeskin 1979, p. 37, with discussion.

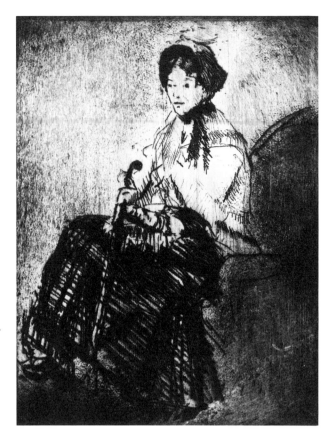

33. *The Umbrella*, 1879
Soft-ground etching
10⅞ x 7⁵⁄₁₆" (27.5 x 18.5 cm)
First of two states
Breeskin 1979, cat. 5
Philadelphia Museum of Art. Gift of R. Sturgis
Ingersoll, Frederic Ballard, Alexander
Cassatt, Staunton B. Peck, and Mrs. William
Potter Wear. 46-11-6

34. *In the Opera Box, No. 3*, c. 1880
Soft-ground etching and aquatint
8¹⁄₁₆ x 7⅜" (20.5 x 18.7 cm)
Fourth of four states
Breeskin 1979, cat. 22
Philadelphia Museum of Art. Acquired by
exchange. 61-191-14

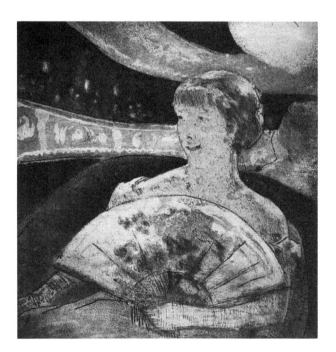

35. **Mrs. Cassatt Knitting,**
Profile View, c. 1882
Soft-ground etching and aquatint
5⅝ x 4½″ (14.3 x 11.4 cm)
Only known state
Breeskin 1979, cat. 75
Philadelphia Museum of Art. Purchased:
Joseph E. Temple Fund. 49-89-13

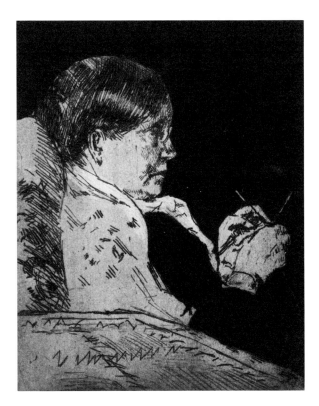

36. **Reading the Newspaper, No. 2**
c. 1882
Soft-ground etching and aquatint
5⅜ x 6½″ (13.6 x 16.5 cm)
Third of three states
Breeskin 1979, cat. 73
Philadelphia Museum of Art. Gift of R. Sturgis
Ingersoll, Frederic Ballard, Alexander
Cassatt, Staunton B. Peck, and Mrs. William
Potter Wear. 46-11-5

37. ***Gardner Held by His Mother***
c. 1887
Drypoint
8½ x 5⁷⁄₁₆″ (21.6 x 13.8 cm)
Only known state
Breeskin 1979, cat. 113
Private Collection

38. ***The Map (The Lesson)***, 1890
Drypoint
6³⁄₁₆ x 9³⁄₁₆″ (15.7 x 23.3 cm)
Second of three states
Breeskin 1979, cat. 127
Philadelphia Museum of Art. Purchased:
Joseph E. Temple Fund. 49-89-16

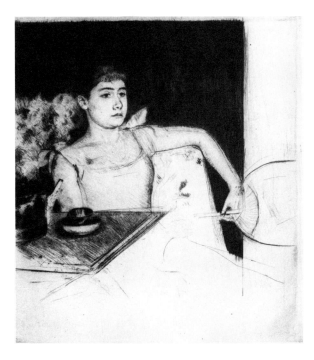

39. ***Tea,*** c. 1890
Drypoint
7³⁄₁₆ x 6³⁄₁₆″ (18.3 x 15.7 cm)
Fifth of five states
Breeskin 1979, cat. 133
Robert K. Cassatt, Brooksville, Maine

40. ***The Bonnet,*** c. 1891
Drypoint
7¼ x 5⅜″ (18.4 x 13.6 cm)
Third of three states
Breeskin 1979, cat. 137
Philadelphia Museum of Art. Purchased:
Joseph E. Temple and Edgar Viguers Seeler
funds. 48-76-98

41. ***The Bath,*** c. 1891
Color print with drypoint and soft-
ground etching
12⁵⁄₁₆ x 9¹³⁄₁₆″ (31.3 x 24.9 cm)
Eleventh of eleven states
Breeskin 1979, cat. 143
Private Collection
(Comparable impression illustrated courtesy of
Worcester Art Museum. 1926.203)

42. ***The Lamp,*** c. 1891
Color print with drypoint, soft-
ground etching, and aquatint
12⁵⁄₈ x 10″ (32.1 x 25.4 cm)
Third of three states
Breeskin 1979, cat. 144
Private Collection
(Comparable impression illustrated courtesy of
Worcester Art Museum. 1926.206)

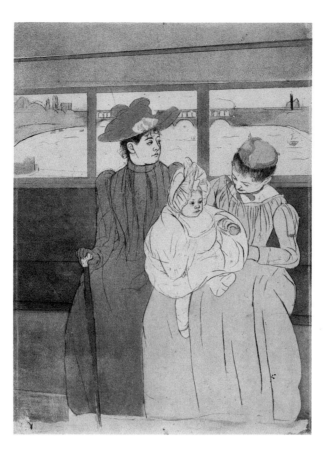

43. ***In the Omnibus,*** c. 1891
 Color print with drypoint and soft-
ground etching
14⅜ x 10½″ (36.4 x 26.7 cm)
Fourth of four states
Breeskin 1979, cat. 145
Bryn Mawr College Library. Gift of Edith
Finch, Countess Russell. From the Library of
Lucy Martin Donnelly. 1949.17

44. ***The Letter,*** c. 1891
 Color print with drypoint, soft-
ground etching, and aquatint
13⅝ x 5¹⁵⁄₁₆″ (34.6 x 15.1 cm)
Third of three states
Breeskin 1979, cat. 146
Philadelphia Museum of Art. The Louis E.
Stern Collection. 63-181-122

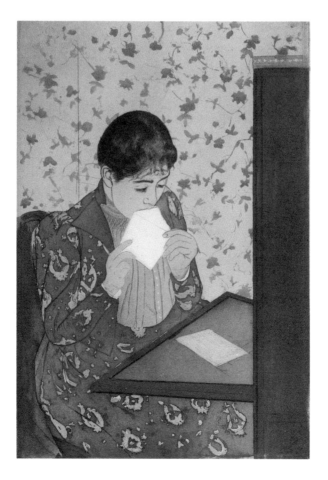

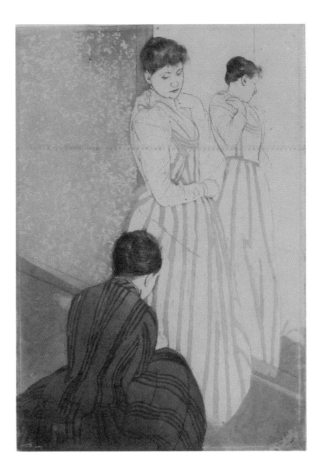

45. ***The Fitting,*** c. 1891
Color print with drypoint and soft-
ground etching
14¾ x 10⅛″ (37.5 x 25.7 cm)
Sixth of six states
Breeskin 1979, cat. 147
Mrs. Gardner Cassatt, Bryn Mawr

46. ***Woman Bathing,*** c. 1891
Color print with drypoint and soft-
ground etching
14⁷⁄₁₆ x 10⁹⁄₁₆″ (36.4 x 26.8 cm)
Fifth of five states
Breeskin 1979, cat. 148
Bryn Mawr College Library. Gift of Edith
Finch, Countess Russell. From the Library of
Lucy Martin Donnelly. 1949.13

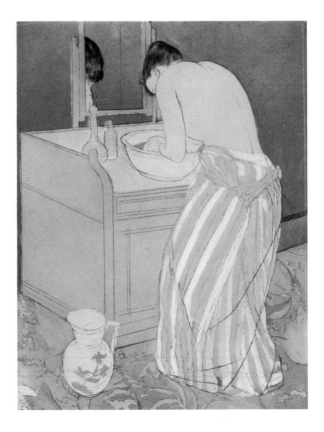

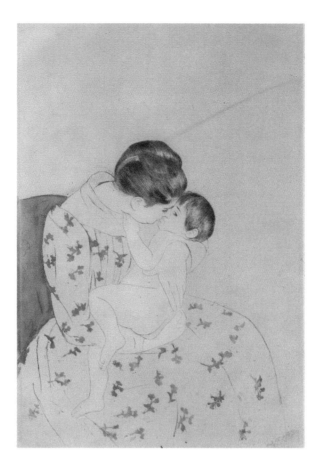

47. ***Mother's Kiss***, c. 1891
Color print with drypoint and soft-
ground etching
13⅝ x 8¹⁵⁄₁₆″ (34.6 x 22.7 cm)
Fourth of four states
Breeskin 1979, cat. 149
Mrs. Gardner Cassatt, Bryn Mawr

48. ***Maternal Caress***, c. 1891
Color print with drypoint and soft-
ground etching
14½ x 10⁹⁄₁₆″ (36.8 x 26.8 cm)
Third of three states
Breeskin 1979, cat. 150
Bryn Mawr College Library. Gift of Edith
Finch, Countess Russell. From the Library of
Lucy Martin Donnelly. 1949.11

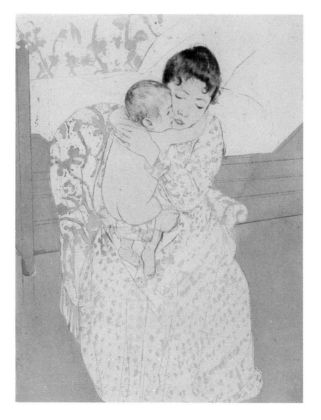

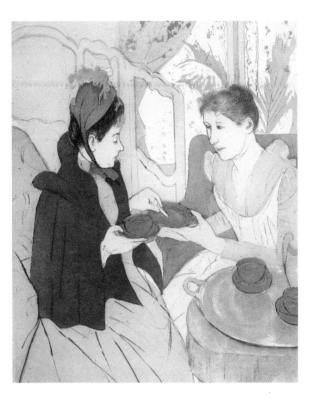

49. ***Afternoon Tea Party***, c. 1891
Color print with drypoint, soft-
ground etching, and aquatint
13½ x 10⅜″ (34.3 x 26.4 cm)
Fourth of four states
Breeskin 1979, cat. 151
Private Collection

50. ***The Coiffure***, c. 1891
Color print with drypoint and soft-
ground etching
14⅜ x 10½″ (36.5 x 26.7 cm)
Fourth of four states
Breeskin 1979, cat. 152
Bryn Mawr College Library. Gift of Edith
Finch, Countess Russell. From the Library of
Lucy Martin Donnelly. 1949.16

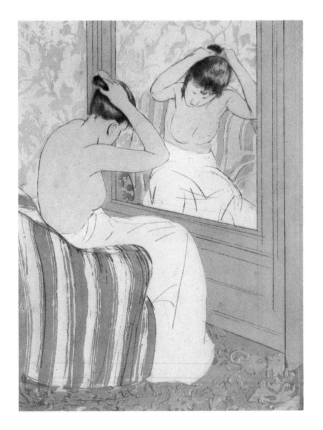

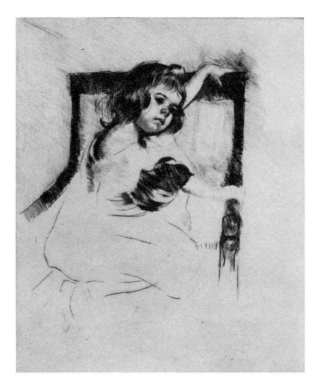

51. ***Kneeling in an Armchair***, c. 1903
Drypoint
11⅞ x 9⁹⁄₁₆″ (30.2 x 24.3 cm)
Only known state
Breeskin 1979, cat. 186
Private Collection
(Comparable impression illustrated courtesy of
the Cleveland Museum of Art. Bequest of
Charles T. Brooks. CMA41.76)

This exhibition record represents the first systematic compilation of Cassatt's work shown in Philadelphia. Where applicable or available, catalogue numbers, titles, and lenders are listed. Indented below each entry, where possible, are the proposed current identifications of the works, whose justification is presented in the notes. Sources for these attributions are primarily of the period; most are either documentary or from critical reviews of the exhibitions. Where more than one entry by the same title appears in a single exhibition, attribution of specific catalogue numbers to known works in the exhibition is purely arbitrary.

1873
Bailey & Co., June–July[1]

Balcony
 On the Balcony (no. 1)
Girl with White Veil
 Spanish Dancer Wearing a Lace Mantilla, 1873, National Museum of American Art, Washington, D.C. (Breeskin 1970, cat. 21)

1876
The Pennsylvania Academy of the Fine Arts, "Forty-seventh Annual Exhibition," April 24–end of May

121. *Portrait of a Gentleman*, owned by the artist
 Portrait of the Artist's Father, Robert S. Cassatt (fig. 27)[2]
136. *Portrait of a Child*, owned by the artist[3]
151. *A Musical Party*, owned by the artist
 Possibly *Musical Party* (fig. 17)[4]

1877
The Pennsylvania Academy of the Fine Arts, "Exhibition of Choice Paintings Loaned from Private Galleries of Philadelphia and Hans Makart's Great Picture of 'Venice Paying Homage to Caterina Cornaro,'" January

343. *The Bacchante*, collection of J. W. Lockwood
 Possibly *Bacchante* (fig. 16)

1877–78
Earle's Gallery, winter–early spring?[5]

Portrait of a Lady

1878
The Pennsylvania Academy of the Fine Arts, "Forty-ninth Annual Exhibition," April 22–June 2

175. *Portrait of a Lady*, owned by H. Teubner, for sale[6]
192. *Spanish Matador*, owned by H. Teubner, for sale
 Torero and Young Girl (fig. 1c)[7]

1879
The Pennsylvania Academy of the Fine Arts, "Fiftieth Annual Exhibition," April 28–end of May (part of the selection from the second annual of the Society of American Artists in New York)

158. *Portrait of a Lady Reading Le Figaro* (fig. 28)[8]
190. *Mandolin Player*, price: $250
 Possibly *Mandolin Player* (fig. 1a)

1885
The Pennsylvania Academy of the Fine Arts, "Fifty-sixth Annual Exhibition," October 29–December 10

62. *Family Group (Portraits)*, lent by Alexander J. Cassatt
 Family Group: Mrs. Cassatt Reading to Her Grandchildren (no. 7)[9]
398. *Portrait of a Child in Pastel*, lent by Alexander J. Cassatt
 Elsie with a Dog, 1880, private collection (Breeskin 1970, cat. 81)[10]

1898
The Pennsylvania Academy of the Fine Arts, "Sixty-seventh Annual Exhibition," January 10–February 22

61. *Woman Seated*, lent by Messrs. Durand-Ruel and Sons[11]
62. *The Toilet*, lent by Messrs. Durand-Ruel and Sons (repr.)
 The Bath (fig. 29)

1899
The Pennsylvania Academy of the Fine Arts, "Sixty-eighth Annual Exhibition," January 16–February 25

708. *Mother and Child*

1900
The Pennsylvania Academy of the Fine Arts, "Sixty-ninth Annual Exhibition," January 15–February 24

217. *Young Woman Gathering Fruit*, lent by Messrs. Durand-Ruel
 Possibly *Young Woman Gathering Fruit*, 1891, Museum of Art, Carnegie Institute, Pittsburgh (Breeskin 1970, cat. 197)[12]

1901
The Pennsylvania Academy of the Fine Arts, "Seventieth Annual Exhibition," January 14–February 23

124. *Baby Arises*

1902
The Pennsylvania Academy of the Fine Arts, "Seventy-first Annual Exhibition," January 20–March 1

529. *Woman Reading in a Garden*
 Possibly *Lydia Reading in a Garden*, 1880, The Art Institute of Chicago (Breeskin 1970, cat. 94)

1903
The Pennsylvania Academy of the Fine Arts,

"Seventy-second Annual Exhibition," January 19–February 28

37. *La Femme au chien*
 Susan on a Balcony, Holding a Dog, 1883, Corcoran Gallery of Art, Washington, D.C. (Breeskin 1970, cat. 125)[13]

1904
The Pennsylvania Academy of the Fine Arts, "Seventy-third Annual Exhibition," January 25–March 5

6. *The Caress* (repr.), awarded the Lippincott Prize
 The Caress, 1902, National Museum of American Art, Washington, D.C. (Breeskin 1970, cat. 383)

1905
The Pennsylvania Academy of the Fine Arts, "One-hundredth Anniversary," January 23–March 4

403. *Portrait of M.D.S.*, lent by Mrs. Clement B. Newbold
 Portrait of Mrs. Clement B. Newbold (figs. 20 and 21; in the latter, lower left between the pillars)
407. *The Toilet: Mother and Two Children*, lent by Alfred Atmore Pope (repr.) (see fig. 21, lower right between the pillars)
 Sara Handing a Toy to the Baby, 1901, Hill-Stead Museum, Farmington, Conn. (Breeskin 1970, cat. 379)

The Art Club of Philadelphia, "Fourteenth Annual Exhibition of Water Colors and Pastels," March 20–April 16

179. *The Caress* (repr.)
 A Kiss for Baby Anne, No. 3, 1897, location unknown (Breeskin 1970, cat. 268)
185. *In the Garden*

The Pennsylvania Academy of the Fine Arts, "Second Annual Water Color Exhibition," April 2–25

7. *Mother and Child*, lent by Clement B. Newbold
 Young Thomas and His Mother (fig. 22)[14]
8. Colored etching, lent by J. Gardner Cassatt
9. Group of colored etchings, lent by J. Gardner Cassatt
 Possibly including *The Fitting* (no. 45) and *Mother's Kiss* (no. 47)
10. Pastel portrait, lent by J. Gardner Cassatt
 Possibly *The Sailor Boy: Gardner Cassatt* (no. 25) or *The Pink Sash* (no. 28)

The Art Club of Philadelphia, "Seventeenth Annual Exhibition of Oil Paintings and Sculpture," November 20–December 17

176. *Mother and Child* (repr.)
 Mother and Child, 1901, The Metropolitan Museum of Art, New York (Breeskin 1970, cat. 342)
195. *In the Park*

1906
The Pennsylvania Academy of the Fine Arts, "One-hundred-first Annual Exhibition," January 22–March 8

19. *In the Woods*
 In the Meadow, No. 2, 1880, private collection (Breeskin 1970, cat. 93)[15]
336. *Mother and Child*
 Reine Lefèbvre Holding a Nude Baby, 1902, Worcester Art Museum (Breeskin 1970, cat. 406)

The Art Club of Philadelphia, "Fifteenth Annual Exhibition of Water Colors and Pastels," March 19–April 15

157. *Enfants jouant avec leur mère*, pastel (repr.)
 Children Playing with Their Mother, 1901, private collection (Breeskin 1970, cat. 386)
158. *Girl with an Orange*, pastel
 Girl with an Orange (Margaret Milligan Sloane) (fig. 30)

The Art Club of Philadelphia, "Eighteenth Annual Exhibition of Oil Paintings and Sculpture," November 19–December 16

156. *Après Le Bain* (repr.)
 The Sun Bath, 1901, private collection (Breeskin 1970, cat. 336)

1907
The Pennsylvania Academy of the Fine Arts, "One-hundred-second Annual Exhibition," January 21–February 24

124. *Dans La Loge*
 At the Opera (fig. 4a)[16]
127. *Femme à l'eventail*
 Possibly *Clarissa, Turned Right, with Her Hand to Her Ear*, 1895, private collection (Breeskin 1970, cat. 250)[17]

The Art Club of Philadelphia, "Sixteenth Annual Exhibition of Water Colors and Pastels," March 4–31

135. *Femmes et enfant*, pastel (repr.)
 Three Women Admiring a Child, 1897, The Detroit Institute of Arts (Breeskin 1970, cat. 272)

The Pennsylvania Academy of the Fine Arts, the Philadelphia Water Color Club, "Fourth Annual Philadelphia Water Color Exhibition," April 1–27

1. *A Cup of Tea*
4. *Mother and Child*
221. *Baby's Toilet*

1908
The Art Club of Philadelphia, "Nineteenth Annual Exhibition of Oil Paintings and Sculpture," November 16–December 20

48. *Fillette au grand chapeau* (repr.)
Mother and Daughter, Both Wearing Large Hats, 1901, private collection (Breeskin 1970, cat. 345)

1909
The Pennsylvania Academy of the Fine Arts, the Philadelphia Water Color Club, "Seventh Annual Philadelphia Water Color Exhibition," November 8–December 19

114. *Fête d'enfant*, lent by Mrs. George E. Hume
217. *Children Playing with Their Mother*
Possibly *Children Playing with Their Mother*, 1901, private collection (Breeskin 1970, cat. 386)

1910
The Pennsylvania Academy of the Fine Arts, "One-hundred-fifth Annual Exhibition," January 23–March 20

682. *Children Playing with a Cat*
Possibly *Children Playing with a Cat*, 1908, private collection (Breeskin 1970, cat. 505)

The Pennsylvania Academy of the Fine Arts, the Philadelphia Water Color Club, "Eighth Annual Philadelphia Water Color Exhibition," November 14–December 18

339. *Girl with an Orange*
Girl with an Orange (Margaret Milligan Sloane) (fig. 30)

1911
The Pennsylvania Academy of the Fine Arts, "One-hundred-sixth Annual Exhibition," February 5–March 26

328. *Woman Reading in a Garden*
Lydia Reading in a Garden (see fig. 26), 1880, The Art Institute of Chicago (Breeskin 1970, cat. 94)
471. *Woman and Child*, lent by John F. Braun (repr.)
Mother and Child (fig. 26, center, right wall)

1912
The Pennsylvania Academy of the Fine Arts, "One-hundred-seventh Annual Exhibition," February 4–March 24

472. *Mother and Child*, lent by Mrs. J. Gardner Cassatt
Children Playing with a Dog, 1908, private collection (Breeskin 1970, cat. 502)[18]

1915
The Pennsylvania Academy of the Fine Arts, "One-hundred-tenth Annual Exhibition," February 7–March 28

354. *After the Bath*
Possibly *After the Bath*, 1901, The Cleveland Museum of Art (Breeskin 1970, cat. 384)[19]
419. *Mother and Child* (repr.)
Reine Lefèbvre and Margot before a Window, 1902, private collection (Breeskin 1970, cat. 408)

The Pennsylvania Academy of the Fine Arts, the Philadelphia Water Color Club, the Pennsylvania Society of Miniature Painters, "Thirteenth Annual Water Color Exhibition and Fourteenth Annual Miniature Exhibition," November 7–December 12

691. *Head of a Child*, watercolor (repr.)
692. *Mother and Child*, watercolor
829. *Mother and Child*, watercolor
830. *Mother and Child*, watercolor
848. *Head of a Child*, watercolor (repr.)
849. *Mother and Child*, watercolor
(Either 691 or 848 conforms to the *Head of a Child* reproduced in the 1915 catalogue.)
Study for Françoise Wearing a Big White Hat, No. 2, c. 1908, location unknown (Breeskin 1970, cat. 662)

1916
The Pennsylvania Academy of the Fine Arts, "One-hundred-eleventh Annual Exhibition," February 6–March 26

134. *A Woman Sitting in a Garden* (repr.)
Lydia Crocheting in the Garden at Marly (no. 6)

1917
The Pennsylvania Academy of the Fine Arts, "One-hundred-twelfth Annual Exhibition," February 4–March 25

99. *Woman at Her Toilet* (repr.)
Antoinette at Her Dressing Table, 1909, private collection (Breeskin 1970, cat. 543)

The Pennsylvania Academy of the Fine Arts, the Philadelphia Water Color Club, the Pennsylvania Society of Miniature Painters, "Fifteenth Annual Water Color Show," November 4–December 9

575. *Child's Head, No. 1*, watercolor
581. *Woman and Child*, watercolor (repr.)
Baby John and His Mother: Two Heads, c. 1910, location unknown (Breeskin 1970, cat. 674)
587. *Child's Head, No. 2*, watercolor

1919
The Pennsylvania Academy of the Fine Arts, the Philadelphia Water Color Club, the Pennsylvania Society of Miniature Painters, "Seventeenth Annual Water Color Exhibition and the Eighteenth Annual Exhibition of Miniatures," November 9–December 14

439. *Mother and Child*, pastel
440. *Two Sisters*, pastel (repr.)
The Conversation, 1896 (Breeskin 1970, cat. 260); sold, Christie's, New York, *Important American Paintings, Drawings and Sculpture of the 15th and 20th Centuries*, June 1, 1984, lot 185
441. *Mother and Child*, pastel

1920
The Pennsylvania Academy of the Fine Arts, "Exhibition of Paintings and Drawings by Representative Modern Artists," April 17–May 9

7. *Filet de coiffant*, lent anonymously
8. *Young Mother and Her Children*, lent by Miss Anne Thomson
 Possibly *Children Playing with Their Mother*, 1901, pastel, private collection (Breeskin 1970, cat. 386)
9. *Young Mother*, lent anonymously
10. *In the Theater*, lent by Mrs. Edgar Scott
 In the Box (no. 4)
11. *Portrait of a Young Girl*, lent by Mrs. W. Plunkett Stewart
 Possibly *Katharine Kelso Cassatt* (no. 19)
12. *Portrait of a Child*, lent by Mrs. W. Plunkett Stewart
 Possibly *Elsie in a Blue Chair* (no. 8)
13. *Portrait of Her Mother*, lent by Mrs. W. Plunkett Stewart
 Possibly *Reading Le Figaro* (fig. 28)
14. *Child with a Dog*, lent by Mrs. W. Plunkett Stewart
 Elsie with a Dog, 1880, pastel, private collection (Breeskin 1970, cat. 81)
15. *Portrait*, lent by Mrs. Clement B. Newbold
 Portrait of Mrs. Clement B. Newbold (fig. 20)
16. *Portrait of a Child*, lent by Mrs. J. Gardner Cassatt
 The Pink Sash (no. 28)[20]
17. *Woman and Two Children*, lent by Mrs. J. Gardner Cassatt
 Possibly *Children Playing with a Dog*, 1908, private collection (Breeskin 1970, cat. 502)
19–20, 22, 24–25, 32–33, 36, 38, 40. Etchings in color, lent by Mrs. J. Gardner Cassatt
 Possibly the set of ten color prints of 1891, including *The Fitting* (no. 45) and *Mother's Kiss* (no. 47)
21, 23, 26–31, 34–35, 37, 39. Etchings, lent by Mrs. J. Gardner Cassatt
41. *Portrait of a Child*, lent by Robert K. Cassatt
 Possibly *Master Robert K. Cassatt* (no. 13)
42. *Portrait of a Child*, lent by Robert K. Cassatt
 Possibly *Alexander J. Cassatt*, 1910, private collection (Breeskin 1970, cat. 568)
43. *Portrait: Alexander J. Cassatt*, lent by Robert K. Cassatt
 Either *Alexander J. Cassatt* (no. 15), *Alexander J. Cassatt* (fig. 15a), or *Alexander J. Cassatt* (no. 17)
44. *Portrait of Two Children*, lent by Mrs. J. Gardner Cassatt
 Gardner and Ellen Mary, 1898–99, pastel, The Metropolitan Museum of Art, New York (Breeskin 1970, cat. 302)
45. *Portrait of Her Mother*, lent by Mrs. J. Gardner Cassatt
 Mrs. Robert S. Cassatt, c. 1889, The Fine Arts Museums of San Francisco (Breeskin 1970, cat. 162)

46. *Family Group*, lent by Robert K. Cassatt
 Family Group: Mrs. Cassatt Reading to Her Grandchildren (no. 7)
47. *Child's Head*, lent by Mrs. J. Gardner Cassatt
 Possibly *Ellen Mary, Aged Four*, c. 1898–99, pastel, private collection (Breeskin 1970, cat. 286) or *The White Hat*, c. 1896, pastel, private collection (Breeskin 1970, cat. 257)

1924
McClees Galleries[21]

1925
The Print Club[22]

1927
Pennsylvania Museum of Art (Memorial Hall), "Mary Cassatt Memorial Exhibition," April 30–May 30

Paintings and pastels:
1. *After the Bath*, 1902 (repr.)
 Adoration, 1897, pastel, private collection (Breeskin 1970, cat. 273)
2. *The Bath*
 Possibly *The Sun Bath* (fig. 33, fifth from left), 1901, private collection (Breeskin 1970, cat. 336)
3. *The Boating Party*, 1893
 Possibly *The Boating Party*, 1893, National Gallery of Art, Washington, D.C. (Breeskin 1970, cat. 230)
4. *Children Playing with a Cat*, 1908
 Children Playing with a Cat, 1908, private collection (Breeskin 1970, cat. 505)
5. *The Cup of Tea*
 The Cup of Tea (fig. 33, left of central doorway), 1879, The Metropolitan Museum of Art, New York (Breeskin 1970, cat. 65)
6. *Family Group*
 Family Group: Mrs. Cassatt Reading to Her Grandchildren (no. 7 and fig. 33, fourth from right)
7. *Girl Arranging Her Hair*, 1886
 Girl Arranging Her Hair (fig. 33, seventh from right), 1886, National Gallery of Art, Washington, D.C. (Breeskin 1970, cat. 146)
8. *Mother and Children*
9. *In the Field*, 1880
 In the Meadow, No. 2 (fig. 32, second from right), 1880, private collection (Breeskin 1970, cat. 93)
10. *In the Garden*, 1893
 In the Garden (fig. 32, fifth from right), 1893, pastel, The Baltimore Museum of Art, Cone Collection (Breeskin 1970, cat. 221)
11. *Lady at the Tea Table*
 Lady at the Tea Table (figs. 11 and 32, first on right)
12. *Little Girl with Dog*, 1908
 Françoise Holding a Little Dog, Looking Far to the Right (fig. 33, third from right), 1908, pastel, private collection (Breeskin 1970, cat. 530)

13. *Little Girl with a Large Hat*, 1900
14. *Maternal Caress*, 1896 (repr.)
 Maternal Caress (no. 26)
15. *Mother and Child*, 1898–99
 The Quiet Time (fig. 33, second from left),
 1888, location unknown (Breeskin 1970,
 cat. 151)
16. *Mother and Child*, 1897
 Baby on Mother's Arm (no. 23)
17. *Mother and Child*
 Mother Nursing Her Baby (fig. 33, right of
 doorway), c. 1908, The Metropolitan
 Museum of Art, New York (Breeskin 1970,
 cat. 504)
18. *Mother and Child*
 Mother and Child (figs. 24 and 33, sixth
 from right)
19. *Mother and Child*
20. *Mother and Child*
21. *Mother and Child*
22. *On the Balcony*, 1872
 On the Balcony (no. 1)[23]
23. *Portrait of the Artist*
 Self-Portrait of the Artist, c. 1878, gouache,
 The Metropolitan Museum of Art, New York
 (Breeskin 1970, cat. 55)[24]
24. *Portrait of the Artist's Father, Robert S.
 Cassatt*
 *Portrait of the Artist's Father, Robert S.
 Cassatt* (fig. 27)
25. *Portrait of the Artist's Mother, Mrs. Robert S.
 Cassatt* (repr.)
 Mrs. Robert S. Cassatt, c. 1889, The Fine
 Arts Museums of San Francisco (Breeskin
 1970, cat. 162)
26. *Portrait of the Artist's Mother, Mrs. Robert S.
 Cassatt*
 Possibly *Reading Le Figaro* (fig. 28) or *Mrs.
 Robert S. Cassatt in a Lacey Blouse*, 1893,
 private collection (Breeskin 1970, cat. 27)
27. *Portrait of the Artist's Sister, Miss Lydia
 Cassatt, in a Garden*, 1881
 Lydia Crocheting in the Garden at Marly
 (no. 6)[25]
28. *Portrait of Alexander J. Cassatt with His
 Son Robert Kelso Cassatt*, 1884
 Alexander Cassatt and His Son Robert
 (no. 16)
29. *Portrait of Miss Ellen Mary Cassatt*
 The White Hat (fig. 33, first on right),
 c. 1896, pastel, private collection
 (Breeskin 1970, cat. 257)
30. *Portrait of Miss Ellen Mary Cassatt*
 The White Coat (fig. 33, fifth from right),
 c. 1896, private collection (Breeskin 1970,
 cat. 258)
31. *Portrait of Miss Ellen Mary Cassatt* (repr.)
 The Pink Sash (no. 28)
32. *Portrait of Miss Elsie Cassatt*
 Possibly *Elsie with a Dog*, 1880, pastel,
 private collection (Breeskin 1970, cat. 81) or
 Elsie in a Blue Chair (no. 8)
33. *Portrait of Master Gardner Cassatt*
 The Sailor Boy: Gardner Cassatt (no. 25 and
 fig. 33, first on left)
34. *Portrait of Miss Katherine Kelso Cassatt*
 Katharine Kelso Cassatt (no. 19)[26]

35. *Portrait of Master Robert Kelso Cassatt*
 Master Robert K. Cassatt (no. 13)
36. *Portrait of Miss Mary Ellison* (repr.)
 Miss Mary Ellison Embroidering (no. 2)
37. *Portrait of Mrs. Clement Newbold*
 Portrait of Mrs. Clement B. Newbold (fig.
 20)[27]
38. *The Toilet*, 1898
39. *Woman at Her Toilet*, 1910
 Possibly *Antoinette at Her Dressing Table*,
 1909, private collection (Breeskin 1970, cat.
 543)
40. *Woman and Child Driving* (repr.)
 Woman and Child Driving (no. 12)
 In the Box, lent by Mrs. Edgar Scott (not in
 the 1927 catalogue)[28]

Watercolors and Drawings:
1. *Child*
2. *Head of a Child*
3. *Head of a Child*
4. *Head of a Child*
5. *Head of a Child*
6. *Head of a Child*
7. *The Reader*
8. *Reading and Sewing*
9. *The Reading at Evening*
10. *The Reading: Study for "Family Group"*
11. *An Old Lady*
12. *By the Fireside*
13. *Woman and Child*
14. *Woman and Child*
15. *Woman Resting in an Armchair*

Prints:
Over one hundred (not itemized in the 1927
catalogue) were in the exhibition[29]

Notes

1. See *On the Balcony* (no. 1).

2. A critic described it as "a head of an elderly gentleman, painted with much vigor and very fine in color"; *Daily Evening Telegraph*, April 29, 1876, p. 5.

3. In the words of a critic (ibid.), "the flat red background to the head of the boy is not altogether pleasing." This portrait thus is not likely to be, as presently thought, that in Breeskin 1970, cat. 12, which has an ocher-gold background.

4. The number of figures and the color of hair described in the following passage differ from those of the *Musical Party* in the Musée du Petit Palais, Paris; the work in Paris comes closest of those known, and is thus identified as the same painting. "A 'Musical Party' . . . shows the heads of three young women, the size of life. One of them has a queer profile face, with the light falling full upon her head and throat and neck, upon which scarcely a degree of shadow defines the forms even about her small, half-averted eyes. A pink ear lies like a shell against her pale cheek . . . while coarse yellow hair is coiled in masses back from her head into the shadows"; see "The Philadelphia Academy Exhibition," *The Art Journal*, vol. 2 (1876), p. 223.

5. A critic from the *Daily Evening Telegraph* (April 25, 1878, p. 4) claimed to have reviewed this painting while it was on exhibition at Earle's Gallery some months earlier.

6. A caricature (fig. 18), which illustrates a bust-length, frontal figure of a woman, conflicts with a critic's description (ibid.): "three-quarter-length seated portrait of a lady, no. 180." Either the critic had mistaken a painting by F. F. de Crano by the same title, which corresponds to the catalogue number cited, or the number is erroneous.

7. "It is a very life-like study of a Spanish bullfighter coquetting with a *tabernera*, who is offering him liquid refreshment"; ibid.

8. Nancy Mathews (1980, p. 51) discovered that *Portrait of a Lady* was described by the critic S. N. Carter when it was exhibited earlier that year in New York: "a capitally drawn figure of an agreeable-looking, middle-aged, lady with a clear skin over her well-formed features, and with soft, brown, wavy hair. . . . [W]e think nobody seeing this lady reading a newspaper through her shell 'nippers,' and seated so composedly in her white morning dress, could have failed to like this well-drawn, well-lighted, well-anatomised, and well-composed painting"; see "Exhibition of the Society of American Artists," *The Art Journal*, vol. 5 (1879), p. 157. The details provided almost certainly confirm that it was *Reading Le Figaro* (Breeskin 1970, cat. 128), which traditionally is dated c. 1883. The Academy Loan Register described the portrait as "Portrait of a Lady—(reading Newspaper)"; see PAFA Archives. Alexander Cassatt was its owner, and he did not want it in the Philadelphia exhibition: "It was sent there by mistake, as it was not my intention to exhibit it"; see the letter dated May 12, 1879, from Alexander Cassatt to Mr. Corliss, actuary, in PAFA Archives.

9. A critic said the work depicted "a charming old lady entertaining a party of youngsters with a story book"; *Daily Evening Telegraph*, November 6, 1885, p. 3.

10. A critic (ibid.) described the work as "a pastel portrait of a little girl with a Scotch terrier in her lap."

11. A third painting, entitled *In the Garden* (no. 1378 in the Loan Register, PAFA Archives), also in the hands of Durand-Ruel, apparently was not included.

12. The Carnegie Institute painting is proposed as this entry on circumstantial and documentary grounds. See the letter dated November 11, 1899, from Durand-Ruel to the Academy, PAFA Archives, which expresses their agreement to lend the painting currently in Pittsburgh, presumably to the 1899–1900 Carnegie Institute exhibition, with which the suggested work is associated.

13. A critic described this work as representing a "girl in white with a pink sunbonnet, seated in the sun, one of those problems in light of which Miss Cassatt is so fond and which she manages so well"; *Public Ledger*, January 18, 1903, p. 5.

14. Illustrated in a review of the exhibition, *The North American*, April 2, 1905, Scrapbook, PAFA Archives.

15. See the installation view including cat. 19 for the 1906 exhibition, PAFA Archives.

16. Illustrated in "The Galleries. The Pennsylvania Academy Exhibition," *The Scrip*, March 1907, opp. p. 193.

17. This proposal is highly speculative, but is based on the fact that the exhibited work was considered late, by contrast with *Dans La Loge*: "Femme à l'Eventail is in Miss Cassatt's present manner, light color, high key, etc."; *Inquirer*, January 20, 1907, Scrapbook, PAFA Archives.

18. See the installation view including cat. 472 for this exhibition, PAFA Archives.

19. This work is identified in a letter dated November 18, 1914, from the secretary of the Academy to Mary Cassatt, as the one in the twenty-seventh annual of the Art Institute of Chicago, which is currently identified as the Cleveland pastel. However, both the Academy catalogue and the entry card for the work describe the entry as an oil painting. (Entry card and letter are in the Registrar's Office, The Pennsylvania Academy of the Fine Arts.)

20. Illustrated in the installation view of the exhibition published in Albert Sterner, "Modern Art Has Its Day at the Pennsylvania Academy," *The Philadelphia Press Sunday Magazine*, n.d., Scrapbook, PAFA Archives.

21. "Late in 1924 an exhibit of Miss Cassatt's work was held in the McClees Galleries"; Cassatt obituary, *Public Ledger*, June 16, 1926, p. 3.

22. "[The McClees Galleries show] was followed by another unusual exhibition early in 1925 at the Print Club"; ibid.

23. Dorothy Grafly, "In Retrospect—Mary Cassatt," *American Magazine of Art*, vol. 18, no. 6 (June 1927), opp. p. 308.

24. Forbes Watson, "Philadelphia Pays Tribute to Mary Cassatt," *The Arts*, vol. 2, no. 6 (June 1927), p. 290.

25. Ibid., p. 296.

26. Ibid., p. 291.

27. Ibid., p. 293.

28. Ibid., p. 289.

29. "The prints, over a hundred representing the entire work of the artist in dry-point and aquatint line the corridor leading [to the east gallery]"; "The Cassatt Exhibition," *The Pennsylvania Museum Bulletin*, vol. 22, no. 113 (May 1927), p. 374.

Abbreviations

AAA, PMA
Archives of American Art, Philadelphia
Museum of Art.

Breeskin 1970
Breeskin, Adelyn Dohme. *Mary Cassatt: A
Catalogue Raisonné of the Oils, Pastels, Water-
colors, and Drawings*. Washington, D.C.,
1970.

Breeskin 1979
———. *Mary Cassatt: A Catalogue Raisonné
of the Graphic Work*. Washington, D.C., 1979.

DAB
Dictionary of American Biography.

Hale 1975
Hale, Nancy. *Mary Cassatt*. Garden City,
N.Y., 1975.

Mathews 1980
Mathews, Nancy Mowll. *Mary Cassatt and the
"Modern Madonna" of the Nineteenth Century*.
Ann Arbor, 1980. Microfilm.

Mathews 1984
———, ed. *Cassatt and Her Circle: Selected
Letters*. New York, 1984.

PAFA Archives
Archives, The Pennsylvania Academy of the
Fine Arts, Philadelphia.

PMA Archives
Archives, Philadelphia Museum of Art.

Segard 1913
Segard, Achille. *Mary Cassatt: Un Peintre des
enfants et des mères*. Paris, 1913.

Sweet 1966
Sweet, Frederick A. *Miss Mary Cassatt:
Impressionist from Pennsylvania*. Norman,
Okla., 1966.

Wildenstein 1974
Wildenstein, Daniel. *Claude Monet: Bio-
graphie et catalogue raisonné*. 3 vols.
Lausanne, 1974–79.

Selected Bibliography after 1970*

Boyle, Richard J. *American Impressionism*.
Boston, 1974.

Bullard, E. John. *Mary Cassatt: Oils and
Pastels*. New York, 1972.

Getlein, Frank. *Mary Cassatt: Paintings and
Prints*. New York, 1980.

Greer, Germaine. *The Obstacle Race: The
Fortunes of Women Painters and Their Work*.
New York, 1979.

Harris, Ann Sutherland, and Nochlin, Linda.
Women Artists: 1550–1950. New York, 1976.
Catalogue of an exhibition held at Los Angeles
County Museum of Art, December 21,
1976–March 13, 1977; University Art
Museum, The University of Texas at Austin,
April 12–June 12, 1977; Museum of Art,
Carnegie Institute, Pittsburgh, July
14–September 4, 1977; The Brooklyn
Museum, New York, October 8–November 27,
1977.

Love, Richard H. *Cassatt: The Independent*.
Chicago, 1980.

Mathews, Nancy Mowll. "Mary Cassatt and
Edgar Degas." In San Jose Museum of Art,
Mary Cassatt and Edgar Degas (October
15–December 15, 1981).

Munro, Eleanor. *Originals: American Women
Artists*. New York, 1979.

Nochlin, Linda. "Women Artists in the 20th
Century: Issues, Problems, Controversies."
Studio International, vol. 193, no. 987 (1977),
pp. 165–74, esp. pp. 170–73.

Novak, Barbara. *American Painting of the
Nineteenth Century: Realism, Idealism, and the
American Experience*. New York, 1969.

Philadelphia Museum of Art. *Philadelphia:
Three Centuries of American Art*. April
11–October 10, 1976.

Pollock, Griselda. *Mary Cassatt*. New York,
1980.

Shapiro, Barbara Stern. *Mary Cassatt at
Home*. Boston, 1978. Catalogue of an
exhibition held at Boston, Museum of Fine
Arts, August 5–September 24, 1978.

Washington, D.C., Smithsonian Institution,
National Collection of Fine Arts. *Mary
Cassatt: Pastels and Color Prints*. February
24–April 30, 1978.

Yeh, Susan Fillin. "Mary Cassatt's Images of
Women." *Art Journal*, vol. 35, no. 4 (Summer
1976), pp. 359–63.

*For an earlier bibliography, see Breeskin
1970.

Photographic Credits

Addendum

Reading Le Figaro, c. 1878
Oil on canvas
39¾ x 32″ (101 x 81.3 cm)
Signed, lower right: Mary Cassatt
Private Asset Management Group, Inc.,
New York

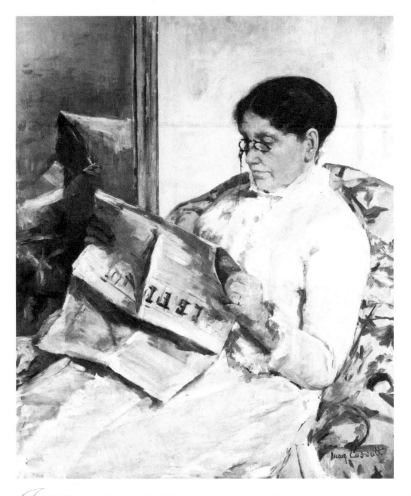

PROVENANCE: Alexander J. Cassatt,
Haverford, between November 1878
and March 1879; Elsie Cassatt
(Mrs. W. Plunkett) Stewart, Haverford, after
1920; Katherine Stewart (Mrs. Eric) de
Spoelberch, Haverford, after 1931; New York,
Christie's, May 17, 1983, lot 28, purchased by
current owner.

CATALOGUE RAISONNÉ: Breeskin 1970, cat. 128.

EXHIBITIONS: 1878, Paris, summer; 1879, New
York, Kurtz Gallery, Society of American
Artists, "Second Exhibition, 1879, at Kurtz
Gallery," cat. 99; Philadelphia, The
Pennsylvania Academy of the Fine Arts,
"Fiftieth Annual Exhibition," cat. 158; 1886,
New York, National Academy of Design,
"Special Exhibition. Works in Oil and Pastel
by the Impressionists of Paris," cat. 310;
possibly 1920, Philadelphia, The Pennsylvania
Academy of the Fine Arts, "Exhibition of
Paintings and Drawings by Representative
Modern Artists," cat. 13; possibly 1927,
Philadelphia, Pennsylvania Museum of Art,
"Mary Cassatt Memorial Exhibition," cat. 26.

*I*n Philadelphia until 1983, this portrait of the artist's mother is the most
celebrated painting by Cassatt originally with the family. Its masterly
composition has long been identified with Cassatt's maturity in the 1880s.[1]
However, Nancy Mathews has discovered a description of a woman's portrait by
Cassatt, shown in the New York Society of American Artists' exhibition of
March 1879, that almost surely refers to *Reading Le Figaro*, probably dating it
to 1878.[2] Various references in the family correspondence of 1878 to a new
portrait of Katherine Cassatt may describe this one. The painting was shipped
to Philadelphia in fall 1878 after exhibition in Paris at an unknown location,
perhaps with a dealer such as Rosenquest on the boulevard Haussmann, who
had handled Cassatt's work in 1874.[3] Katherine Cassatt observed of the portrait
to Alexander: "I think you will like the picture as some people think it is the
best portrait as far as likeness and color goes they ever saw."[4] By October, the
portrait was en route, placed in a carved gilt frame purchased earlier in Rome.[5]
That this portrait was not one painted in 1873 in Antwerp (Breeskin 1970, cat.
27, private collection) is suggested in a letter from Katherine Cassatt
concerning the one being shipped: "[The new] portrait makes me look so much
younger than I am that I am sure that it will mislead them & Katherine
[Alexander's daughter and Mrs. Cassatt's namesake] will say as she did of the
one painted at Antwerp—'Grandma you are all rough & that picture is all
smooth.'"[6] Mark of the importance of the portrait to Alexander and his family,
the painting hung in Cheswold, their preferred home (fig. a).

New evidence also indicates that the painting was crucial in establishing
Cassatt's professional reputation in the United States. American critics
recognized the quality of the portrait when it was first exhibited in 1879.

FIG. a. Dining room in Alexander Cassatt's Haverford house, Cheswold, c. 1900. Mary Cassatt's *Reading Le Figaro* is above the fireplace at left. Estate of Mrs. John B. Thayer.

1. See Breeskin 1970, cat. 128.
2. See the Exhibition Record.
3. Letter dated October 4, 1878, from Robert Simpson Cassatt to Alexander Cassatt, AAA, PMA, in Mathews 1984, pp. 137–38. For identification of Rosenquest, see the 1874 Paris Salon catalogue (cat. 326) for Cassatt's *Ida* (under the name Mary Stevenson).
4. Undated letter, probably 1878, from Katherine Cassatt to Alexander Cassatt, AAA, PMA, in Sweet 1966, p. 35 (as dated July 1878).
5. Letter cited in n. 3.
6. Letter dated October 18, 1878, from Katherine Cassatt to Alexander Cassatt, Estate of Mrs. John B. Thayer.
7. S. N. Carter, "Exhibition of the Society of American Artists," *The American Journal*, vol. 5 (1879), p. 157.
8. William C. Brownell, "The Younger Painters of America. III," *Scribner's Monthly*, vol. 22, no. 3 (July 1881), p. 333.
9. Ibid.
10. *Daily Evening Telegraph*, May 6, 1879, p. 8.

Writing of the New York Society of American Artists' show, S. N. Carter applauded the work for its engaging human empathy and strength of composition and anatomy.[7] Another critic, also moved by the portrait, mildly chided the expatriate for having kept Americans ignorant of her work; he praised its "intelligent directness" of touch and attitude, a welcome contrast, he claimed, to the customary "charm" in paintings by American women artists.[8] This critic felt that Cassatt was particularly unusual in striking a successful course between conservative and radical artistic currents of the time; he called the portrait a "good example of the better sort of 'impressionism,'" which might be due to her academic training and maturation before joining Degas and the Impressionists.[9] When it was shown later that year at the Academy in Philadelphia, the portrait once again drew high praise. The critic from the *Daily Evening Telegraph* singled it out for a refinement and mastery that showed complete command of her formal experiments.[10]

Reading Le Figaro is the fruition of several of Cassatt's pictorial concerns beginning in the late seventies. It is born of her interest, shared with her French colleagues, in representing women seated in a domestic interior engaged in everyday, undramatic activities. It is the most famous example of her long-lived preference for reading subjects, a particular favorite also of Manet and Renoir. The painting represents a woman keeping apprised of current events in a far more emphatic manner than do her so-called portraits of Lydia reading the morning newspaper, executed around 1878 (Breeskin 1970, cat. 51, Joslyn Art Museum, Omaha, and cat. 52, Norton Simon Foundation, Pasadena). Here, the newspaper confronts the viewer with its title prominently displayed.

The portrait conveys a compelling sense of human presence. The absorbed, utterly static figure has been endowed with both psychological and physical life through a broadly handled, evenly lit naturalism. Katherine Cassatt is rendered with sympathetic honesty as an interesting, handsome woman who seems alive and physically close at hand. The thoughtful mood is complemented by an extraordinary subtlety of composition and color. The opposition of the compressed space of the room with reflected, open space in the mirror is the primary compositional strategy in the picture, emphasizing as the fragmentary reflection the object of Mrs. Cassatt's concentration, the newspaper in her hands. The portrait anticipates the spatial plays in many of Cassatt's later works, particularly the theater subjects (nos. 3–5), with similar formal and narrative interests.

Cassatt frequently explored the variation of hue within a single color, particularly that in white (see nos. 8 and 11), but nowhere does she realize to this degree the potential beauty of high-keyed neutral tones. She has modulated luminous and liquidly brushed whites, creams, and grays, all shot through with delicate color and subtly enriched by the occasional vermilion strokes and muted pattern in the armchair. The quiet animation of the surface is controlled by the broad masses and rhythms of the composition.

The success of this experiment in bold austerity attests to the command of métier and pictorial invention that Cassatt had achieved by the late 1870s. As has long been acknowledged, it also makes *Reading Le Figaro* her most extraordinary portrait.